China Chic

East Meets West

China Chic

East Meets West

Valerie Steele
& John S. Major

Yale University Press
New Haven & London

Designed by Gillian Malpass

Printed in Singapore

Library of Congress Cataloging-in-Publication Data

Steele. Valerie, 1955–
 China chic : East meets West / by Valerie Steele and
John S. Major.
 p. cm.
 Includes bibliographical references and index.
 ISBN 0-300-07930-3 (cloth : alk. paper).
 1. Costume–China–History. 2. Costume–United States–Chinese
influences. 3. East and West. 4. United States–Civilization–
Oriental influences. I. Major. John S. II. Title.
GT1555.S8 1999
391′.00951–dc21 98-47310
 CIP

A catalogue record for this book is available from
The British Library

Endpapers: Detail of a woman's skirt panel in silk damask
with multicolor embroidery. China 1900–25.
The Museum at F.I.T., New York,
Gift of Adele Simpson, 69.172.33B.
Photograph by Irving Solero.

Frontispiece: Detail of a woman's "Dragon robe" in multicolor thread
on a silk ground, China, 1880. The Museum at F.I.T., New York,
Gift of Clare J. Kagel, 72.56.1
Photograph by Irving Solero.

Contents

Foreword

THE HISTORY OF FASHION IN CHINA compellingly illustrates how clothing gives us insight into the society in which it is created. In *China Chic: East Meets West*, authors Dr. Valerie Steele, Chief Curator of The Museum at F.I.T., and Dr. John S. Major, a historian of China, examine the evolution of Chinese dress in the context of that country's political, economic, and cultural history, and consider its impact on fashion in the West. They have commissioned fascinating essays by a distinguished group of scholars, who focus on specific aspects of the complex interplay between East and West.

The significance of clothes in China and their continuous influence on western styles is the subject not only of this book but of a major exhibition presented at The Museum at F.I.T. in the spring of 1999. The exhibition brings together a beautiful selection of traditional Chinese clothes and western garments inspired by these styles. Through juxtaposition and contextualization, the presentation affords a new understanding of the mutual influence and interplay of Chinese and western fashions over the past hundred years.

The Museum at F.I.T. has one of world's great collections of twentieth-century clothing and textiles. It is not only a respository for the documentation of changing styles but also a resource for understanding the history, social context, and cultural significance of fashion. We are thus delighted to be associated with the publication of *China Chic: East Meets West*, a perfect example of our interest in the broader meanings of fashion. It has been a pleasure to participate in this book by providing for it a selection of photographs of objects in the show. Our exhibition is amplified and preserved in this valuable book on Chinese fashion and style and their influence on the West.

Dorothy Twining Globus
Director
The Museum at the Fashion Institute of Technology

Notes on the Contributors

Valerie Steele is Chief Curator of The Museum at the Fashion Institute of Technology. John S. Major is an editor and independent scholar of Chinese history based in New York. Suzanne Cahill is Lecturer in Chinese History at the University of California, San Diego. Antonia Finnane is Senior Lecturer in History at the University of Melbourne. Martha Huang recently completed her doctorate at Columbia University and is an independent scholar of modern Chinese history and popular culture; she currently lives in Moscow. Dorothy Ko is Associate Professor of History and Women's Studies at Rutgers University. Hazel Clark is Lecturer in the School of Design of The Hong Kong Polytechnic University. Verity Wilson is Assistant Curator in the Far Eastern Department of the Victoria and Albert Museum.

The Principal Dynasties of China

Xia	*c.*1875–*c.*1550 B.C.E.
Shang	*c.*1550–*c.*1050 B.C.E.
Zhou	*c.*1050–256 B.C.E.
Western Zhou	*c.*1050–780 B.C.E.
Eastern Zhou	780–226 B.C.E.
Spring and Autumn	780–481 B.C.E.
Warring States	481–256 B.C.E.
Qin	221–206 B.C.E.
Han	206 B.C.E.–220 C.E.
Three Kingdoms (Shu Han, Wei, and Wu)	220–265
Period of Disunion	265–589
Jin	265–419
Northern Wei	386–535 (Toba conquest dynasty)
Sui	589–618
Tang	618–907
Song	960–1279
Northern Song	960–1127
Liao	907–1125 (Khitan conquest dynasty; in northeast)
Southern Song	1127–1279
Jin	1115–1260 (Jürchen conquest dynasty; in north)
Yuan	1279–1368 (Mongol conquest dynasty)
Ming	1368–1644
Qing	1644–1911 (Manchu conquest dynasty)

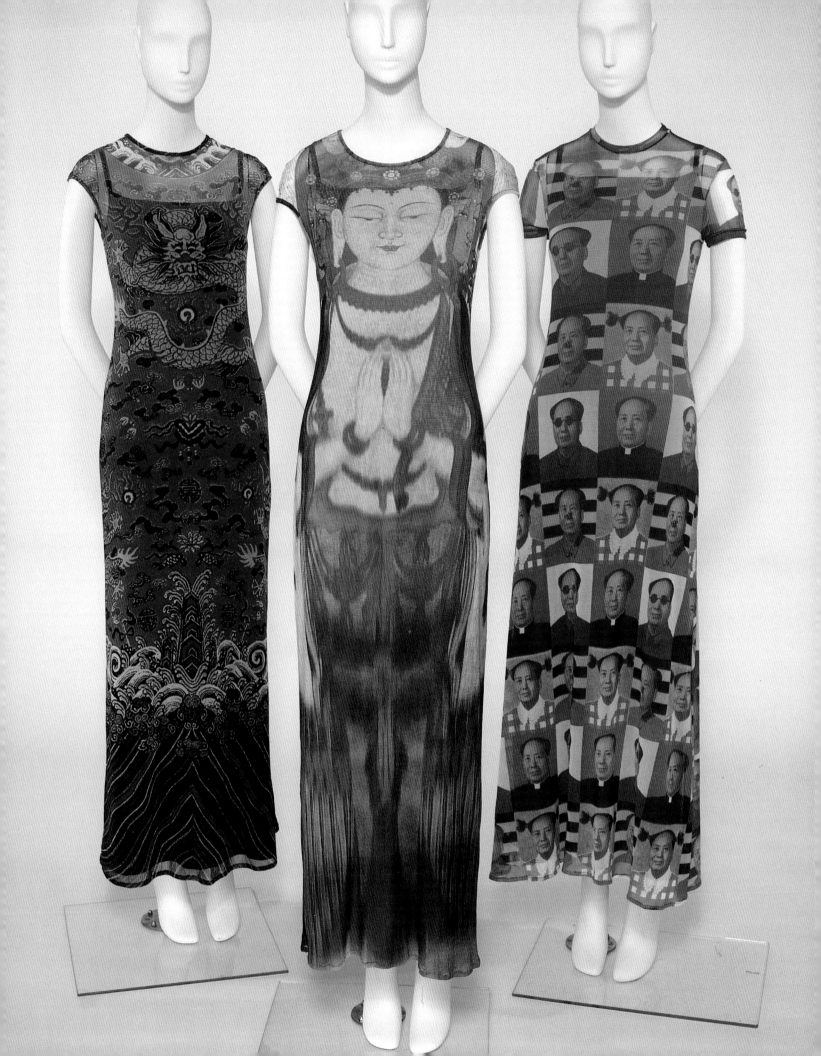

Introduction and Acknowledgments

IN 1926 A RETIRED FRENCH MISSIONARY DOCTOR recounted his impressions of Chinese clothing:

> With [Chinese] clothing, it is the same as with houses: there is no change over periods of thousands of years. In China, one ignores fashion; even the most progressive mandarins, the most elegant *taitai* (*grandes dames*), dress themselves now as did the contemporaries of Confucius; and their clothing does not differ from that of workers except in the richness of its material.[1]

Dr. Legendre's description of Chinese clothing is profoundly mistaken, but it conforms to a long-standing western belief in "unchanging China," a belief that retains its currency even today. Most people know, of course, that China has experienced enormous changes in the past century or so, and that China today is not at all like the China of the imperial dynasties of the past. Still, a surprisingly large number of people have the impression (without thinking about it very much) that China changed hardly at all during the long traditional era from the time of Confucius to the fall of the last emperor – a span of time equivalent, in European terms, to the period from the rise of classical Athens to the eve of the First World War.

It is true that there was a greater degree of political and cultural continuity over the long run in China than in any country or region of Europe. There would have been, for example, a somewhat less drastic difference between the clothed appearance of an upper-class Chinese woman of the Warring States period, around the fourth century B.C.E., and one of the mid-nineteenth-century Qing dynasty, as compared with that between an Athenian woman in a chiton and a Victorian woman in her corset and crinoline. Nevertheless, a woman of the Warring States period transported to the Qing capital city of Beijing would have been amazed to see the dragon robes of the imperial family, women with bound feet wearing the standard Qing woman's ensemble of trousers, overskirt, and jacket, and men whose foreheads were shaved bare and who wore the rest of their hair in a long queue (fig. 2). Virtually none of these styles – which taken together make up what we think of as the stereotypical clothed appearance of traditional China – would have been recognized by our hypothetical visitor from the past, who would have worn a wrapped long robe secured with a sash, and who would never have heard of foot binding.

1 Vivienne Tam, Three dresses. Dragon dress, Spring 1998. Collection of Genevieve Field. Kuan Yin dress, Spring 1997. Gift of Vivienne Tam. The Museum at F.I.T. 98.50.2. Mao dress, Spring 1995. Gift of Vivienne Tam. The Museum at F.I.T. 95.82.6. Photograph by Irving Solero. Courtesy of The Museum at F.I.T.

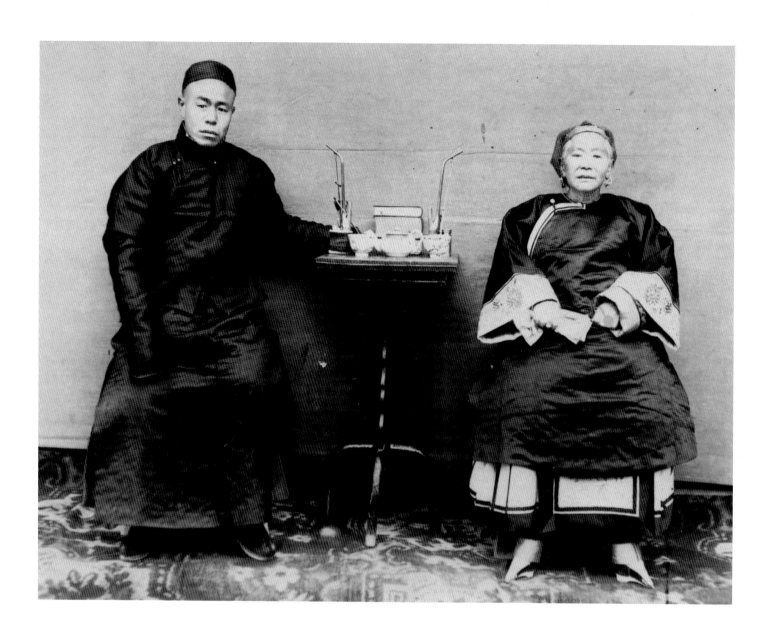

2 Chinese couple, late nineteenth century. She wears jacket, skirt, and trousers (*ao, qun, ku*); he wears a padded silk jacket over a long silk gown (*changpao*). Courtesy of Glenn Roberts.

As fashion today becomes increasingly international and multicultural, many designers are inspired by Chinese clothing and decorative motifs. Yet few people – western or Chinese – understand the historic significance of Chinese clothing. This book uses new perspectives in the history of fashion to explore the evolution of Chinese dress, from the dragon robes and lotus shoes of the imperial era to the creation of new fashions like the *cheongsam* and the "Mao suit" that at various times in the twentieth century have symbolized modern Chinese identity. We have tried especially to break new ground by emphasizing the theme of East meets West. We describe how traditional Chinese dress evolved, consider the social significance of dress in China, and explore how and why both "traditional" and "modern" Chinese dress have influenced western fashion in the twentieth century. For China specialists the

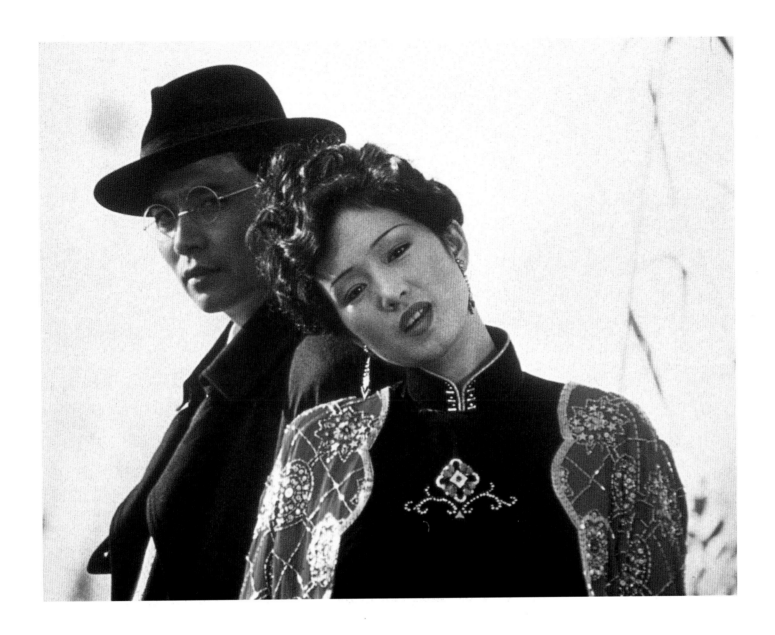

3　Gong Li and Shun Chun in the film *Shanghai Triad* (1996). NA/Fotos International/Archive Photos.

focus on fashion will open up an entirely new way of thinking about modern Chinese society and culture. For readers whose primary interest is fashion, *China Chic* demolishes the Eurocentric myth of an ancient, unchanging mode of dress. Although there have been a number of good books on the history of Chinese clothing, this is the first to address the complex interplay of influences that led both to the westernization of dress in China and the incorporation of Chinese fabrics, styles, and decorative motifs into the western wardrobe.

The book is in two parts. The first, comprising chapters 1 through 4, is a narrative and interpretive history, jointly written by the two of us, Valerie Steele and John S. Major. The title of the first chapter, "Decoding Dragons," pays obvious homage to the work of John Vollmer;[2] because the history of the dragon robe is well known, we touch on it only briefly, focusing instead

on the broader relationship between clothing and Chinese cultural identity. Among the subjects we address are the long-standing Chinese preference for silk, the sartorial divide between Chinese and Manchus during the Qing dynasty (1644–1911), and the factors that led to the demise of the old sartorial order as the imperial era came to an end. The second chapter looks at the controversial subject of foot binding in China. There, we also explore the factors that led to the rapid development of new, post-dynastic styles of Chinese clothing, including the cheongsam. The third chapter considers the influence of the Communist Revolution on clothing in China, as the quasi-military "Sun Yat-sen suit" of the republican period gave way to the proletarian uniform, the "Mao suit" and the virtual disappearance of alternative styles of dress until the late 1970s. The fourth and final chapter of part I considers the phenomenon of "China chic" within the context of western society – from the chinoiserie of the eighteenth century to the "cool coolies" of the 1970s in designer Mao suits, and from the orientalism of Yves Saint Laurent to the Shanghai-inspired dresses of John Galliano. This chapter concludes with a look at some of the most important Chinese and Chinese–American designers at work today.

Part II of the book consists of essays that amplify and complicate some of the themes raised in part I, and gives the perspectives of six well-known scholars on these issues.

In "Our Women are Acting Like Foreigners' Wives!," Suzanne E. Cahill looks at a particularly interesting aspect of one of the most enthusiastically fashionable eras in all of Chinese history. The ruling house of the Tang dynasty (618–907) was of partly Turkish descent; under the Tang, trade on the Silk Route rose to unprecedented levels, bringing a great deal of foreign influence to bear on Chinese taste in music, furniture, decorative art, fashion, and other aspects of upper-class cultural life. Because terracotta funerary figurines and tomb murals from the Tang realistically and meticulously depict the costumes of the time, they give excellent evidence of fashion changes throughout the period, including fashions for foreign styles (see fig. 6).

"Military Culture and Chinese Dress in the Early Twentieth Century," by Antonia Finnane, looks at transitions in Chinese dress at the very end of the Qing dynasty and in the formative years of the republican period, a time when nationalist revolution and social upheaval led many Chinese people to consider, for the first time, undertaking serious reforms in everything from military affairs and industrial technology to literature and art. Leaders of China's modernized armed forces introduced military uniforms that evolved into the "Sun Yat-sen suit"; both boy and girl students in modern schools and universities wore variations on western school uniforms and hybrid Sino-western clothing styles. A decades-long debate on what was modern, Chinese, and appropriate in dress had begun.

"A Woman Has So Many Parts to Her Body, Life is Very Hard Indeed," by Martha Huang, takes a closer look at debates on what constituted suitable

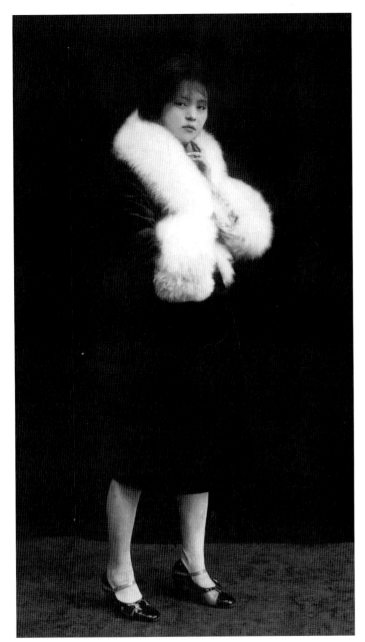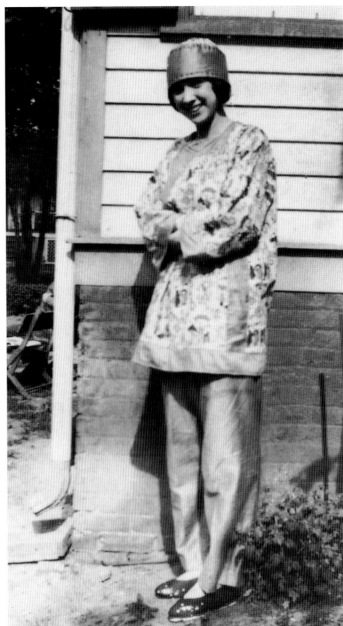

women's clothing around the time of the May Fourth Movement (roughly 1915 to the early 1920s), a period marked by intense debate in intellectual circles over issues of modernization and westernization. Some reformers argued for clothing of puritanical simplicity; others advocated unisex clothing for men and women alike; others saw outright adoption of western styles as progressive. Meanwhile the women themselves settled the issue by following fashion trends that they considered attractive and appropriate.

The fourth essay is "Jazzing into Modernity: High Heels, Platforms, and Lotus Shoes," by Dorothy Ko. The "lotus shoes" worn on the bound feet of ethnic Chinese women, and the wood-soled platform shoes of Manchu

4 Miss Yao Chin Chu wearing a velvet coat with fur trim, Shanghai, early 1920s. Courtesy of Dora Wong.

5 Miss Kathryn Demarest wearing an ensemble of Chinese pyjamas, New Jersey, 1925. Courtesy of John S. Major.

6 Chinese calendar poster of the 1930s showing qipaos worn with western accessories. Collection of Valerie Steele and John S. Major.

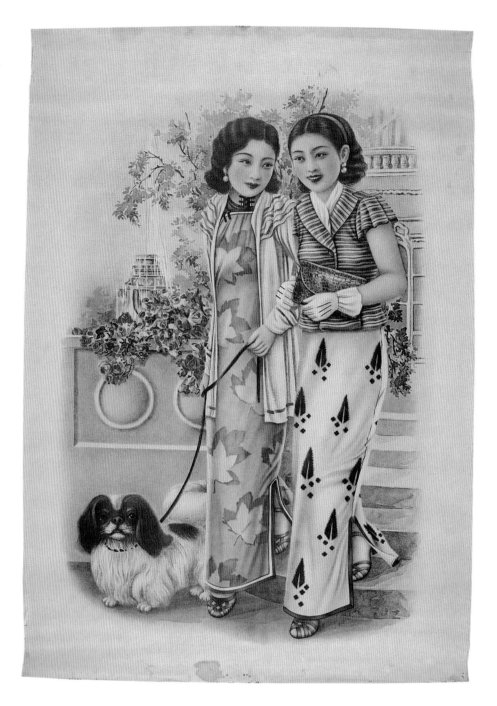

women, represented two opposing traditions – not only of footwear, but of personal identity at the end of the imperial period. The centuries-old consensus in favor of foot binding collapsed in the early twentieth century in the face of missionary disapproval and a sense shared by many patriotic Chinese that a nation in drastic need of modernization could not afford such a symbol of the past. The Manchu long gown formed the basis for a new, modern women's dress – the *cheongsam* or *qipao* – but the platform shoes that had accompanied

the traditional long gown were discarded in favor of western high heels by young women who liked them for being both "modern" and western.

In "The Cheung Sam: Issues of Fashion and Cultural Identity" Hazel Clark looks more closely at the evolution of the cheung sam (she prefers that spelling). She stresses the role of functional considerations in its development; part of its initial appeal was that it seemed more suitable for modern, active women in the twentieth century than the bulky and ornate garments of the past. Ironically, as its fit got tighter and its collar higher and stiffer, these functional advantages diminished. Nevertheless, the cheung sam became for a time the dominant style of Chinese women's clothing, as well as, in effect, the "national dress" of Hong Kong (itself a peculiar mixture of China and the West). After a long, slow decline in popularity, the cheung sam has recently experienced a revival as a symbol of Hong Kong identity as the former British colony is absorbed into the Chinese sovereign state.

In "Dress and the Cultural Revolution," Verity Wilson looks more closely at how politics affected clothing in China under communist rule. The question

7 Tseng Kwong Chi. From the series "East Meets West," 1979. Courtesy of the Estate of Tseng Kwong Chi and the Artists Rights Society (ARS), New York.

of dress became acute during the Great Proletarian Cultural Revolution of 1966–76, when any expression of individuality in dress invited severe social and political repercussions. Mao Zedong, Zhou Enlai, and other leaders competed to display appropriate "proletarian simplicity" in dress. Wilson's essay concludes with an analysis of image creation and self-presentation in poster art, photographs, and mirrors in the People's Republic.

★ ★ ★

A note on Chinese words in this book: We use the *pinyin* system of romanization throughout, except in the cases of a few names (Sun Yat-sen, Chiang Kai-shek) that are generally familiar in non-Mandarin dialect form. Similarly, we have followed individual authors' preferences in spelling the word *cheongsam* (or *cheung sam*), which is in Cantonese, not Mandarin. Dates are given as B.C.E. (Before Common Era) and C.E. (Common Era), corresponding to B.C. and A.D. of the Christian calendar.

8 "Chinese Acrobat." Lambesis/Airwalk advertisement Spring/Summer 1998. Reproduced courtesy of Lambesis, Inc.

We are grateful to many people who helped us in various ways as we worked on this book. First and foremost we thank our six co-authors, Suzanne Cahill, Antonia Finnane, Martha Huang, Dorothy Ko, Hazel Clark, and Verity Wilson. We appreciate their enthusiastic participation, their erudite contributions, and their willingness to work to very tight deadlines. Many thanks also to our editor, Gillian Malpass, and our copy-editor, Celia Jones.

A major exhibition on *China Chic: East Meets West* was organized at The Museum at the Fashion Institute of Technology in New York City in conjunction with this book's publication. *China Chic* is not a catalogue for that exhibition, although the primary text addresses the exhibition's core themes, and the book's illustrations are drawn in part from items of clothing and works of graphic art included in the exhibition. As curator of the exhibition, Valerie

Steele would like to thank her colleagues, especially the Director of the museum, Dorothy Twining Globus. The museum's photographer, Irving Solero, played an important role in this project, as did Fred Dennis, Associate Curator of Costume. Thanks to all the members of the departments of costume and textiles, the conservation laboratory, the exhibition department, and the museum registrar's office. Thanks also to Laird Borrelli, Lynn Sallaberry, and the exhibition designer, Lawrence Robinson.

It is with great pleasure that we thank the Henry Luce Foundation for providing a grant to support the museum exhibition, *China Chic: East Meets West*. Special thanks to the Foundation's Vice-President, Dr. Terrill E. Lautz, for encouraging the museum's staff to apply for the grant. Similarly we thank Blanc de Chine and Vivienne Tam for generous grants in support of the exhibition; special thanks to Kin Yeung, Kawai Fong, and Lydia Reeve at Blanc de Chine, and Vivienne Tam and Margaret Schell at Vivienne Tam. We would also like to thank Nancy Jervis and Colin Cowles of the China Institute in America for arranging the Institute's co-sponsorship of a lecture series in conjunction with the museum exhibition. For lending or donating objects to the exhibition and/or allowing us to copy photographs and other materials, and for giving us permission to publish works in their collections, we are grateful to Amedeo Angelillo of *Fashion Almanac*, Archive Photos, Hamish Bowles, Amy Chan, Maximilian Chow, Joan Lebold Cohen, Carol Conover and Arnold Chany of the Kaikodo Gallery, Inger McCabe Elliott, Han Feng, Genevieve Field, Harry Fireside, Lucia Hwang, Claus Jahnke, Martin Kamer, Donna Karan, Krizia, Christian Lacroix, Lambesis Inc., Davie Lerner, Michael Mundy, Museum of Fine Arts (Boston), Dries van Noten, Todd Oldham, Glenn Roberts, Lillian Schloss, Rudy Faccin von Steidl, Anna Sui, Vivienne Tam, John Bigelow Taylor, Blaine Trump, Muna Tseng, the Estate of Tseng Kwong Chi and the Artists Rights Society, Valentino, Mark Walsh, Dora Wong, Linda Wrigglesworth, and Yeohlee. Thanks also to Katell Le Bourhis of Christian Dior, Connie Uzzo of Yves Saint Laurent, Richard Martin of The Costume Institute at The Metropolitan Museum of Art, Phyllis Magidson of The Museum of the City of New York, Valrae Reynolds of The Newark Museum of Art, and Myra Walker of the Texas Fashion Collection. Hazel Clark thanks the Regional Council, Hong Kong, and The Hong Kong Polytechnic University for funding the early stages of the research for her essay. We would also like to thank everyone else who helped our co-authors and, in particular, those who gave permission for their objects and images to be reproduced in part II of this book. Their names appear in the captions of the illustrations.

Valerie Steele and John Major
New York, 1998

Following pages: Detail of fig. 41.

Part I

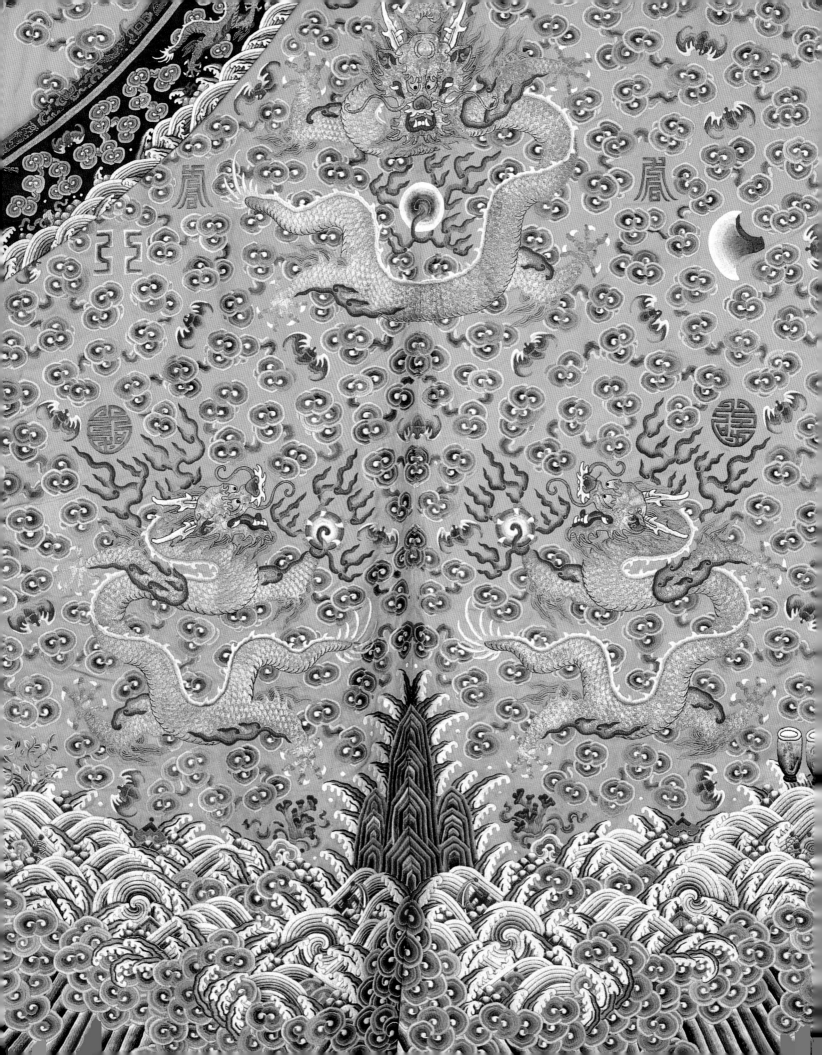

Decoding Dragons:
Clothing and Chinese Identity

THE FAMOUS DRAGON ROBES of the Chinese emperors seem, in western eyes, to define the very notion of Chinese imperial regalia; but in fact they are not (in the Chinese scheme of things) very old – they date back only a few hundred years. The habitual wearing of robes woven or embroidered with dragon symbols by Chinese emperors does not apparently go back beyond the Southern Song period, around 1200 C.E. Not only that, but the characteristic dragon symbol on such robes – a *long* dragon displayed against a background of clouds, and chasing a fiery pearl (fig. 9) – may have originated with the Khitan and Uyghur weavers of Central Asia, along the Silk Route to the west of China proper, rather than at the Chinese court itself.[1]

Nevertheless, the dragon is a very ancient element of Chinese symbolism and religious iconography, and it was from very early times associated especially with the ruler. A famous anecdote about the ancestry of the founding emperor of the Han dynasty (206 B.C.E.–220 C.E.) illustrates this point vividly:

> Before [Liu Bang, later Emperor Gaozu of the Han] was born, Dame Liu was one day resting on the bank of a large pond when she dreamed that she encountered a god. At this time the sky grew dark and was filled with thunder and lightning. When Gaozu's father went to look for her, he saw a scaly dragon over the place where she was lying. After this she became pregnant and gave birth to Gaozu.
>
> Gaozu had a prominent nose and a dragon-like face, with beautiful whiskers on his chin and cheeks . . .[2]

Draconic ancestry was claimed by or ascribed to a number of Chinese dynastic founders over the centuries; it was an excellent credential for claiming the Mandate of Heaven.

The dragon robe was part of a larger trend, from the Song period onwards, toward use of explicit badges of rank and distinction. There developed a vocabulary of imperial regalia that included not only dragons (and phoenixes for women), but the distinction between the five-toed dragon (*long*) and the four-toed dragon (*mang*); the use of an embroidered border at the hem of the robe depicting the sacred Mount Kunlun, the pivot of the universe, as an emblem of the axial nature of the emperor's rule; and the "twelve sacred

8 Detail of fig. 9.

symbols" – the sun, moon, seven stars, dragon, pheasant, sacrificial cup, water weed, grains of millet, flames, sacrificial axe, and *fu* symbol, representing the forces of good and evil – that were embroidered or woven into all imperial garments. Along with this, one finds the development of mandarin squares, as badges of civil or military rank, together with a similar regulation of hat-buttons, plumes and crests, and so on.

All of this in turn is related to an increasing centralization and bureau-cratization of Chinese government from the latter Song period onward; a movement, one might say, from aristocratic to authoritarian monarchy. In 1127 the armies of the Jin dynasty (1115–1260) – a conquest dynasty, estab-lished by the Jürchen people of Manchuria, that first occupied the provinces of the northeast and then went on to rule most of northern China – dealt a devastating defeat to the Song dynasty (960–1279). The court was forced to flee from the capital of Kaifeng, on the North China Plain, to a new capital at Hangzhou, in the Yangtze River delta; the dynasty would henceforth be known to history as the Southern Song (1127–1279). This event marked the final stage in a long process of eclipse and extinction for the traditional northern Chinese aristocracy – powerful families that traced their position, their wealth, and their prominence in imperial councils back well beyond the Tang dynasty (618–907), even to the Han and before. These families, collectively, were influential enough to ensure that emperors were powerful, but not all-powerful. The emperor might sit splendidly on his throne, wearing emblems reserved by law to himself, but the current patriarch of the Cui or the Ouyang clan sat in his fortified country mansion like a minor monarch in his own right. Over the centuries the onslaughts of popular rebellions, barbarian invasions, and dynastic upheavals took their toll on these old aristocratic families. After 1127 they were almost all gone – killed on the field of battle, slaughtered in the looting and destruction of conquest, at the very least humbled by the loss of their estates and mansions, deprived of the vast independent wealth that had allowed them such influence with the throne.

The vanished aristocracy was replaced, not with a new nobility (emperors by this time generally had learned to ennoble their relatives but prevent them from acquiring any real power), but by an expanded cadre of civil servants, the famous Chinese system of bureaucratic government. This was not a new idea – a professional civil service had already existed in China for well over a thousand years – but the net was spread more widely, the rules were made more uniform, the constraints on office-holders were more confining. China's governing class came to be chosen by competitive examination from men of the gentry class, rural landowners who (especially in comparison with the old aristocracy) were people of modest wealth and social position, dependent on their civil service rank for the social advantages they enjoyed of money, power, and prestige. From his dragon throne the emperor towered over these civil servants like a dragon indeed; and he wore robes that served to prove the point.

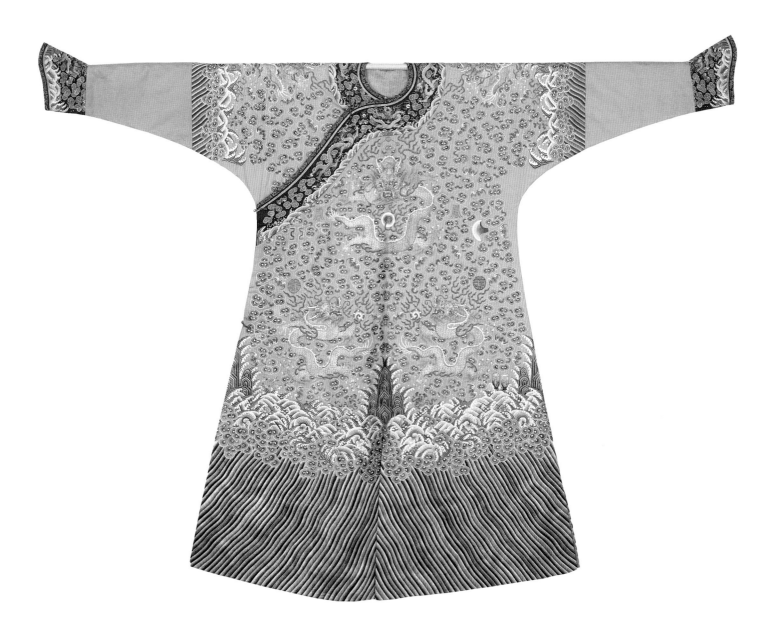

Clothing and Chinese Identity

The emperors of China were under a more than ordinarily strict obligation to dress appropriately at all times. In a book about ritual and the calendar from the third century B.C.E., we read that

> In the final month of summer . . . the Son of Heaven wears yellow clothing. He mounts a carriage drawn by black-maned yellow horses. He wears yellow jade pendants and flies a yellow banner . . . The imperial ladies of the central palace wear yellow clothing with yellow trim . . .
>
> The emperor commands the intendants of the women's quarters to dye fabrics in various hues and multicolored designs, patterned and ornamented, bluegreen, vermilion, yellow, white, and black. There may be none that are

9 Dragon robe. An imperial yellow twelve-symbol emperor's robe; padded with raw silk for winter wear; embroidered in satin stitch and couched gold thread depicting nine dragons. China, nineteenth century, attributed to the Xianfeng Emperor. Courtesy of Linda Wrigglesworth, London, England.

not beautiful and fine. This is to provide new vestments for the ancestral temple: there must be a display of things that are brightly new.[3]

In the traditional Chinese world-view, the emperor was not merely the ruler of an earthly country, but the sovereign of "All Under Heaven," ruling the earth on heaven's behalf. He was responsible, through his ritual behavior, for ensuring that the sun and moon, the seasons and the weather, and all the rhythms of the natural world kept to their proper cycles throughout the year. For example, by adopting regalia in a color that resonated with a particular season (such as yellow at the height of summer), he was doing his part to ensure that appropriate seasonal energy radiated throughout the realm.

Clothing was thus considered a matter of great importance in ancient China. It was an instrument of the magical aura of power through which the emperor ruled the world; in addition it served to distinguish the civilized from the barbarous, the male from the female, the high from the base, the proper from the improper – in short, it was an instrument of order in a society dedicated to hierarchy, harmony, and moderation, a society in which chaos was to be feared above all else.

The role of clothing as a badge of Chinese cultural identity is seen vividly in a passage from the *Analects of Confucius* dating to around 400 B.C.E., in which the Master extols the virtue of Guan Zhong, a famous prime minister of the state of Qi:

> When Guan Zhong served as prime minister . . . he . . . brought good government to All Under Heaven. From his time down to the present, the people have enjoyed the benefits of his rule. Had it not been for Guan Zhong, we would now be wearing our hair unbound, and buttoning our garments on the left side.[4]

That odd phrase – with hair unbound, buttoning garments on the left – was apparently even in the time of Confucius a stock phrase that meant "living like barbarians." Nearly two thousand years later it retained its currency and power to shock. The Tang dynasty poem cycle *Eighteen Songs of a Nomad Flute* tells the sad story of the Han princess Wen Ji, who was given as an unwilling captive wife – a diplomatic offering – to the khan of a northern nomadic tribe, and forced to remain beyond the frontier for many years. Her complaint that she must "button her garments in barbarian fashion" speaks volumes about the indignities she is forced to endure. Clearly clothing in traditional China was not simply a matter of fashion or taste or social status, although it was all of those too; it was perhaps most importantly a signifier of cultural identity – and superiority.

Remarkably, the notion of clothing as a sign of the difference between Chinese and non-Chinese was accepted with equal fervor, though with quite opposite ideas about superiority, by the "barbarians" as well. In 1636, for

example, Hongtaiji, one of the founders of the Manchu Qing dynasty (which ruled China from 1644 to 1911), issued a code of clothing regulations for Manchu tribesmen. He argued that the "wide robes with broad sleeves" of Ming China were unsuitable for Manchus, and he expressed grave concern that the Manchus might eventually lose their sense of identity and their martial spirit if they emulated Chinese dress and customs.[5]

For the Chinese themselves, the issues of civilization and superiority admitted no argument. From high antiquity, they considered themselves to be the people of the Middle Kingdom, distinguished by their civilized arts from the barbarians who surrounded them. To be Chinese – to be a civilized person, which amounted to the same thing – was to participate in a literate culture, to eat a proper diet of grain and vegetables, to conduct one's self with proper decorum, and to dress in a civilized manner. Hair, for men, was always worn long, bound in a topknot, covered with a hat or cap; garments, whether a peasant's short tunic or an aristocrat's long robe, fastened on the right side. Over the centuries, the cut and appearance of Chinese clothing changed considerably, as we shall see; but the social obligation to appear properly dressed never changed.

For Mencius, who wrote a century or so after the death of Confucius, the disgrace of appearing in public with one's hat and hair in disarray was so great as to overcome the normal social duty to aid one's neighbors:

> If people are fighting in the same house that you are in, you should separate them, even though your hair be unbound and your hat be only loosely tied; but if people are fighting out in the neighborhood, and your hair is unbound and your hat is only loosely tied, it would be an error to go out and separate them. On the contrary it would be proper for you to shut yourself up indoors.[6]

Given that elsewhere Mencius used the tendency of people to go to the aid of others in distress as one of the cornerstones of his argument in favor of the fundamental goodness of human nature, his contention here that a bad hair day justifies barring the door rather than aiding fellow townsmen in difficulty powerfully emphasizes the significance of propriety in dress and appearance to conservative Chinese notions of proper social order.

In the Confucian world view, people with long, unbound, unkempt hair were barbarians, or were otherwise outside the bounds of normal, civilized society. Witches, shamankas, and sorceresses were identifiable by their wild, long hair; popular religious rites that involved trance, "speaking in tongues," the loosening of hair and garments, and other evidence of spirit possession were often suppressed by the civil authorities.

The same holds true of clothing that was absent or unkempt. Under certain circumstances, of course, a "sweet disorder of the dress" had for the Chinese the same sorts of erotic connotation that it would have for most western

readers; Tang dynasty poets were fond of extolling the charm of courtesans with their sashes loose and stocking-ribbons untied after a bout of love-making. But in public, clothing was expected to be appropriate, moderate, neat, and, above all, present. Very low status people might shed their clothing to work; the "trackers" who hauled on bamboo cables to drag ships upstream through the Yangtse River rapids, for example, often wore only trousers, or even just loincloths. But people of any pretensions to status were expected to be dressed. Chinese visitors to lands far to the south of China's southern borders took it as a sign of local barbarism that even people of high status exposed an unseemly amount of bare skin – on arms, chests, and lower legs, for example.

Sexual nudity was sometimes regarded with apprehension, even fear: Eric Henry has shown that in a number of instances spanning many centuries, Chinese cities under siege took the defensive measure of displaying naked women on the tops of their ramparts; the exposed female genitalia were supposed to radiate such an aura of malevolence that the besieging troops would retreat in disarray.[7]

Clearly the assumption of Chinese society was that people would be appropriately dressed at all times, except under quite unusual circumstances. What then constituted appropriate clothing? The simple answer is that clothing should be appropriate to one's gender, age, and place in the social hierarchy. Clothing, in other words, not only served to distinguish Chinese people from barbarians; it also served, through elaborate sumptuary rules and social conventions, to reinforce the structure of Chinese society itself. Throughout Chinese imperial history, sumptuary laws were promulgated regulating the cut, color, and decoration of robes, as well as headgear, sashes, pendants, tassels, and other ornaments. The *Book of Guanzi*, a text from about 300 B.C.E. that deals with a wide range of social and political topics, includes a section entitled "The Regulation of Clothing," which says, in part:

> Let clothing be regulated according to gradations in rank . . . In life, let there be distinctions in regard to carriages and official caps, clothing and positions, stipends and salaries, and fields and dwellings. In death, let there be gradations in coffins, shrouds, and tombs. Let no one, even if worthy and honored, dare wear clothing that does not befit his rank. Let no one, even if coming from a rich family and possessing extensive property, dare spend wealth that exceeds his salary.
>
> Let the clothing of the Son of Heaven be decorated with insignia. Let the royal concubines never dare wear leisure dress when making sacrifices in the temple, nor the generals and great officers dare wear it in the temple, nor the officials and functionaries dare wear it at court. Let the gentlemen of the court be limited to decorations on their belts and on the hems of their robes.
>
> Let ordinary people never dare wear mixed colors, nor the various artisans, merchants, and traders be permitted to wear long-haired sable . . .[8]

Predictably, the official chronicles are full of complaints that such regulations were violated with impunity. As in other traditional societies, the sumptuary laws of China did not work very well, as can be seen from the apparent need to promulgate them repeatedly. Some regulations achieved the true force of law: hardly anyone in traditional China would have lightly committed treason by usurping the emblems of imperial regalia; hardly any commoner would have had the temerity to wear the official hat of a bureaucrat. But as for keeping commoners from wearing colored fabrics, or merchants from wearing the richest clothing their wealth could support, the laws were generally a lost cause. In the *Debates on Salt and Iron*, an account of a court debate about economic policy in the first century B.C.E., we read that

> We would like yet to report the tales told by the elders of our village communities. It is not so long ago, it seems, that the common people were clad in warm and comfortable clothes with no ostentatiousness and were perfectly satisfied in making use of crude and simple materials and instruments . . .
>
> In olden times . . . people wore plain clothes and ate from earthenware . . . Nowadays manners have degenerated in a race of extravagance. Women go to the extreme of finery and artisans aim at excessive cleverness . . .

The same text reports that even in small villages, young women liked to "squeeze their waists" and apply too much make-up.[9]

Seventeen centuries later, the situation had not improved. "Long skirts and wide collars, broad belts and narrow pleats – they change without warning. It's what they call fashion," complained the scholar Chen Yao, using the word *shiyang*, literally "the look of the moment." Writing in the 1570s, he contrasted the "plain," "inexpensive," and "unadorned" robes worn in his youth by gentry and scholars with the modish and ostentatious styles of the present: "Now the young dandies in the villages say that even silk gauze isn't good enough and lust for Suzhou embroideries, Song-style brocades, cloudlike gauzes, and camel serge, clothes high in price and quite beautiful."[10] This was not merely a reprise of the complaints of Han dynasty conservatives; by the Ming dynasty (1368–1644), the development of commerce had triggered even more intense status competition, played out especially in the arena of fashion.

Thus we see that, far from being a bulwark of social stability and hierarchy, dress in traditional China was always a contested realm of behavior. Even the bedrock belief that there was some standard of "Chinese" clothing that distinguished the civilized world from the surrounding barbarity was illusory, as can be seen from the long-term history of Chinese dress.

★ ★ ★

The Fabric of Society

Cultures tend to have deep-seated preferences for particular kinds of cloth, embracing both types of fiber and techniques of weaving – for example, the preference of the Egyptians for linen, and of the Celts for woolen plaid twill. Such preferences reflect, in part, local differences in plant and animal fiber resources, but over time they become embedded in the notion of cultural identity itself. In China this phenomenon expressed itself very strongly as a preference for silk over all other kinds of cloth, and a general dislike of woolen cloth.

Silk was *not* discovered when a cocoon dropped in the teacup of China's first empress, as some modern books erroneously maintain. (Among the many things wrong with this doubtful bit of folklore is that tea was unknown in China until the Tang dynasty, when it was introduced by Buddhist monks returning from pilgrimages to India.) The so-called "Silkworm Empress," the supposed wife of the Yellow Emperor – who allegedly lived in 2700 B.C.E. – was mythical. So, of course, was the Yellow Emperor himself. To credit the Silkworm Empress with inventing sericulture is like saying that Athena taught the Greeks to weave. The tale of the Silkworm Empress does suggest one true fact, however, which is that the use of silk in China is very ancient indeed. In fact it predates civilization itself; already in the Neolithic villages of north China, silk cloth was being produced, made perhaps from cocoons of the wild ancestors of the domestic silkworm, *Bombyx mori*.

By the Shang dynasty (*c*.1550–1050 B.C.E.) sericulture – the raising of

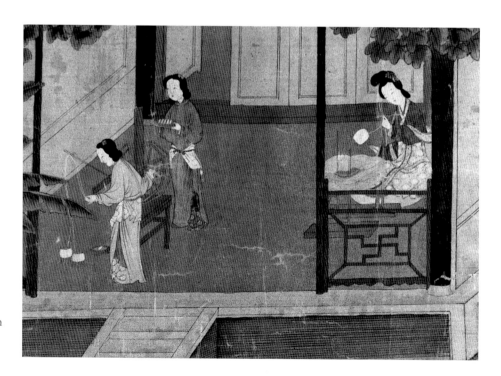

10 Anonymous painting on silk, China, eighteenth century (detail): ladies in a garden spinning and reeling silk. Collection of Valerie Steele and John S. Major.

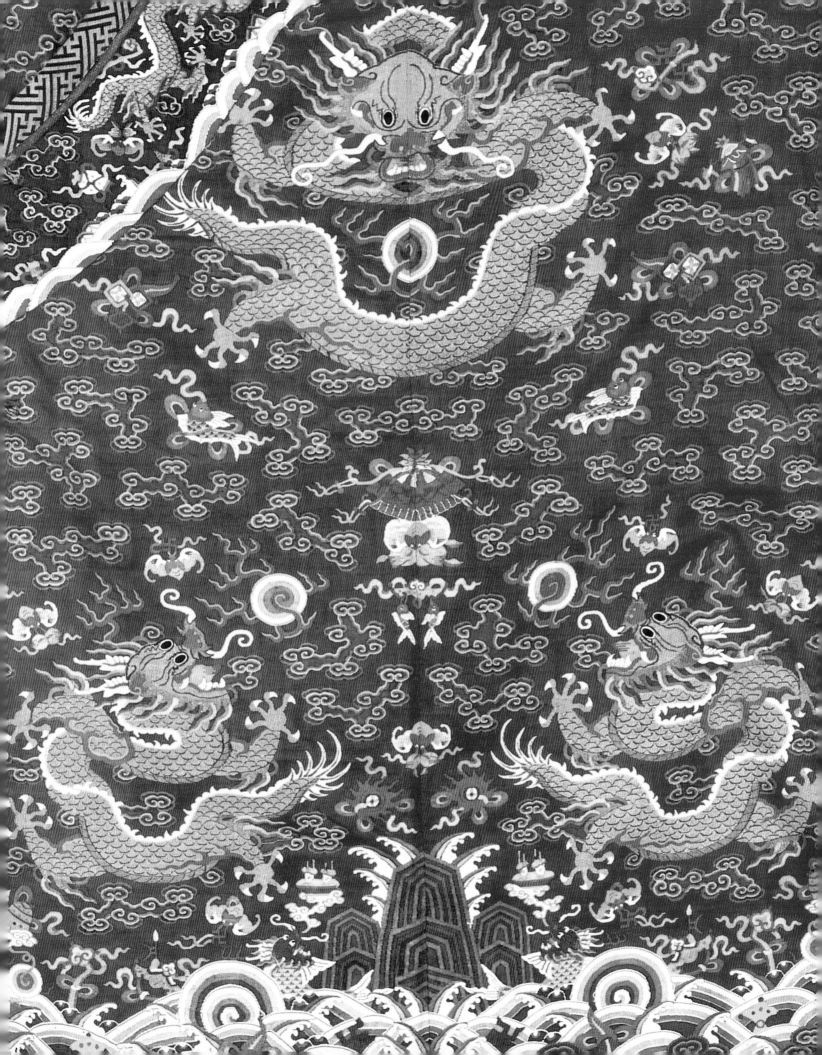

silkworms and the production of silk – had developed to a very high degree. The silkworm had become a true domestic animal, bred for a variety of desirable characteristics; the typical Chinese farmstead included not only fields for grain and vegetables, but also a grove of mulberry trees, the leaves of which are the sole food of the silkworm caterpillar. Ordinary peasant women were expert in the special techniques associated with silk weaving; silk was produced in quantity and worn, at least on some occasions, by a wide range of people, not just the aristocracy.

The other common fiber of ancient China was hemp, which was worn mainly by peasants and the poor. During the hottest part of summer, however, lightweight hempen cloth (which was similar to fine linen) was worn by all classes. Hemp fabric came to have connotations of virtuous simplicity, to the point that a Han dynasty official, who would as a matter of course have been expected to wear silk, was criticized for his ostentatious display of austerity in choosing to wear hemp.[11] The same connotations of simplicity and austerity made plain, unbleached and undyed hempen cloth the preferred fabric for mourning garments.

From the Song dynasty (960–1279) onwards, hemp tended to be replaced by cotton, an import from India; the growing and weaving of cotton soon became a major economic activity, and cotton became established as the characteristic fabric of peasant and working-class clothing. Ramie, a plant fiber from Southeast Asia that can be woven into a light, cool, linen-like cloth, also entered China's fabric repertoire in the Song period.

Wool was not generally worn in China. In fact, throughout the history of Chinese clothing wool is conspicuous by its absence; because it was regarded as a "barbarian" fabric, its use was consciously avoided. Wooly sheep were a relatively late product of selective breeding under domestication, originating in western Asia only around 4000 B.C.E. (Wild sheep have coarse hair rather than wool; early domestic sheep were raised for meat and milk, not for fiber.) Groups of people who migrated eastward to the deserts and river valleys of what is now Chinese Central Asia brought sheep along with them;[12] the animals, though not the felt cloth and woven fabric made from their wool, were incorporated into Chinese culture (along with other western innovations, such as wheat and the horse-drawn chariot) during the Shang dynasty. In part, the limited role of sheep in China reflects another cultural preference, namely for a diet based on grain and vegetables, with small amounts of animal protein. All fertile land was devoted if possible to agriculture, with more marginal lands employed for raising mulberry trees for sericulture. Grazing was limited to roadsides, edges of fields, and other waste areas; this left no scope for the raising of large flocks of sheep for fiber production. Such practical considerations aside, the fact that wool was worn by the nomads of the north and west was reason enough for the Chinese to eschew it.

For their part, the "barbarians" tended to confirm China's high opinion of

silk; silk cloth was eagerly imported north of the Great Wall, for luxury use by the nomads themselves and as a high-value commodity to be traded westwards. At the same time, they too were aware of the importance of textiles as cultural signifiers. For example, when Genghiz Khan promulgated his code of laws, the *Yasa*, in the early thirteenth century, he specified that it was to apply to "all peoples who live in felt tents" – in other words, nomads like the Mongols themselves, or Tibetans, or Uyghurs; but not to subject sedentary peoples, like the Chinese, who were to live outside both the application and the protection of the khan's laws. By the time of the Mongol Empire, felt – wool that was matted, rather than woven, into a fabric – had been the signature textile of the northern nomads for well over two millennia.

The Chinese prejudice against woolen cloth endured until modern times. One of the frustrations of British merchants trading on the China coast in the eighteenth century is that the Chinese had no interest in the woolen cloth the British wished to exchange for porcelain and tea. (The search for a product that China would buy in quantity from western merchants led, tragically, to the opium trade.) Wool became an especially contested fabric in the twentieth century. Made up into a standard western men's business suit, woolen cloth could be seen as symbolizing an overt commitment to westernization and modernization, but it also was vulnerable to criticism for "foreignness." Domesticated in the form of the Sun Yat-sen suit popular from the early republican period onward, however, wool came to connote a thoroughly Chinese, and thus unimpeachable, form of modernity.

In preference to the felts and twills of the northern and western "barbarians," Chinese people depended for warmth on padded clothing (padded with silk floss, a readily available by-product of silk production). Like the use of silk, padded clothing was a cultural preference that endured for tens of centuries. Padded clothing might be trimmed or lined with fur; in winter the rich typically wore silk robes that were both fur-lined and padded with silk floss. After cotton became established in China, cotton batting sometimes replaced silk floss in cheaper grades of padded clothing.

Textile production in China was strongly associated with women. As the Chinese proverb put it, "Men till, women weave."[13] Nor was this only a question of home weaving, for by the Eastern Zhou period (eighth to third centuries B.C.E.) there already existed state textile workshops, staffed primarily by skilled female workers.[14] The art of weaving complex textiles was by then well advanced, and embroidered silk gauze robes have been excavated from a number of early tombs. Indeed, by the Han dynasty virtually every technique of weaving now known had already been invented in China. China's achievements – both technical and aesthetic – in weaving lead us directly to a further consideration of the history of clothing and fashion in China.

★ ★ ★

The next time you admire a Tang dynasty figurine or a portrait of a Ming dynasty official, notice the clothes. Many westerners believe that traditional Chinese clothing remained "timeless" and "unchanging" over the centuries, yet Chinese dress has changed greatly over the past five thousand years. Paintings and sculpture show the changing styles of dress, while recent archaeological discoveries have unearthed many garments whose cut and decoration vary widely. To some extent, developments in Chinese dress were the result of cultural contact with outsiders. The Tang dynasty, for example, was a time of great expansion into central Asia, and foreign fashions proliferated accordingly. Moreover, foreigners – mounted nomads from beyond China's northern frontier – often conquered China and introduced elements of their own styles of dress. Thus, during the Qing dynasty, Manchu styles greatly influenced the cut of court robes. However, new fashions also developed from *within* Chinese culture. In particular, during the Ming dynasty there were many complaints about rapidly changing fashions.

As the market economy developed, fashion diffused outward from luxury production centers such as Suzhou. Just as Paris had become the fashion capital in seventeenth-century France, so also did Chinese towns like Suzhou exert an influence on surrounding areas. According to Zhang Hou, by the 1590s,

> People from all over favor Suzhou clothing, and so Suzhou artisans work even harder at making them . . . This drives the extravagance of Suzhou style to even greater extravagance, so how is it possible to lead those who follow the Suzhou fashion back to sensible economy? . . . The present having become so decadent, how could we now return to a simpler beginning even if we wanted to?

In fact, of course, China's past was hardly as simple and austere as the moralists imagined, and even Zhang Hou admitted that "From early times the people of Suzhou have been habituated to rich adornment and have favored the unusual, so everyone is moved to follow fashion."[15]

The shape of garments changed noticeably in China over the years. Artifacts from the Shang (*c.*1550–1050 B.C.E.) and Western Zhou (*c.*1050–780 B.C.E.) depict men and women of the ruling class wearing robes with narrow sleeves, belted with a sash. By the Warring States period (481–221 B.C.E.) sleeves were fuller and robes were shaped so as to wrap with a spiral effect. In the Qin (221–206 B.C.E.) robes once more had narrow sleeves, and men wore trousers underneath. During the Han dynasty (206 B.C.E.–220 C.E.) sleeves were broad, and elite men replaced their trousers with a skirt. During the Wei (220–260) and Jin (265–419) dynasties men (but not women) flaunted enormous sleeves and tied aprons around their waists. Generally, members of the elite wore some kind of long robe, while peasants wore trousers and short jackets.

Distinctions were made between ritual or ceremonial attire, formal attire, military clothing, and ordinary clothing – as well as between the types of clothing appropriate for different categories of people. During the Han dynasty, for example, officials wore elaborate court hats, which indicated their rank, while scholars wore simple hats. Yet despite the codification of dress, fashion flourished.

Sumptuary laws failed to prevent the diffusion of luxury textiles from the upper to the lower ranks of the aristocracy, and then into the commoner class. For example, in the Mashan tomb of a lady who died some time between 340 and 278 B.C.E. are twelve robes, many featuring patterned weaves – although, according to the *Book of Rites*, a person of her rank was not allowed to wear that type of textile. The Mawangdui tomb of the Lady of Dai (168 B.C.E.; fig. 11) contained many elaborate robes in the new wrapped style, which required more material than earlier robes. The trim on her robes was also wider. By this time, the aesthetic focus of Chinese dress had shifted from individual ornamented components of dress, such as decorative belt buckles, to the dress itself.[16] This shift in focus persisted.

In the late sixth century C.E., for example, the Sui dynasty (589–618) saw the beginning of a new style of female dress, marked by a high waistline. Its silhouette was similar to the Empire dresses of Napoleonic France, although its construction differed, since the Chinese fashion consisted of a separate skirt and bodice. By the same time Chinese women had also adopted a low décolletage, which shocked moralists, just as it did in Europe many centuries later. In the early decades of the Tang dynasty (618–907), which followed the Sui, women continued to wear a high-waisted, low-cut bodice and a long skirt. In other respects, however, Tang fashion differed from its predecessor. (See Suzanne Cahill's analysis of Tang fashion in chapter 5 below.)

The exuberance and glamour of Tang fashion is evident in statues and paintings of court ladies, many of whom wear elaborate hairstyles, huge sleeves, and bodices with stiff collars and wing-like appendages over their shoulders. By the mid-Tang period, however – around the middle of the eighth century – the low décolletage had fallen out of fashion and ladies had begun wearing shawls. The new ideal of female beauty was extremely plump and voluptuous, in striking contrast to the youthful slenderness of Sui and early Tang beauties. Until foot binding appeared towards the end of the Tang dynasty, elite women, like their male counterparts, wore high, elaborate shoes. Aristocratic women also had considerable personal and economic autonomy – again, up until the

11 Woman's robe, red silk with white silk trim, from the tomb of the Lady of Dai, Mawangdui, Changsha, 168 B.C.E. Hunan Provincial Museum, Changsha.

Tang funerary figurines, two court ladies with elaborate hair styles, c.700 C.E. Photograph copyright 1998 by John Bigelow Taylor, N.Y.C. Courtesy of Kaikodo.

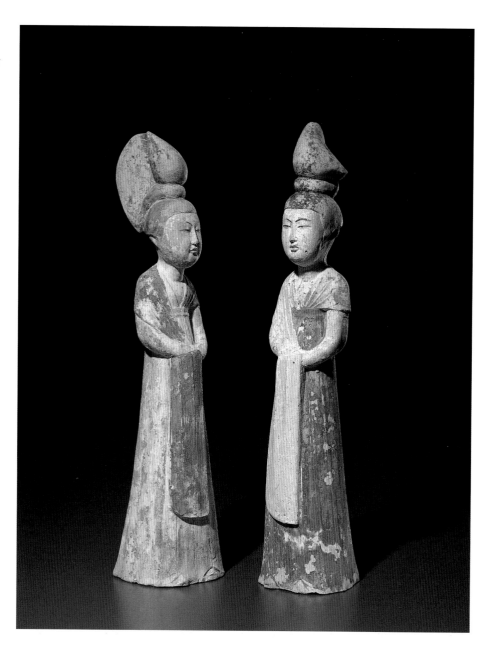

late Tang. For example, there exist many statues of Tang women in trousers, riding horseback and playing polo (see fig. 73).

With the coming of the Song dynasty, however, women's clothing became noticeably more modest. Full robes and over-dresses replaced the fanciful styles of the Tang – and the practice of foot binding began to spread throughout Chinese society. (We shall return later to the subject of foot binding.) After invasions from the north, the Song dynasty fell and the (Mongol-ruled) Yuan dynasty (1279–1368) was established. Mongol clothing had already been much influenced by the Chinese style, but it was more close-fitting, since this accorded better with a traditionally nomadic, horse-riding way of life.

大學士一等
忠勇公傅恒
世冑元臣與國
休戚早年金川
亦建殊績定策
西師惟汝子同
鬱侯不戰宜居
首功
乾隆庚辰春
御題

13　Portrait of Grand Secretary of the First
Rank Fuheng, 1760. Hanging scroll, ink,
and color on silk, studio of Giuseppe
Castiglione (Lan Shining). Fuheng is
portrayed in the robes worn for the most
important court ceremonies. Over his
dragon robe, he wears a surcoat with rank
insignia (dragon roundels) that identify his
position in the imperial court. Collection of
Dora Wong.

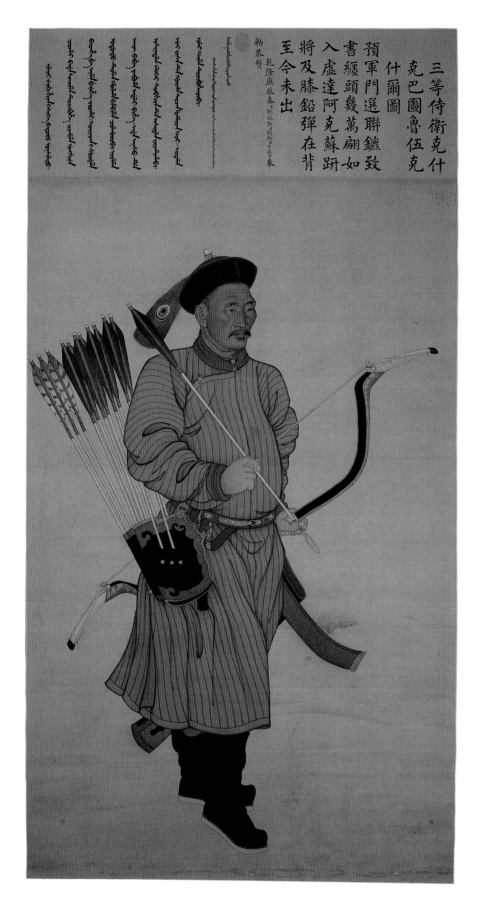

勃恭賛

乾隆庚辰春 四庫全書 勅恭十載 奉

三等侍衛克什
克巴圖魯伍克
什爾圖

預軍門選聯鑣致
書纒頭幾萬翩如
入虛達阿克蘇跰
將及膝鉛彈在背
至今未出

Over the course of its history China
was repeatedly conquered and ruled by
invaders such as the Mongols and
Manchus. During eras of foreign
domination, the Han (or ethnic)
Chinese looked back with nostalgia
at the dress of the native Chinese
dynasties, such as the Han, Tang, and
Song. In 1368 the Yuan dynasty
collapsed in the face of a popular re-
volt led by General Zhu Yuanzhang,
a commoner, orphan, and former
Buddhist novice, who established his
own dynasty, which he called the
Ming, literally "brilliant." The Ming
rulers lost no time in restoring earlier
Chinese rules of dress.[17]

Precise clothing regulations were
established. The emperor's own
clothing was classified in five groups:
ceremonial attire, leather military
attire, regular military attire, formal
attire, and ordinary attire. Dragon
robes for ordinary attire were the
prototype for robes worn by noblemen
and officials. Ming robes became
increasingly voluminous, reinforcing
the idea that this was a Chinese
dynasty. Although the Ming dynasty
was fundamentally conservative, one
significant clothing innovation was
established: insignia badges were intro-
duced, with the emperor and his sons
wearing circular medallions with five-
clawed dragons embroidered or woven
in gold. Officials wore square badges –
known to the West as "mandarin
squares" – that reflected the nine ranks
into which the civil and military
services were divided. (Imperial badges
were circular and officials' badges
square, because in Chinese cosmology
the circle is a symbol of heaven, the

square a symbol of earth; thus the shape reflected the hierarchy of power in dynastic rule.) The mandarin squares of civil officials were woven or embroidered with insignia of birds; those of military officials used animals.[18]

Although women held no rank themselves, their relationship to powerful men was also marked with clothing insignia. Thus, women at court wore embroidered neckbands, the pattern of which indicated their rank. The empress wore a pattern of dragons; imperial concubines, wives of princes, and princesses wore phoenixes; and so on. Rank badges were also worn, with women wearing the same rank of bird or animal as their husbands. Elite women also wore dragon robes corresponding in rank to those their husbands wore. Basic female dress, however, consisted of a robe or blouse with wide sleeves and a full skirt. Foot binding spread throughout society. Both high-heeled and flat-heeled styles of "lotus shoes" were worn. An upper-class woman of the Ming would undoubtedly have seen her own clothing as up to date and fashionable in its details, and also as securely and conservatively within the Chinese tradition in its overall style and signification.

In 1644 the Manchus conquered China and established the Qing dynasty. Conscious that other foreign dynasties had eventually been overthrown, the Manchus were determined not to allow themselves to fall under Chinese cultural dominance. Thus, they promulgated laws intended to establish Manchu customs, including styles of dress and adornment. In particular, Han Chinese men were legally required to shave the front of their heads and wear their hair in a single plait, or "queue," as a sign of their submission. Both Manchus and Han Chinese officials were required to wear Manchu-style robes on all formal occasions, such as government business (fig. 13). On informal occasions Chinese men could wear their own style of clothing. These rules did not apply to women, and Chinese women continued to wear their own dress.

Despite their insistence on imposing their own culture, the Manchus had, in fact, already become familiar with Chinese robes, which they had long received as gifts (or bribes) from the Ming rulers. As a result, when they came to rule China, Manchu imperial regalia was closely based on Chinese dragon robes. More generally, however, Manchu robes were not nearly as voluminous as the robes worn by Chinese. They also had a number of features that testified to the Manchu heritage as nomadic horsemen, such as vents in front and at the back at the hem (like those on an English riding coat) and horseshoe-shaped cuffs, which did not billow in the wind (as wide Chinese-style sleeves would have) and also protected the hands. Manchu robes also had a curving over-lapping right front, which may have been based on earlier clothing made from animal skins (fig. 14).

The regulations governing the imperial wardrobe were immensely complex, as were the rules for courtiers' and officials' dress. Clothing was divided into official and unofficial dress, and subdivided into formal, semi-formal, and informal dress. The number, type, and placement of dragons on robes were

14 (*facing page*) Portrait of Imperial Guard of the Third Rank Uksiltu, known as the "Cat Hero," 1760. Hanging scroll, ink, and color on silk, studio of Giuseppe Castiglione (Lan Shining). Uksiltu wears a long robe (*changshan*) ancestral to the twentieth-century women's dress, the cheongsam (qipao). Collection of Dora Wong.

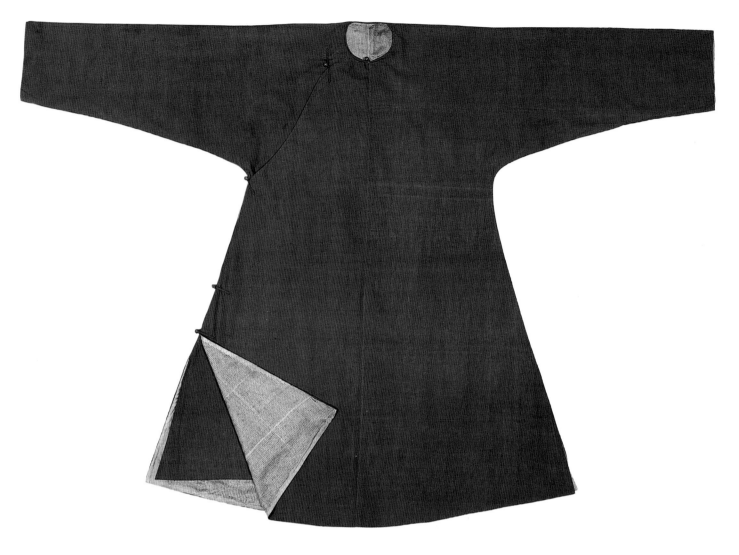

15 Man's robe; blue silk lined with white silk printed with Chinese characters, *c.*1900. Property of Maximilian Chow. Photograph by Irving Solero. Courtesy of The Museum at F.I.T.

meticulously detailed, as were the colors of robes. The emperor was entitled to wear yellow robes (although he also wore other colors according to the occasion), with nine *long* dragons; the crown prince wore apricot yellow, also with nine *long* dragons; the emperor's other sons wore golden yellow robes with nine *mang* dragons; first and second rank princes wore blue or brown robes (or golden yellow if this had been conferred) with nine *mang* dragons, and so on. This wealth of semiotic information was usually invisible, however, since dragon robes were usually covered with dark surcoats, and only the rank badges on these indicated position in the hierarchy.

In a hierarchical society, distinctions of dress came down to the principle of "more": the rich, and the imperial family most of all, wore clothing that was more elaborate in every way than those of lesser rank. Rank was expressed through more color, more embroidery, thicker shoe soles, more elaborate (*much* more elaborate) hats, exclusive access to certain types of fur, certain grades of jade, and so on.

Unlike their men, who increasingly dressed alike, Manchu women and

Chinese women wore distinctively different styles of dress. As explained below, these differences were even enshrined in law. Nevertheless, each group borrowed from the other, and in practice it is not always possible to tell whether a particular item of clothing was worn by a Manchu or a Chinese. In the simplest terms, however, Manchu women wore a long robe with a curving front, while Chinese women wore a shorter robe (more like a jacket) and skirt. Under the skirt, Chinese women wore loose trousers, unless they were unmarried or peasant women, in which case they wore trousers without an overskirt. Naturally, both Manchu and Chinese women also wore a variety of other garments, such as sleeveless vests, although Manchu women seem never to have adopted skirts.

"A roomful of Chinese ladies presents a very pretty appearance, from the exquisite gradations of colour of their embroidered skirts and jackets," wrote one Englishwoman in the late nineteenth century. "Their skirts are very prettily made, in a succession of tiny pleats longitudinally down the skirt, and only loosely fastened together over the hips, so as to feather round the feet when they move in the balancing way that Chinese poets liken to the waving of the willow."[19] These pleated skirts were, in fact, a relatively new fashion, although the foreigner was not aware of this. She did, of course, realize that Chinese women had bound feet, and probably also knew that Manchu women did not. Although Manchu women sometimes wore flat shoes, not unlike those worn by Chinese men, they were more famous for their high platform shoes (which were also worn by Mongolian women). When looking at photographs or paintings, the fastest way to tell if the woman portrayed is Chinese or Manchu is by looking at her feet.

The End of the Old Sartorial Order

By the early decades of the twentieth century the differences between Chinese and Manchu styles of dress had faded, and all traditional styles of dress in China were beginning to disappear. Two powerful long-term influences, both rooted in the seventeenth century, lay behind this radical transformation of Chinese dress. The first of these influences to have a significant impact was the advent of China's Manchu rulers, the founders of the Qing dynasty, who, by reconstituting China as a multi-ethnic empire in which Han (i.e. ethnic Chinese) norms in clothing, architecture, food, and so on were simply one preference among many, raised the possibility of radical change in Chinese customs themselves. Specifically, in the realm of dress, by decreeing an elaborate set of rules governing the clothing and appearance of both Manchus and Chinese (and allowing non-Chinese indigenous groups within the empire to retain their own distinctive clothing), and by investing their own clothing styles as a matter of course with the prestige of a ruling group, the Manchus

16 (*following page*) Cixi, Empress Dowager of China, the power behind the throne at the end of the Qing dynasty. Note her platform shoes. From J. O. P. Bland and Edmund Backhouse, *China Under the Empress Dowager* (London, 1910). Photograph courtesy of Glenn Roberts.

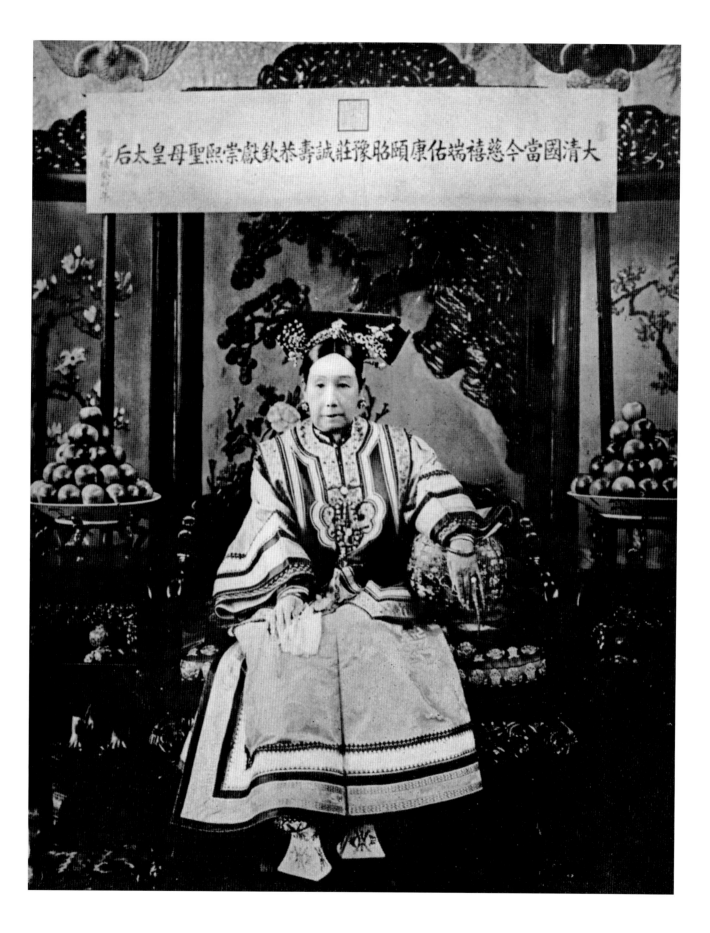

大清國當今慈禧端佑康頤昭豫莊誠壽恭欽獻崇熙聖母皇太后

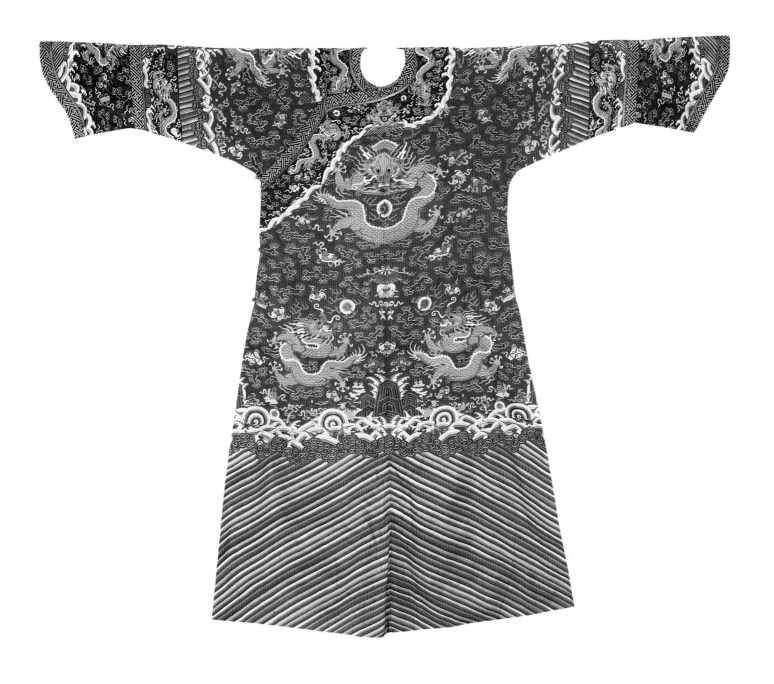

valorized new modes of appearance that would inevitably influence Chinese styles themselves.

The second, and much more subtle, influence that lay at the roots of China's modern sartorial revolution was the impact of the West. This too goes back to the period of transition from Ming to Qing, though for a long time the influence of the West seemed limited, unimportant, and benign. The handsome European-style instruments of the Beijing Observatory, cast in bronze in the 1660s by the Belgian Jesuit Ferdinand Verbiest, were a source of dynastic pride for the Qing rulers, whose multi-ethnic imperial policies made it easy for them to feel comfortable employing European missionaries as

17 Silk tapestry Manchu woman's dragon robe, c.1890. The magenta color and nine dragons signify that this robe was worn by an imperial consort. A fine robe of this type, woven with the intricate *kesi* tapestry weave, took three to five years to make; it was worn only at official functions. The bright aniline dyes used were a late Qing innovation, much favored by the Empress Dowager Cixi. Courtesy of Linda Wrigglesworth, London, England.

technical experts in the Bureau of Astronomy. (As members of the imperial civil service these Europeans naturally wore official Manchu robes.) The great eighteenth-century emperor Qian Long was particularly fond of the paintings in Sino-western style by his court artist Giuseppe Castiglione (known in China as Lan Shining); the emperor also employed European architects to create several Baroque pavilions – "europerie" at a time when the fad for chinoiserie was sweeping Europe – for his summer palace in the northwestern suburbs of Beijing. Wealthy Chinese and Manchus at the end of the century were happy to buy chiming clocks, spyglasses, and music-boxes from British merchants who wanted instead to establish a trade in machine-made woolen and cotton textiles. The growing use of opium in China troubled the country's rulers, but they saw it as a moral issue, not a question of trade; and in any case the problem was most acute in the southeastern provinces, a very long way from Beijing.

All of this changed radically in the nineteenth century. A series of wars (ostensibly brought about by Chinese efforts to prohibit the European trade in opium, but really about trade access more broadly), diplomatic incidents, and treaties negotiated at gunpoint led to the ceding of Hong Kong to Great Britain and the establishment of "treaty ports" – portions of Chinese cities directly ruled by the European powers, and devoted to international trade – along China's coast and inland in the great river valleys. In 1844 there were five such ports, in 1860 twenty; by the end of the century there were several dozen. The Europeans were no longer innocuous curiosities; they were a clamorous presence in China, insisting on their special rights and privileges, claiming superiority for their own peculiar customs and beliefs, and posing a nearly intractable challenge to Chinese ways of dealing with the world. It seemed almost inconceivable to most educated Chinese that they should ever want to, or have to emulate the Europeans; but how could one not need to learn at least something from these people who had brazenly challenged the might of China, and of the glorious Qing dynasty, and gotten away with it? And if the sources of European power were to be found obviously in steamships and power looms, were they to be sought in bustles and tailored suits as well? If one bought into the idea of westernization as a means of strengthening China, was it necessary to accept all of the incidental phenomena and attitudes that went with westernization, from Christianity and anti-foot-binding to roast beef? These questions agitated two generations of Chinese reformers, from the "self-strengtheners" of the 1860s and 1870s to the Reform Movement of 1898, without leading to either a philosophical consensus or to much in the way of coherent and concrete results.

By 1911 it took only a slight shove from a nationalist uprising of republican forces loyal to Sun Yat-sen to topple the last Manchu emperor from his throne. With the demise of the Qing court came the extinction of the old dynastic sartorial rules; men all over China cut off their queues as a sign that they no longer owed allegiance to the imperial throne, while in the capital dragon robes

and mandarin squares were packed away as family heirlooms, relics of a vanished era – or sold to foreigners in the burgeoning market for curios. Despite a brief and ill-fated attempt by Yuan Shikai, the former imperial general and new president of the Republic of China, to restore the throne with himself as founder of a new dynasty, the old order was truly a thing of the past. As Chinese intellectuals struggled with the implications of a new way of looking at China as part of the modern world,[20] Chinese men and women in both official and private circles were inventing new ways of being seen by the world.

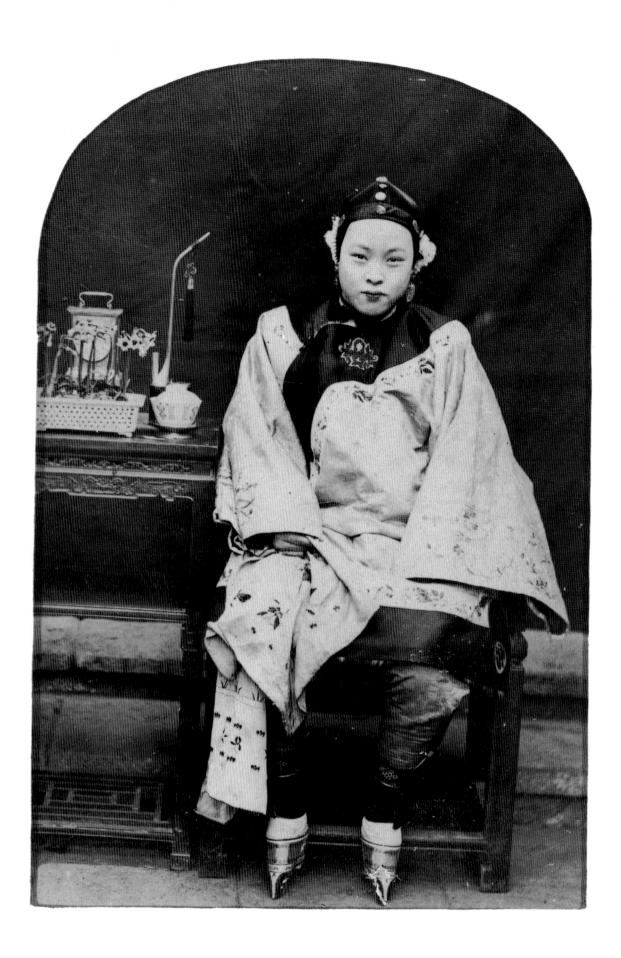

From Foot Binding to Modern Fashion

FOOT BINDING LASTED FOR A THOUSAND YEARS. It apparently began in the declining years of the Tang dynasty and it persisted in remote areas of China until the middle of the twentieth century. Yet despite its manifest significance within Chinese history, foot binding has been the subject of surprisingly little scholarly research. Recently, however, scholars such as Dorothy Ko have begun to explore the subject – with surprising results. As Ko points out, "It is natural for modern-day reformers to consider footbinding a men's conspiracy to keep women crippled and submissive, but this is an anachronistic view that finds no support in the historical records."[1]

Many of the sources on which our understanding of foot binding are based are themselves highly problematic. Western missionaries attacked the "barbaric" practice of foot binding, but they did so within the context of a prejudiced and ignorant denunciation of many other aspects of Chinese civilization. Most of the Chinese literature on the subject was written by men, who often emphasized the erotic appeal of foot binding. For a better understanding of foot binding, it is necessary to search for evidence of what Chinese women themselves thought about the practice. It is also necessary to place foot binding within its (changing) historical context. As Ko puts it, "Foot binding is not one monolithic, unchanging experience that all unfortunate women in each succeeding dynasty went through, but is rather an amorphous practice that meant different things to different people . . . It is, in other words, a situated practice."[2]

What did foot binding signify to the Chinese, and why did they maintain the practice for so long? Although historians do not know exactly how or why foot binding began, it was apparently initially associated with dancers at the imperial court and professional female entertainers in the capital. During the Song dynasty (960–1279) the practice spread from the palace and entertainment quarters into the homes of the elite. "By the thirteenth century, archeological evidence shows clearly that foot-binding was practiced among the daughters and wives of officials," reports Patricia Buckley Ebrey, whose study of Song women reproduces photographs of shoes from that period. The Fujian tomb of Miss Huang Sheng (1227–43), for example, contained shoes measuring between 13.3 and 14 cm. (5¼ to 5½ inches), while the Jiangxi tomb of Miss Zhou (1240–74) contained shoes that were 18 to 22 cm. (7 to 8⅝ inches) long.[3]

18 Portrait photograph of a Chinese woman with bound feet, late nineteenth century. She wears a loose jacket over trousers. Courtesy of Glenn Roberts.

Over the course of the next few centuries foot binding became increasingly common among gentry families, and the practice eventually penetrated the mass of the Chinese people.

Foot binding generally began between the ages of five and seven, although many poorer families delayed beginning for several years, sometimes even until the girl was an adolescent, so they could continue to benefit from her labor and mobility. First-person accounts of foot binding testify that the procedure was extremely painful. The girl's feet were tightly bound with bandages, which forced the small toes inward and under the sole of the foot, leaving only the big toe to protrude. Then the heel and toe were drawn forcefully together, breaking the arch of the foot.

This was the most extreme type of foot binding. However, many girls apparently had their feet "bound in less painful styles that 'merely' kept the toes compressed or limited the growth of the foot, but did not break any bones."[4] Nevertheless, there is no doubt that foot binding was a radical form of body modification. As early as the Song dynasty, Che Ruoshui made perhaps the first protest against foot binding. He wrote: "Little children not yet four or five *sui* [i.e. five to seven years old], who have done nothing wrong, nevertheless are made to suffer unlimited pain to bind [their feet] small. I do not know what use this is."[5]

In fact, foot binding served a number of uses. To begin with, as Ebrey suggests, by making the feet of Chinese women so much smaller than those of Chinese men, it emphasized that men and women were different. Then, too, since only Chinese women bound their feet, the practice also served to

19a–c Shoes for bound feet, from the collection of Glenn Roberts.
(a) Celadon colored satin shoes with embroidered melon and vine motif. Red cotton tie fasteners. Northern China. Nineteenth century. 4½ inches.
(b) Northern style shoes in aqua and black satin. The sole is decorated with an embroidered bat; a pink tassel dangles from the head of the bat. Nineteenth century. 6½ inches. (c) Red silk wedding shoes embroidered with peony and phoenix in flight. The bird's head freely projects beyond the tip of the toes. The unusual heels are composed of four tiny panes of glass. Late nineteenth or early twentieth century. 4 inches. Photographs by Ed Pfizenmaier, originally published in *Arts of Asia* 27.2 (March–April 1997). Courtesy of Glenn Roberts.

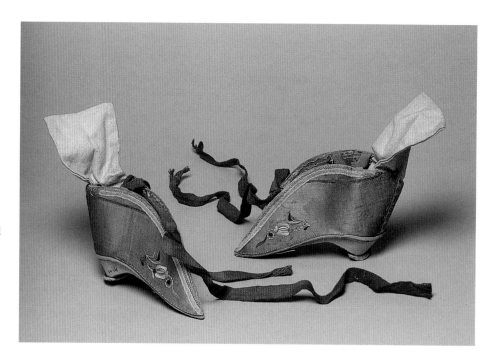

distinguish between Chinese and non-Chinese. An investigation of the political situation suggests why this might have been thought desirable. At the time when foot binding began (in the late Tang) and spread (in the Song), China was in bad shape. Various foreign peoples who lived along the frontiers repeatedly raided and invaded China, sometimes conquering sizeable portions of Chinese territory and establishing their own dynasties on land that the Chinese regarded as properly theirs – as the Khitans did in the northeast when

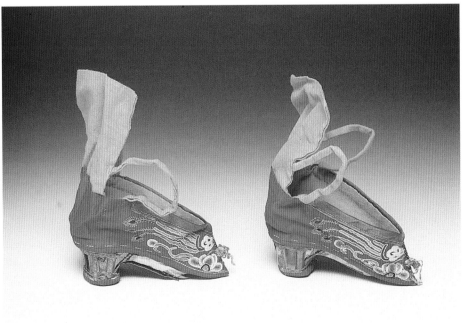

they defeated the Tang and established the Liao dynasty (907–1125), as the Tanguts did in the west when they established the XiXia Kingdom, and again as the Jürchens did in the north when they established the Jin dynasty (1115–1260) to succeed the Khitan Liao.

Although the Chinese managed to establish the Song dynasty in 960, after the turmoil that accompanied the fall of the Tang, it occupied only a portion of what had been Chinese territory, and even that portion decreased dramatically. Chinese men must often have been reminded of their military inferiority in the face of the aggressive "barbarians" encroaching from the north. Did they, perhaps, feel reassured about their strength and masculinity when they compared themselves to their crippled female counterparts? It may be possible to infer something of the sort when we analyze Song erotic poetry, devoted to the charms of tiny feet and a hesitant gait.

The suggestion that the spread of foot binding in the Song may have been related to the perceived need on the part of the Chinese gentry to emphasize the distinctions between men and women, Chinese and non-Chinese is strongly supported by Ebrey's analysis. "Because the ideal upper-class man was by Sung times a relatively subdued and refined figure, he might seem effeminate unless women could be made even more delicate, reticent, and stationary," she writes. In other words, anxieties about masculinity and national identity, rather than the desire to oppress women, *per se*, contributed to the spread of foot binding. "But," Ebrey adds, "we must also come to grips with women's apparently eager participation." A crucial element here, she argues, was the competition between wives and concubines. Chinese mothers may have become enthusiastic proponents of foot binding because small feet were regarded as sexually attractive, yet unlike the other tricks used by courtesans and concubines, there was nothing "forward" or "immodest" about having bound feet.[6]

The spread of foot binding during the Song dynasty also coincided with a philosophical movement known as Neo-Confucianism, which placed a pronounced ideological emphasis on female inferiority. (In Neo-Confucian metaphysics, the *yang* male principle was seen as superior to the *yin* female principle in both a cosmological and a moral sense). Moreover, as already seen, political developments in the Song contributed to the demise of the great aristocratic families and the corresponding proliferation of gentry families, whose social and economic position was much more insecure, and whose predominant social function was to serve as bureaucrats. Members of this new class may have been especially receptive to foot binding, because the practice simultaneously provided reassurance about their social status, proper gender relations, and Chinese identity.

Foot binding may have been reassuring to the Chinese, but it did not prevent the Mongols from becoming the first foreigners to conquer all of China. Genghiz Khan unified the Mongols, and Kublai Khan established the Yuan dynasty (1279–1368). Similar anxieties about sexual and racial boundaries

appeared again several centuries later toward the end of the Ming dynasty, when the Chinese began to be threatened by the Manchus. Moreover, when the Manchus succeeded in conquering China and establishing the Qing dynasty in the mid-seventeenth century, they passed edicts ordering Chinese men to shave their foreheads and Chinese women to cease foot binding.

The resulting "hysterical atmosphere" was "full of sexual overtones," since both cutting men's hair and unbinding women's feet were perceived by Chinese males almost as a symbolic mutilation or castration, which might even be worse than death. As Ko points out, "Although no one openly advocated footbinding, the very establishment of the Manchu dynasty created a need to re-emphasize the differences between 'we' and 'they' and between 'he' and 'she'. The ban on footbinding, thus doomed from the start, was rescinded in 1668, four years after its promulgation."[7]

Contrary to popular belief, it was not only the wealthy who bound their daughters' feet. By the Qing dynasty, the majority of Chinese women had bound feet – peasants included – although there did exist variations in the degree and type of foot binding. According to one Qing observer, "The practice of footbinding is more widespread in Yangzhou than in other places. Even coolies, servants, seamstresses, the poor, the old, and the weak have tiny feet and cramped toes."[8] Manchu women, however, did not bind their feet, nor did members of other ethnic minority groups. Indeed, under the Qing, Manchu women were specifically forbidden to bind their feet, which is intriguing, since it implies a desire to do so.

Because foot binding is usually interpreted today as a gruesome example of women's oppression, it is important to stress that women who experienced the practice rarely perceived it in those terms. Indeed, Ko has unearthed considerable evidence that many Chinese women felt proud of their bound feet, which they regarded as beautiful and prestigious. Foot binding was a central part of the women's world. The rituals surrounding foot binding were female-exclusive rituals, presided over by the women of the family, especially the girl's mother, who prayed to deities such as the Tiny Foot Maiden and the goddess Guanyin. According to Ko, these rituals "and the beliefs behind them help explain the longevity and spread of the custom."

> For all its erotic appeal to men, without the cooperation of the women concerned, footbinding could not have been perpetuated for a millennium. In defining the mother–daughter tie in a private space barred to men, in venerating the fruits of women's handiwork, and in the centrality of female-exclusive religious rituals, footbinding embodied the essential features of a woman's culture documented by the writings of the women themselves.[9]

Women wrote poems about lotus shoes and they exchanged them with friends. Proverbs emphasized women's control over foot binding: "A plain face is given by heaven, but poorly bound feet are a sign of laziness."[10]

Good mothers were supposed to bind their daughters' feet tightly so they could make advantageous marriages, just as they made their sons study hard so they could pass their examinations. The Victorian traveler Isabella Bird visited China and reported that "The butler's little daughter, aged seven, is having her feet 'bandaged' for the first time, and is in torture, but bears it bravely in the hope of 'getting a rich husband' . . . The mother of this suffering infant says, with a quiet air of truth and triumph, that Chinese women suffer less in the process of being crippled than foreign women do from wearing corsets!"[11]

Indeed, Chinese and westerners alike not infrequently compared foot binding with corsetry, debating their relative injuriousness and irrationality. Yet measurements of existing corsets and lotus shoes indicate that both the sixteen-inch waist and the three-inch golden lotus were only achieved by a minority of women. Writing at the turn of the century, the sociologist Thorstein Veblen used foot binding (as well as such western fashions as corsets and long skirts) as examples of what he called "conspicuous leisure," because they supposedly indicated that the wearer could not perform productive labor. Yet, contrary to popular belief, neither bound feet nor corsets prevented women from working and walking; most Chinese women worked very hard, albeit usually at home. Moreover, although foot binding was believed to ensure female chastity by, literally, preventing women from straying, in fact women were far more restricted by social and legal constraints.

Although for many centuries most Chinese men and women approved of foot binding, the practice eventually ceased to be valorized as a way of emphasizing the beauty and virtue of Chinese women and/or the virility and civility of Chinese men. Writing in the early nineteenth century, the novelist Li Ruzhun attacked foot binding on the grounds that it oppressed women. His novel *Flowers in the Mirror* included a satirical sequence about a country where women ruled and men had their feet bound.

Missionary efforts undoubtedly played a role in the demise of foot binding, as the Chinese were made aware that Westerners thought the practice was "barbaric," unhealthy, and oppressive to women. The Chinese girls who attended mission schools were taught that foot binding was bad. More significantly, however, growing numbers of young Chinese men (and a few educated Chinese women) began to reinterpret foot binding as a "backward" practice that hindered national efforts to resist western imperialism.

Chinese reformers began to discuss whether China could be strengthened *vis-à-vis* the West, if only Chinese women became stronger physically. This, in turn, seemed to depend on the elimination of what was increasingly regarded by progressive Chinese as the "feudal" practice of foot binding. Organizations such as the Natural Foot Society were founded, and struggled to change the idea that unbound female feet were "big" and ugly. Indeed, it was apparently difficult to convince the Chinese that foot binding was any more "unnatural" than other kinds of bodily adornment, such as clothing, jewelry, hairstyles, or cosmetics.[12]

20 Chinese woman with bound feet wearing a jacket over matching loose trousers. Painting on glass. Courtesy of Glenn Roberts.

There is even some evidence that the introduction of western high-heeled shoes, which give the visual illusion of smaller feet and produce a swaying walk, may have eased the transition away from the bound foot ideal. Manchu shoes were another alternative to lotus shoes in the early years of the anti-foot-binding movement, although with the rise of anti-Manchu nationalism at the time of the 1911 Revolution, this style disappeared. (Dorothy Ko explores these issues further in chapter 8, below.)

Foot binding had never been mandated by any Chinese government. Indeed, various Qing rulers had sporadically attempted to abolish foot binding,

without success. After the Qing dynasty was overthrown and a republic was declared, foot binding was outlawed. Laws alone would not have sufficed to end the practice, however, had it not already ceased to claim the allegiance of significant segments of the Chinese population, but once foot binding began to be regarded as "backward," modern-thinking Chinese increasingly attacked the practice.

Older brothers argued that their sisters should not have their feet bound, or should try to let their feet out – a process that was itself painful and only partly feasible. Sometimes husbands even abandoned wives who had bound feet, and looked for new, suitably modern brides. Obviously, these developments took place within the context of broader social change. The new generation of educated, urban Chinese increasingly argued that many aspects of traditional Chinese culture should be analyzed and improved. Women, as well as men, should be educated and should participate in athletic activities. Arranged marriages should be replaced by love matches. The Chinese nation should modernize and strengthen itself.

The Creation of Modern Chinese Fashions

In her influential article, "What Should Chinese Women Wear?" Antonia Finnane pointed out that "The abandonment of foot binding posed a problem of footwear for Chinese women and may have destabilized established styles of dress. It seems clear that to Chinese eyes, Chinese women's clothing for the genteel class looked strange worn with natural feet."[13] Western dress was, of course, an option, especially for elite women in the coastal cities of China, but the rise of nationalist sentiment made foreign dress problematic for both men and women. New kinds of Chinese clothing would have to be created.

During the nineteenth century, Chinese women usually wore a combination of two or three garments: a full jacket (*ao*), pleated skirt (*qun*), and/or loose, wide trousers (*ku*). The jacket was fairly long and loosely cut with wide sleeves. The skirt was wrapped, and often pleated and extravagantly embroidered. Under the skirt, women wore trousers. Chinese women often wore just trousers instead of a skirt. Trousers were not in any way regarded as "masculine," the way they were for centuries in the West. Instead, they were perceived as being relatively informal and were commonly worn by young unmarried women, as well as working-class people of both sexes.

By contrast, Chinese men of the elite traditionally wore long robes. Manchu women, of course, also traditionally wore long robes, although their hair styles and accessories made them unmistakably feminine in appearance. In the late nineteenth and early twentieth centuries, some Chinese men adopted western suits, while others modernized their robes with accessories such as leather shoes and western hats.

Chinese women also began to modernize their clothes by combining aspects of eastern and western styles. Skirts, jackets, and trousers were all cut closer to the body. Skirts were not only shorter, they were also constructed more like western skirts. Jackets often acquired a fashionably high collar, a feature that is still associated with Chinese dress (fig. 23). This new skirt and jacket ensemble (often made of the same material) was one of several hybrid styles that young Chinese women developed. Matching jacket and trouser ensembles were also increasingly popular. Sometime in the mid-1920s, probably first in Shanghai, some young women, including students, also began wearing the qipao.

The qipao, better known in the West by its Cantonese name, the cheongsam, is widely regarded as "traditional" Chinese dress. In fact, however, it is a hybrid design, combining elements of Chinese, Manchu, and western

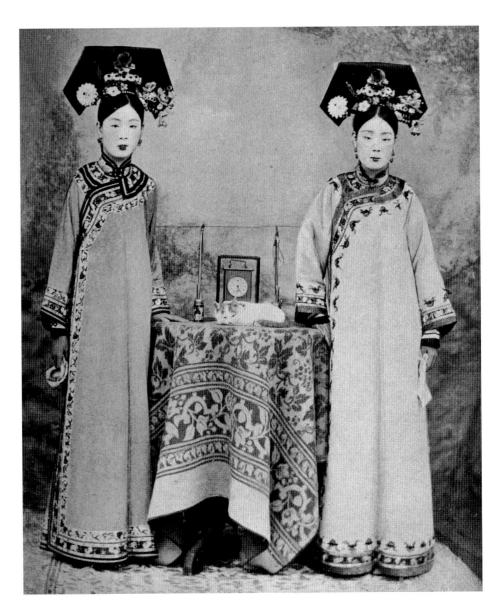

21 Two young Manchu women wearing long robes. From J. O. P. Bland and Edmund Backhouse, *China Under the Empress Dowager* (London, 1910). Photo courtesy of Glenn Roberts.

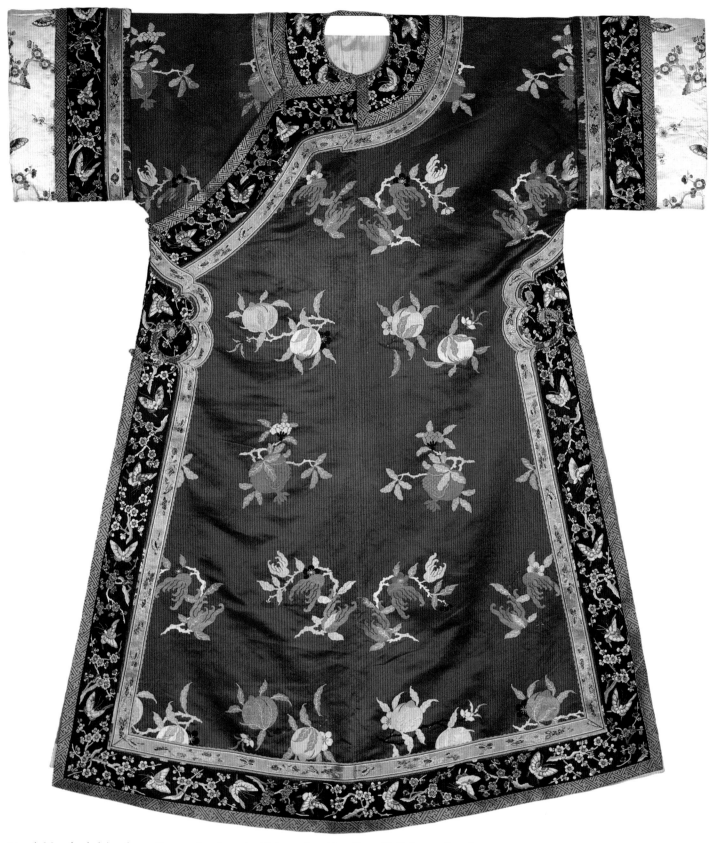

22 A Manchu lady's robe, *c.*1890, made of purple silk brocade with yellow silk lining, and with trim and sleeve edges of embroidered silk. Courtesy of Linda Wrigglesworth, London, England.

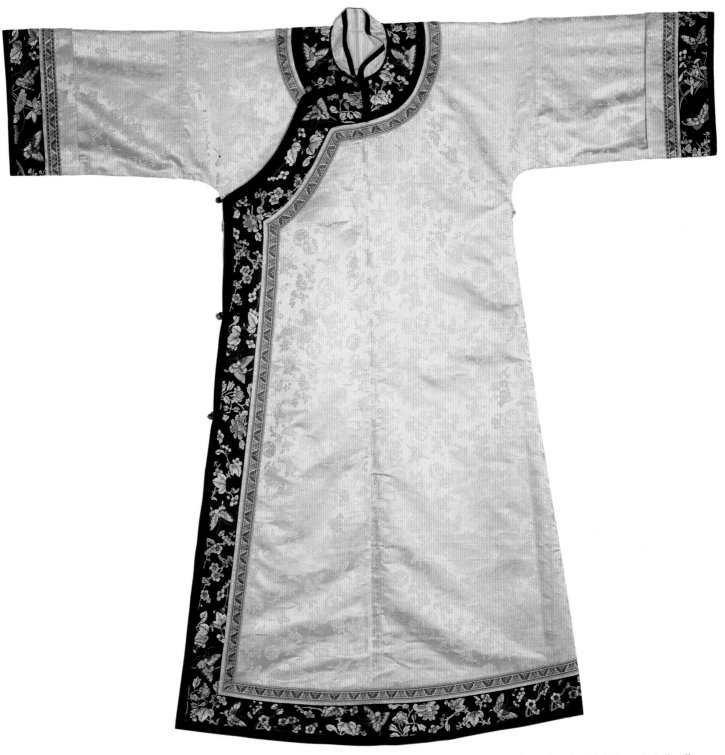

23 Yellow silk damask informal robe for a woman, with wide, turned back sleeve cuffs in Manchu style, and with a high "mandarin" collar, a late Qing innovation. This type of robe is a precursor of the modern qipao. Courtesy of Linda Wrigglesworth, London, England.

25 (*facing page*) Chinese calendar poster of the 1930s showing a woman in a qipao. Collection of Valerie Steele and John S. Major.

clothing. In their early stages of development, qipaos were by no means the form-fitting dresses later made famous in the West by Suzie Wong. The term *qipao* (a Mandarin word used in north China) literally means "banner gown," and was applied to the new style of dress because it somewhat resembled the robe worn by Manchu women, "the women of the banners," rather than the jacket and skirt worn by most Han women.[14]

On the other hand, the word *cheongsam* (also spelled *cheungsam*) means "long gown," and, indeed, in its early form, the garment resembled a Chinese man's long robe (in Mandarin *changshan*; an alternative term is *changpao*). Unlike the Chinese woman who traditionally dressed in a jacket and skirt (and/or trousers), her male counterpart wore a single garment. It is possible, therefore, that the adoption of this new garment in the 1920s signified a kind of "vestimentary androgyny" – with Chinese women deliberately dressing like Chinese men.[15] Other scholars suggest that the qipao may have evolved from the long, sleeveless vest called the *majia*. Perhaps the origins of the qipao really are to be sought in more than one type of traditional garment. In any case, the style became popular among young urban women.

The significance of the qipao derived, as Finnane puts it, "not from the number of women who wore it, although they certainly increased over time, but from who these women were. They were the women of an emerging middle class, who lived in or were susceptible to the effects of life in the modernizing cities . . .They were the female face of a progressive China and what they wore assumed a transcendental importance, signifying the hegemony of the modern."[16]

The qipao evolved over time, and its changing fashions were set primarily in Shanghai, "the Paris of the East" (fig. 25). Originally, the qipao was loosely fitted and ankle-length, but its hemline rose to mid-calf in the later 1920s and then fell again in the 1930s, by which time the dress itself had

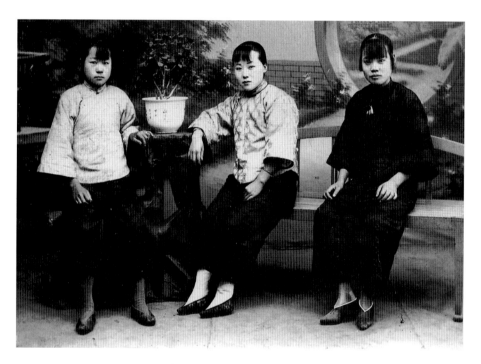

24 Three Chinese women, *c.*1920. Courtesy of Glenn Roberts.

become much more form-fitting. (The very same trajectory was followed in western fashion. In the 1930s the fashion for bias cutting made dresses everywhere more revealing.) Sleeves varied according to fashion and the wearer's taste, but long and medium sleeves increasingly gave way to small cap sleeves and then sleeveless styles. Many of the styles of the 1930s also incorporated anomalous elements of western fashion, such as bolero jackets.

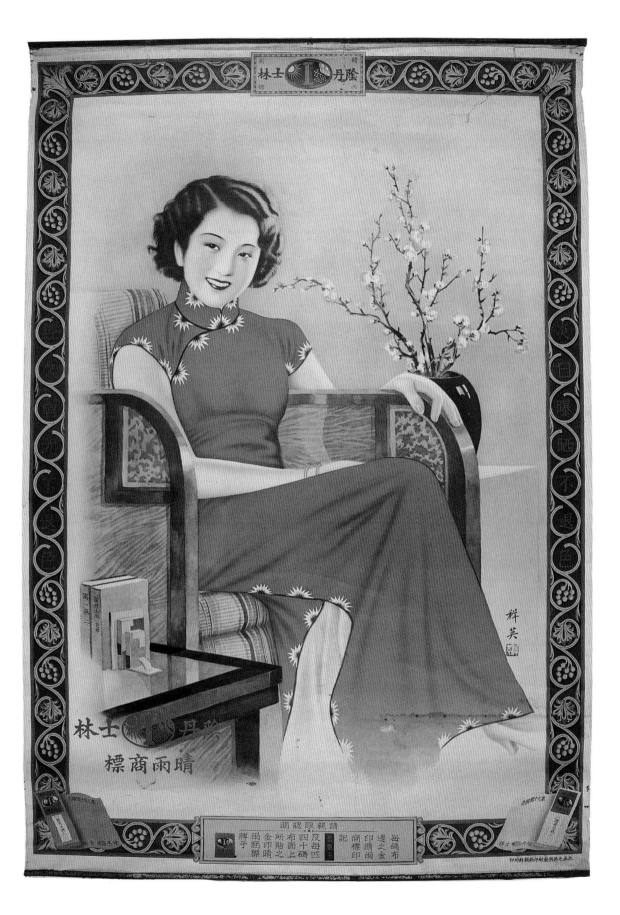

26 Detail of long-sleeved scarlet silk qipao showing fastenings. From the collection of Davie Lerner. Photograph by Irving Solero. Courtesy of The Museum at F.I.T.

27 *(facing page)* Detail of printed silk qipao, probably 1930s. From the collection of Davie Lerner. Photograph by Irving Solero. Courtesy of The Museum at F.I.T.

In chapter 9 Hazel Clark traces the evolution of the qipao; therefore, it is sufficient here to summarize that history briefly. Calendar posters and movies helped promote the image of the qipao as a fashion that was both modern and Chinese. Fabric designs and embroidery patterns ranged from traditionally Chinese motifs, such as flowers and auspicious symbols, to modern western motifs, such as Art Deco designs. The knotted buttons and loops known as *huaniu* (in the West they are called "frogs") derived from a long Chinese tradition of knotting craft (fig. 26). Yet the qipao was worn with western accessories, such as stockings, high-heeled shoes, gloves, hats, and purses. Moreover, the qipao's side slits became increasingly revealing as Chinese women imitated the foreign propensity to expose the legs – clad in silk stockings and high heels.

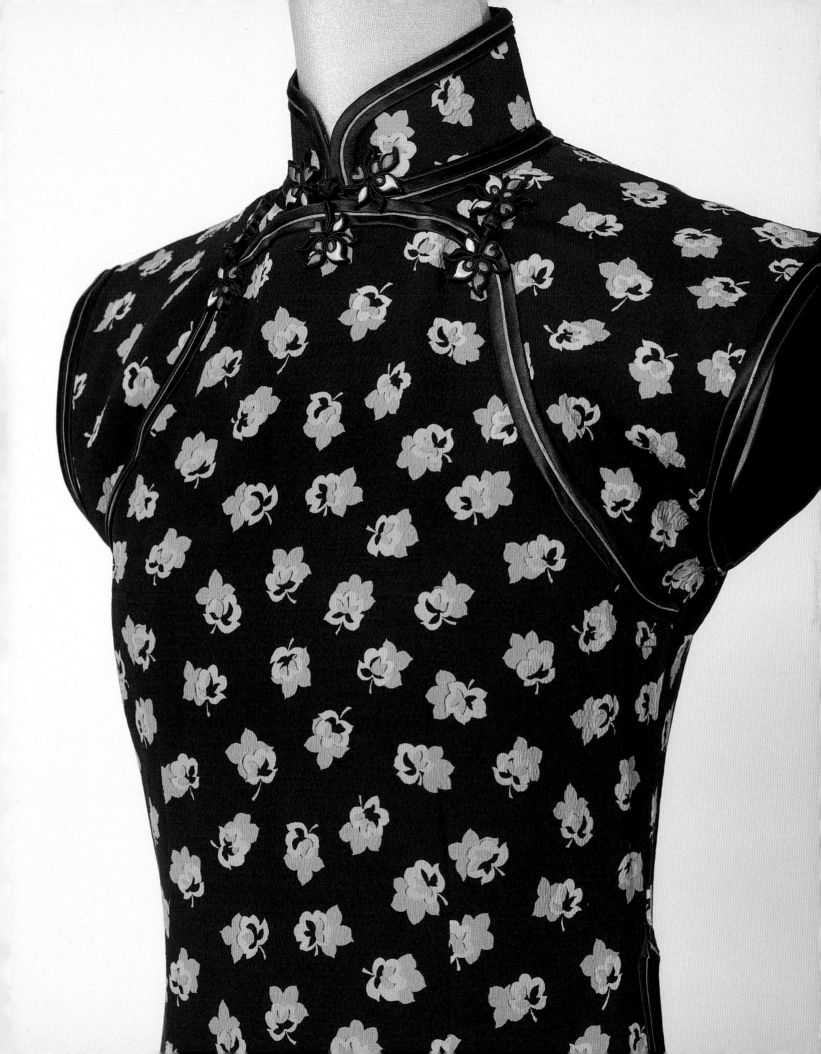

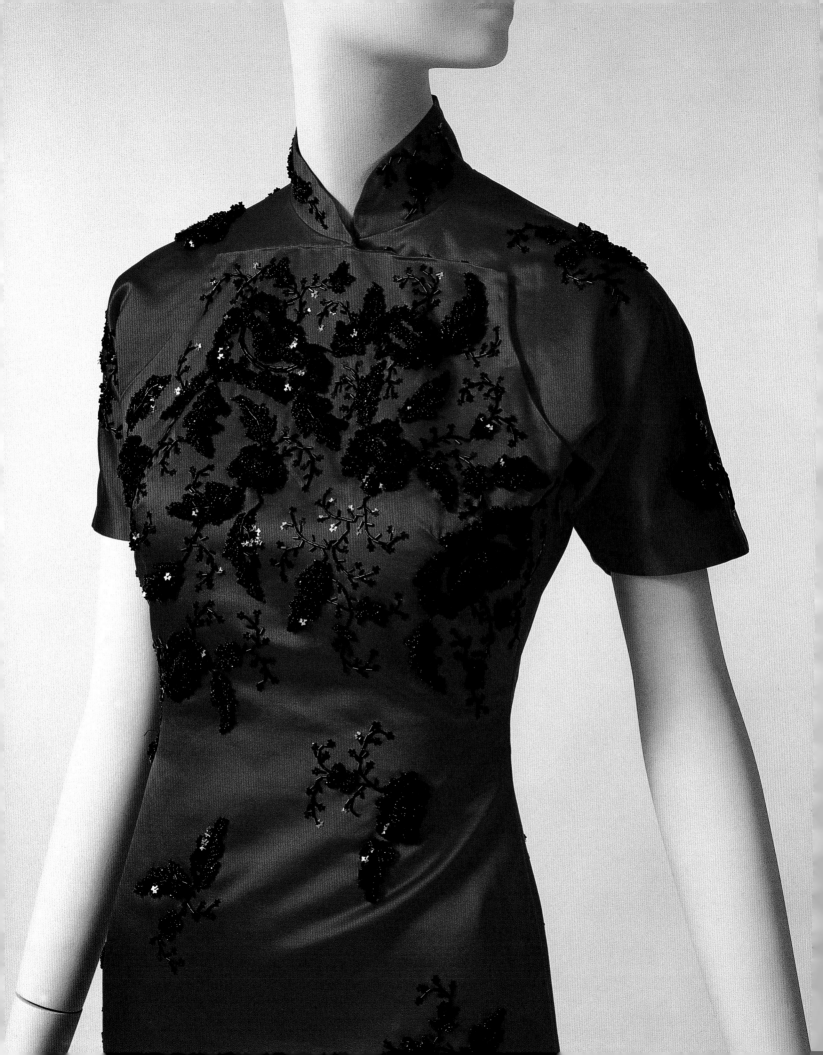

The heyday of the qipao lasted from about 1930 to 1950. Thereafter, the gradual shutting off of vestimentary possibilities in mainland China under communist rule meant that the qipao essentially disappeared in its homeland. As we shall see in the next chapter, wearing fashionable dress became nearly the equivalent of a criminal offense in China during the Great Proletarian Cultural Revolution. The qipao survived in other Chinese communities, however – Hong Kong, Taiwan, Singapore, and among overseas Chinese throughout the world – and in the occasional forays of western fashion designers into Chinese exoticism. For the past half-century the qipao (usually known by its alternative name, the cheongsam) has been the unofficial national dress of women in non-communist China, and an international symbol of Chinese femininity. In the latter context, it came to be the almost obligatory dress of Chinese women in the service industry (hotels, restaurants, night clubs, and the like in Hong Kong, Taiwan, and elsewhere) and in movies and the theater.

Chinese men in these same settings, outside China proper, came to wear variants of conventional western dress – ordinary work clothes for most people, business suits for the middle and upper classes on formal occasions, and the business uniform of the East and Southeast Asian tropics – a white short-sleeved shirt and dark trousers – for normal office wear. The high-collared Sun Yat-sen suit went out of fashion for Chinese men outside of China except for a few older officials of the republican government on Taiwan, and then only on formal occasions; in mainland China the Sun Yat-sen suit evolved into the more proletarian Mao suit, as we shall see.

It would take many decades for China to rejoin the international world of fashion.

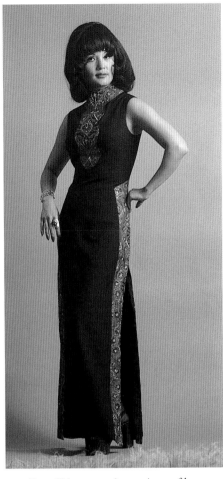

29 Dora Wong wearing a qipao of her own design, c.1965. Courtesy of Dora Wong.

28 Qipao from the 1950s. Collection of Lucia Hwang. Photograph by Irving Solero. Courtesy of The Museum at F.I.T.

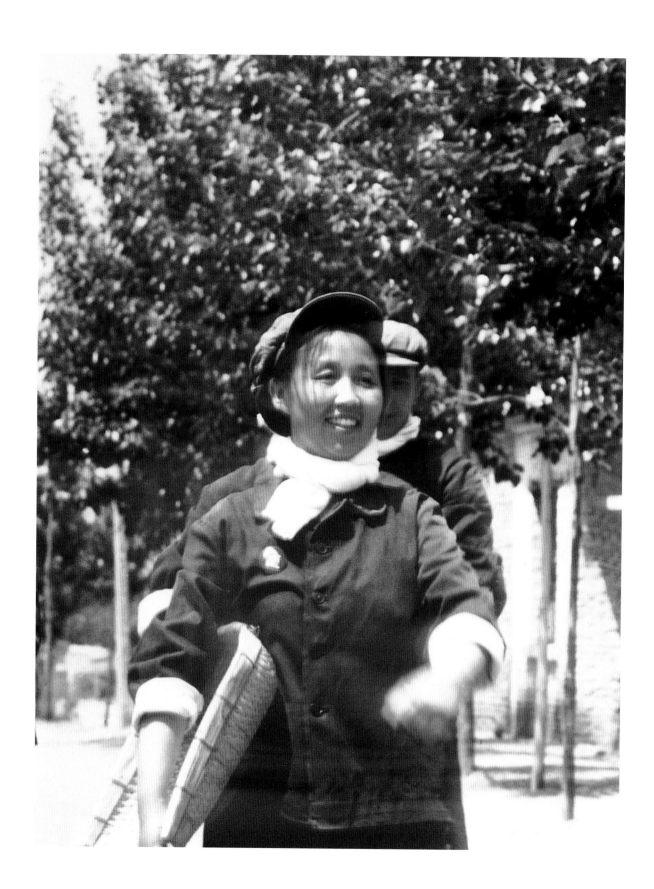

Fashion Revolution: The Maoist Uniform

WHEN THE COMMUNISTS CAME TO POWER in China in 1949, they inaugurated not only a social but also a sartorial revolution. The uniform of revolutionary China is generally known in the West as the Mao suit, but the Chinese themselves usually still call it the Sun Yat-sen uniform. This is, in fact, a more accurate term, since the style actually dates from the formative years of the Chinese Republic and is named after its first president.[1]

Sun Yat-sen was born in 1866 into a progressive, well-to-do Cantonese family that despised the Manchus. At the age of thirteen, he was sent to school in Hawaii and later studied medicine in Hong Kong. Dr. Sun spent much of his early career abroad, trying to organize a revolution in China. When the revolution of 1911 broke out, he rushed home and was proclaimed provisional president of the Republic of China in 1912. Within a few years, however, he had lost power and China disintegrated into a prolonged period of chaos and warlordism. Basing himself in Guangdong, Dr. Sun continued his struggle to establish a functioning Chinese government.

A photograph of Sun Yat-Sen taken in 1915 shows him wearing a western business suit. His wife, the American-educated Song Qingling, was also dressed in the height of western fashion. By the 1920s, however, Chinese nationalists were no longer content to wear foreign fashions. Now Dr. Sun preferred to wear either a Chinese gown and jacket or a new kind of suit, featuring a high-collared tunic with breast pockets (see figs. 96a–c)

Like the qipao, the Sun Yat-sen uniform was in origin a hybrid style, combining elements of East and West. Although some popular writers imply that Dr. Sun was personally responsible for "designing" the Sun Yat-sen jacket, in fact the style was based on already existing Chinese student uniforms. As A. C. Scott observes,

> A photograph taken in Hong Kong in 1907 shows Chinese students in the dress of a school physical training corps, the uniform of which is very similar to that worn by British soldiers . . . This corps was afterwards banned . . . on the grounds that it was a vehicle designed to train revolutionaries for the events of 1911. It was but a short step from the high collared tunic with breast pockets worn by these Hong Kong students to the Sun Yat-sen suit of the Republic and thence to the official garb of Communist China.[2]

30 Cadre marching and singing a harvest song. May 7th Cadre School (a mandatory work-study program designed to instill Maoist enthusiasm in Communist Party cadres), Beijing, 1972. She wears a Mao button on her Mao suit. From Joan Lebold Cohen and Jerome Alan Cohen, *China Today and Her Ancient Treasures* (New York: Harry N. Abrams, 1974), plate 281. Photograph by Joan Lebold Cohen.

Even during the last years of the Qing empire, Manchu officials tentatively imported western military advisors. Like the Japanese before them, Chinese reformers looked to the West for ideas about modernization. In addition, many Chinese studied in Japan and there adopted student uniforms, which were themselves based on Japanese imitations of German military uniforms. Other Chinese (including, ironically, Chiang Kai-shek) went to the Soviet Union to study, and the uniforms of the U.S.S.R. provided yet another sartorial influence. Warlords throughout China adopted variants of western military uniforms, just as Chinese civilians experimented with western business suits. (The militarization of Chinese clothing is explored in detail by Antonia Finnane in chapter 6, below.)

When Japanese imperialism began to encroach on Chinese sovereignty, Chinese student protests marked the second phase of the Chinese revolution: the May Fourth Movement. It was a revolution not in the sense of over-throwing the government, but rather in the sense that it involved the radical reevaluation of an entire society. In dozens of new magazines, written in a modernized vernacular language, intellectuals called for new perspectives in government, literature, history, and national culture; "science and democracy" became a popular rallying cry for reform. In 1921 a small group of Chinese radicals, including Mao Zedong, founded the Chinese Communist Party. Sun Yat-sen, seeking to broaden his political base as much as possible, pursued a policy of cooperation with the Communists. Then, after Sun Yat-sen died in 1924, the Nationalist Party (Guomindang) came under the leadership of Chiang Kai-shek.

31 The Chinese writer Lu Xun. Oil painting, 1972, after a photograph *c.1925*. He is depicted as wearing a scholar's robe, the collar of which shows some influence from the contemporary Sun Yat-sen suit. From Joan Lebold Cohen and Jerome Alan Cohen, *China Today and Her Ancient Treasures* (New York: Harry N. Abrams, 1974), plate 246. Photograph by Joan Lebold Cohen.

Chiang's period of study in Russia convinced him of two things: he hated communism, and he admired the power of the Leninist one-party state. Imposing a new level of discipline on the Guomindang, he turned against the Communist Party in 1927, in the course of a campaign to unite China under his government. In a series of "extermination campaigns," thousands of Communists were killed; in the early 1930s the remaining members of the party fled to the northwest in the famous Long March. The struggle between Communists and Nationalists continued throughout the Second World War. Although both parties claimed to be the true heirs of Sun Yat-sen,

their interpretations of his heritage differed significantly (their uniforms also differed slightly). When the Civil War ended in 1949, Mao Zedong emerged victorious and proclaimed the founding of the People's Republic of China; the defeated Nationalists retreated to Taiwan. The Communists claimed victory on behalf of "workers, peasants, and soldiers," and that claim was reinforced by the way the government encouraged people to dress. The uniform of the People's Liberation Army was made of green cotton cloth. Civilian cadres wore a grey administrative uniform, while workers and peasants were clad in dark blue tunics and trousers.

Although the original Sun Yat-sen uniform had drawn primarily on western military prototypes, the emerging Maoist uniform also referenced the traditional trousers and tunics of Chinese peasants, as well as Chinese black cotton shoes. To some extent the movement toward modest and "proletarian" dress of China in the early 1950s marked a return to ideas of revolutionary simplicity (or, put more pejoratively, revolutionary puritanism) that had surfaced as early as the time of the May Fourth Movement. As Martha Huang shows in chapter 7 below, the modern schoolgirl of the Republican era – a paradigmatic figure of Chinese modernity – was always depicted as dressing in a plain, unadorned outfit of dark, calf-length skirt and simple white blouse. In the 1930s the Republican government of Chiang Kai-shek promoted the New Life Movement to strengthen the nation through purity and highmindedness in the face of the twin threats of communism and Japanese imperialism; young people enrolled in the movement wore plain, quasi-military clothing.

No government directives were issued, but under the newly established People's Republic of China it was tacitly understood that dressing in a simple "proletarian" style was once again appropriate. Men and women usually wore the same style of garments. As the Chinese communist government consolidated its power the early 1950s, the qipao essentially disappeared from everyday life. Nevertheless, to the extent that the "national bourgeoisie" was still tolerated (because the new communist government needed the expertise of the business and industrial communities), bourgeois fashions, such as qipaos, fur coats and high heels, were occasionally worn. Female cadres also sometimes wore the qipao when they went on missions abroad.

32 Cadres marching and singing in praise of Mao Zedong. May 7th Cadre School, Beijing, 1972. This scene captures the extreme uniformity of clothing at the height of the Cultural Revolution. From Joan Lebold Cohen and Jerome Alan Cohen, *China Today and Her Ancient Treasures* (New York: Harry N. Abrams, 1974), plate 278. Photograph by Joan Lebold Cohen.

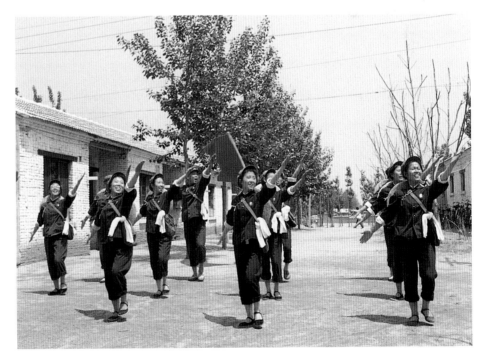

By 1956 Mao apparently felt confident enough about his power and accomplishments to invite public comments and criticism. "Let a hundred flowers bloom," he said, "let a hundred schools of thought contend." But the chairman was shocked by the barrage of criticism that resulted; it was clear that many people were not at all satisfied with the progress and direction of the revolution. The Hundred Flowers Movement came to an abrupt end in 1957 with the Anti-Rightist Campaign, a movement that branded tens of thousands of people as "class enemies," sending them to labor camps or placing them under surveillance.

The Maoist uniform was not, in and of itself, a significant source of unhappiness for many Chinese. However, the drabness and conformity of dress was symptomatic of the absence of personal freedom. In the summer of 1955 the *New Observer* of Beijing held a forum to discuss clothes in response to many letters on the subject from its readers. One participant argued that "being progressive" was not "dependent on wearing drab colours."

Another pointed out that their present clothing was based on a combination of the Sun Yat-sen style and the uniform of the People's Liberation Army; these styles, however, belonged to recent history and should be reformed with contemporary life in mind. He then added that traditional peasant clothing was actually more practical for working in the fields than ready-made uniforms. A music critic advocated a return to the qipao, which he thought made women look more beautiful. A female trade union leader replied that the qipao was neither beautiful nor convenient; if they wanted to abolish uniformity, they must develop new styles. The forum concluded by resolving that "Artists should produce new designs and fashions should be discussed more in newspapers and journals. As a basis we should study peasant and national dress, everyone should try to help clear away the mental resistance to more varied cut and colour, then the people themselves will create new styles."[3]

In 1956 there was a brief flowering of interest in fashion. East German tailors came to Beijing to teach new methods to Chinese tailors. (The Hong Kong press had a laugh at the idea of East German elegance.) A department store in Beijing held its first fashion show. "Prominently displayed," said Beijing radio, "were short jackets, fur robes, and spring wearing apparel." Manufacturers in Shanghai began to produced flower-printed dresses. Another fashion show was held, this time at Beijing's Palace of Culture, which included variations on the qipao – with slits replaced by pleats.[4] Modest as these endeavors were, they apparently faded away by the end of the following year as people fearfully avoided anything that might carry the taint of "rightist" views.

Following the Anti-Rightist Campaigns, the years 1958–61 brought Mao's Great Leap Forward, an attempt at rapid and comprehensive economic development on all fronts that in retrospect has been recognized as a total disaster for the country. At the time it was greeted with enthusiasm, much of it stridently generated by official propaganda campaigns; proletarian virtue and vigor were the order of the day, and "bourgeois" fashions disappeared.

一代新人接班来

In the wake of the Great Leap Forward, cooler heads (people like Liu Shaoqi and Zhou Enlai) once again prevailed in Communist Party leadership circles. In the resulting climate of greater personal freedom and economic stability, people once again began to venture to wear slightly more colorful and fashionable clothing. In 1965 Mao struck back by proclaiming the Great Proletarian Cultural Revolution, an attack on "counter-revolutionary" tendencies within the party leadership itself. Calling on China's youth to "bombard the headquarters," Mao unleashed a campaign of terrifying repression of anything that might be regarded as "counter-revolutionary" or "un-Chinese."

Fashion suddenly came under violent attack in August 1966 at the hands of the Red Guards, the shock troops of the Cultural Revolution. Nien Cheng, for example, recalls seeing a young woman seized by Red Guards who forcibly removed her fashionable trousers and shoes in front of a jeering crowd.[5] A former Red Guard recalled being part of a "purification team" in Guangzhou

33 *Changing the Guard: A New Generation*, propaganda poster, 1975. Depicting young students being issued work clothing on their arrival to do (mandatory) volunteer work in the countryside, this poster dates from near the end of Mao's lifetime and the waning days of his wife's political power. It attempts to generate nostalgia for the revolutionary enthusiasm of the mid-1960s, at the start of the Cultural Revolution. Collection of Valerie Steele and John S. Major.

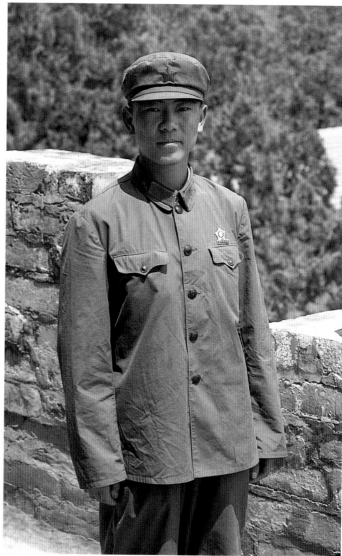

34 *I am a Seagull*, by Pan Jiajun, 1972. Oil on canvas. Idealized portrayal of a heroic model worker. From Joan Lebold Cohen and Jerome Alan Cohen, *China Today and Her Ancient Treasures* (New York: Harry N. Abrams, 1974), plate 337. Photograph by Joan Lebold Cohen.

35 Soldier of the People's Liberation Army, 1970s. He wears a Mao button, and is standing on the Great Wall. Photograph by Joan Lebold Cohen.

that consisted of several youths, one with a pistol, one with a pair of scissors, and several others to participate with their bare hands. They wandered the streets of the city looking for women whose dresses were too long, or tight, or otherwise fashionable, or who wore long or permed hair. Any who were found were detained on the spot at pistol-point while their hair was cut off or their clothing cut to ribbons.[6] A large number of similar accounts in the retrospective literature on the Cultural Revolution makes it apparent that such sartorial terrorism was quite common throughout China.[7]

In one of the most notorious incidents of the time, Red Guard interrogators forced Wang Guangmei to wear a qipao, high-heeled shoes and a necklace of ping-pong balls while being denounced in a struggle session at Qinghua University. As the wife of President Liu Shaoqi, she had worn a qipao and pearl

necklace in 1963 while on a state visit to Indonesia, and this was now held against her.

> Interrogator: We want you to put on the dress that you wore in Indonesia.
>
> Wang Guangmei: That was summer . . . Chairman Mao has said that we must pay attention to climate and change clothing according to it.
>
> Interrogator [amid laughter]: What Chairman Mao has said refers to the political climate. According to your standpoint, even though you are wearing a fur coat, you will also freeze to death.[8]

After being humiliated and physically tortured, Wang Guangmei was imprisoned for more than a decade.

During the Cultural Revolution (1966–76) much of China's cultural life came under the direct influence of Mao's wife Jiang Qing. Although she was later accused, after the death of Mao and her own arrest along with her fellow radicals in the "Gang of Four," of having worn fashionable western clothing in the privacy of her official mansion, in public she was a leading advocate of revolutionary austerity in dress. During the Cultural Revolution contemporary fashion was attacked as "foreign" and traditional clothing as "feudal," and in general a concern with personal appearance was interpreted as an expression of "bourgeois tendencies" and extreme "individualism." This strictures did not apply to Jiang Qing, however. Having been, in her youth, a minor actress in Shanghai's film industry, she retained a keen personal interest in dress.

In 1974 she launched what was apparently her own fashion design. The Jiang Qing dress was supposedly inspired by the clothing of the Song dynasty, although it closely resembles a western-style shirtwaist dress, *circa* 1950. Approximately 80,000 such dresses were produced by a state-owned clothing factory in Tianjin. Jiang Qing tried to popularize the outfit by having it worn by members of her revolutionary opera and dance troupes, but it did not get a good reception from the masses, and the attempt to introduce it was abandoned.[9]

The performances of the opera and dance troupes that she so energetically championed did, however, perhaps serve to impress on the general public the revolutionary suitability of the Maoist uniform. In particular, *The Red Detachment of Women*, one of several "model revolutionary ballets" promoted by Jiang Qing, shows the uniform of the People's Liberation Army in an unusually attractive light. As worn by female members of the *corps de ballet*, the uniform became a stylish ensemble of tight-fitting shorts and closely tailored tunics (fig. 36).

The same confusion of signs can be seen in the propaganda posters that were such a ubiquitous feature of the Cultural Revolution. These posters featured an absolutely stereotyped cast of characters – happy peasants, resolute workers (led, usually, by a muscular, lantern-jawed middle-aged veteran), caring PLA

36 *Red Detachment of Women*, performance of a model revolutionary ballet. The dancers on point wear summer military uniforms of tunics, shorts, and knee socks, and carry swords and red kerchiefs. From Joan Lebold Cohen and Jerome Alan Cohen, *China Today and Her Ancient Treasures* (New York: Harry N. Abrams, 1974), plate 335. Photograph by Joan Lebold Cohen.

soldiers, happy, colorful non-Han ethnics. What is truly striking about the posters, in their own historical context, is the disjuncture between their brilliant colors and the drab colorlessness of the contemporary Chinese populace. This was, after all, the time when the Chinese people were being derided by hostile westerners as "blue ants," and praised by other westerners for having shed the shackles of fashion and overturned the cult of personal appearance. Young women in posters wear pretty flower-patterned jackets; real young women in the late 1960s who wore pretty flower-patterned jackets found themselves stripped and spat upon by Red Guards.

How is one to interpret the disparity between image and reality in these posters? The only interpretation that seems satisfactory is that the poster images represent an ideal, not yet realized in society but so close to being realized, so tangibly near in the future in a society in which the cultural transformation of an entire people is nearly complete, that it is already legitimate to portray it graphically as if it already existed in fact. The posters seem to say: You, the spectator, are now wearing drab blue, or gray, or green; but soon it will be possible for you to dress in brighter colors, colors to match the happiness of your circumstances, in a society that is just around the corner. In this new society, colorful clothing will be untainted by individualism, purged of the cult of appearances, cleansed of the stain of fashion; it will be colorful in the bright colors of revolutionary purity.

The one great exception to the rule that everyone had to wear plain, drab clothing was in the clothing of children. Mao consistently rejected birth control schemes, and saw population growth as being unambiguously beneficial: the more workers the better.[10] Chinese society valued, loved, and indulged children, who were typically dressed in brightly colored and gaily patterned

clothes; red, the traditional color of happiness in China, and now the color of revolutionary enthusiasm as well, was especially favored for children's clothing and accessories. The uniform of the Young Pioneers, communist China's answer to the scouting movement for both boys and girls, featured a red kerchief. Once past elementary school, however, children of both sexes graduated to plain school uniforms that reflected the sobriety of adult dress.

Bright clothing for adults did eventually return to China, but only after the death of Mao and the arrest of Jiang Qing and her supporters in the Gang of Four. Mao died in 1976. In late 1978 the streets of Beijing and other big cities bloomed with "big-character posters," publicly posted messages airing grievances and suggesting remedies; for a few heady weeks, "Democracy Wall" in Beijing seemed to hold the promise of real political reform. In 1979 Jiang Qing and the others were convicted of treason. At about the same time, young women in Shanghai and Guangzhou began to venture to wear jackets in flowered prints or colors such as rust or plum.

The return of fashionable clothing to China after 1978 was a slow process, however (fig. 37). Taken individually, the changes were so slight as to be almost imperceptible; but for the Chinese they were highly significant. Young women, especially in large cities, began to appear in tailored slacks and zippered nylon jackets, skirts and blouses, and shirtwaist dresses. In addition to the ubiquitous black cotton shoes, leather shoes with one-inch heels began to be seen. A fashion exhibition was shown on national television in 1980, featuring clothes by students at the Fashion Design Institute of the Central College of Industrial Arts in Beijing.

37 Drinking tea and smoking in the Western Tea Garden Temple, Suzhou. From Joan Lebold Cohen and Jerome Alan Cohen, *China Today and Her Ancient Treasures* (New York: Harry N. Abrams, second edition, 1980), plate 254. Photograph by Joan Lebold Cohen.

Fashion magazines also appeared once again (fig. 38). The first such magazines, such as *Fashion* (*Fuzhuang*), typically featured styles that were being produced in China for export – cheap, rather unfashionable clothes, by international standards, but new and attractive to Chinese consumers. The magazines were obviously intended to promote the Chinese garment industry abroad, and the models wearing the clothes were often westerners. Nevertheless, the magazines also functioned as a reference for the Chinese home dressmaker. They often included patterns and instructions for making the clothes, which were difficult to find in shops and might be too expensive to buy ready-made. The French designer Pierre Cardin held fashion shows in Beijing and Shanghai in March 1979, and maintained that he had been

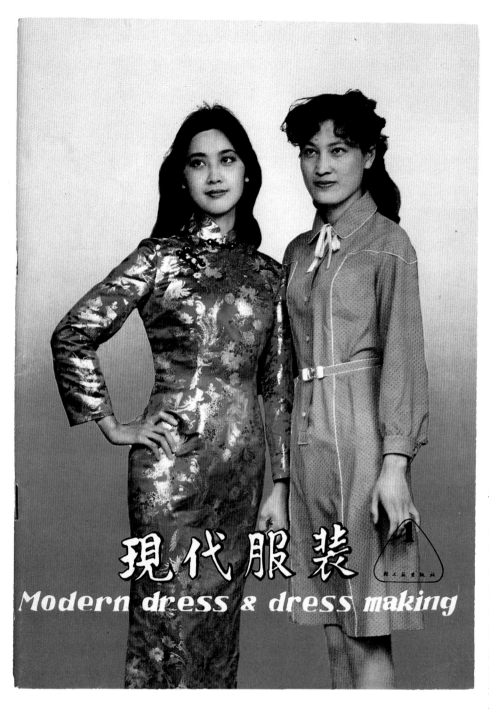

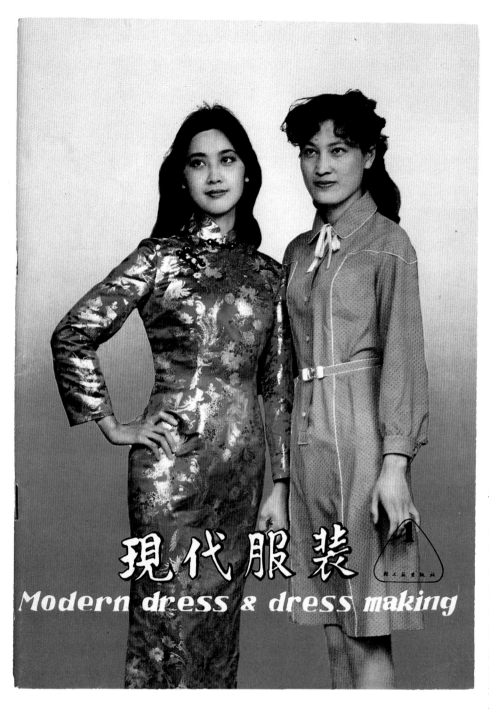
現代服裝
Modern dress & dress making

38　*Modern Dress and Dress Making*, 1981.
Collection of Valerie Steele.

influenced by Chinese design motifs. These foreign clothes were not, however, intended for the Chinese market.

Nor was the new freedom of dress unrestricted. After decades of repressive government, people tended to proceed cautiously in the direction of fashionable dress, trying not to get into trouble. It was clearly apparent that both inside the government and among the masses, not everyone favored the relative liberalization of dress. Various governmental bodies did certainly try to regulate what people wore. We remember seeing a hand-painted poster at a factory in Chengdu in 1982 warning young workers against wearing "hoodlum" (*liumang*) styles, such as bell-bottom trousers, tee-shirts, dark sunglasses, and the like. Strikingly, on the same visit to China we saw similar hand-painted posters in Guilin advertising just such garments for sale in shops along the town's main street. This example shows several contradictory forces at work. The anti-"hoodlum style" poster was at a state-owned factory, in effect an organ of the government; the bell-bottoms offered for sale were being sold by private petty merchants in a newly resurrected free market. The factory was in sober, conservative Chengdu, the free market more typical of the anything-goes attitude of the southern provinces. And Guilin is a small city far from Beijing, showing perhaps that the reach of government control was weakening; authoritarian government in the post-Mao era was not as strong as it had been in the chairman's heyday.

Although one can speak of a "return to fashion" in China beginning in the late 1970s, the brighter, more attractive clothes that were being widely worn had almost nothing to do with contemporary international fashion. The bell-

64

bottoms worn by would-be "hood-lums" in 1982 were a decade out of fashion. Factory-made clothing promoted for export in the new fashion magazines, and imitated by domestic dressmakers, featured silk brocade in outdated patterns and colors, and Chinese specialty items such as Swatow-style openwork embroidery that played no role in the international fashion scene. Chinese consumers were dressing in a wider range of styles, and had the latitude to express their own fashion sensibilities to some extent, but China was far from being fashionable.

From 1979 through 1981 there seems to have been considerable debate in China about the abandonment of rigid uniformity of dress. Some people argued against the "westernization" of clothing and the preoccupation with the self that was supposedly a distraction from the goal of building a strong socialist nation. Defenders of fashion replied that it was perfectly legitimate to want to improve one's appearance and express one's personality. The writers for China's growing fashion press tried to steer a middle course in determining the guidelines for appropriate dress.

"The garments themselves have an ideology in them," argued Cheng Tianbao, Chief Editor of *Fashion*. But he admitted that it was difficult to define precisely what was meant by "bourgeois" and "proletarian" clothing, or truly "Chinese" dress. In a conversation that we had with him, he said that he believed that in the United States and Europe there was too much emphasis on "sexy" fashion, whereas in China and Japan, for reasons of "tradition and environment," clothing tended to be more modest. Still, he acknowledged that in some communist countries even the mini-skirt was regarded as "proper and beautiful."

"Life is complicated," he said. "The true self can not be judged by the

39 Signboard for a private tailor shop, Guilin, 1982. Photograph by John S. Major.

external appearance alone." In the recent past some people had been severely criticized for their appearance, but it was "human nature" for people to "want to dress themselves beautifully." Rather than struggling against human nature, the solution should be to "educate" people, so that they recognized "what is beautiful in spirit."[11]

"Appropriate Clothing is Beautiful," wrote Yue Hua in an article for the summer 1981 issue of *Fashion*. Echoing Victorian fashion writers, she stressed that clothing should be "suitable for one's age, personality, figure, and occupation." "A university professor naturally does not look right in a gorgeous dress, nor does a short old woman in modish western dress." She was particularly critical of the "many young women decked out in clothing that is neither western nor Chinese." "For Chinese, the most liberating thing is to use things that are really Chinese."

It is not enough that there should be greater production, diversity and beauty of dress, declared Li Long, Vice-Director of the Ministry of Light Industry, in the September 1981 issue of *Modern Dress and Dressmaking* (*Xiandai Fuzhuang*). The clothing of "New China" should be based "on the special characteristics of Eastern peoples" and it should have "the ability to reflect the spirit of socialism." Bai Chongli, of the Central Institute of Industrial Arts, also advised Chinese fashion designers that, rather than simply looking back to the past with its "beautiful and colorful clothing culture," they should "advance down the road to a Chinese-style modern fashion revolution."[12]

Nevertheless ... "Peking's Fashion Code Leans Towards the Don'ts," reported the *New York Times* in 1983. City employees in Beijing were told to avoid "bizarre dress" or they would be sent home from work. "We must preserve our habits of simplicity and bitter struggle," warned the *Beijing Daily*. "Strange" hairstyles and other kinds of "unhealthy beauty" were said to promote "unhealthy thoughts." Some Communist Party officials such as Zhao Ziyang and Hu Yaobang appeared in western-style suits and ties, although Deng Xiaoping stuck to the Sun Yat-sen uniform. Modern apparel was mostly made for export, and trendy clothes – such as blue jeans – had to be smuggled in from Hong Kong. Pierre Cardin held another fashion show in China to promote his line of apparel produced in Chinese factories for export, but when he presented gifts of clothing to the models they were confiscated by the authorities.[13]

Yet even at the height of the Cultural Revolution, many young people wanted to look attractive. One young woman who visited an American college in the mid-seventies was scornful of American press reports of that time that socialist China had gone beyond fashion: "Of course we were constrained in what we could wear, but it was still only natural that young people wanted to look as attractive as possible. Everyone wanted to go to Shanghai, because it was rumored that there one could get uniforms that were not cut like grain sacks."[14]

As this anecdote suggests, the revival of more varied and colorful dress in China from the late 1970s onward was fueled at first by a powerful reservoir of pent-up demand. It is no wonder that this revival, in its earliest years, was marked by confused ideas of what was fashionable and suitable, and that the visual effect of the new clothing was not always very successful. It is probably true that for many people who wore the newly available fashions of the time, what they were wearing was less significant than what they were *not* wearing – the boring old Mao uniform of many years past.

By the late 1980s and early 1990s, a decade of phenomenal economic growth and gradual relaxation of government regulation in matters of life-style (though not of politics) had made an enormous difference in the Chinese fashion scene. More and more people traveled abroad, or knew someone who had; magazines and books from abroad were more widely available; movies, videos, and television programs from the outside world (and especially from Hong Kong) were full of messages about fashion. These incentives to fashionable dressing were seized upon especially by the young. As a writer for *China Reconstructs* put it in 1985, "Even the most conservative elders could see that the clothes worn by Beijing young people were no more outlandish than those worn by foreign tourists and overseas Chinese."[15]

Fashion is still primarily for the young. Finnish journalist Linda Jakobson describes a 1995 visit to the family of Chinese photographer John Lee:

40 Gong Li in the film *Shanghai Triad* (1996). NA/Fotos International/Archive Photos.

> John's mother was 58, with short-cropped hair. She wore dark cotton trousers and a white short-sleeved shirt. Her outfit was nearly identical to that of John's father, except that his slacks were gray . . . She belongs to the generation of women taught to rebuff the slightest feminine nuance. The new socialist woman in Mao's time was neither frivolous or romantic, a dramatic contrast to the women in John's life. His girlfriends favor tight-fitting miniskirts and open-necked tops. They paint their fingernails a shocking red and expect John to bring them gifts of Yves Saint Laurent perfume or Revlon mascara when he returns from work trips to other cities.[16]

Today China has to a large extent rejoined the world of fashion – a process amplified by the return of Hong Kong to Chinese sovereignty in 1997 – with a burgeoning young middle class continuing to search with increasing sophistication for ways of dressing that are both fashionable and in some sense distinctively Chinese. At the same time a number of young designers of Chinese descent are increasingly making their presence felt in the western fashion world.

China Chic: East Meets West

WESTERN FASHION HAS ALSO BEEN INFLUENCED by China. During the past decade alone, a host of designers from around the world have been inspired by visions of China. In Paris, Christian Lacroix creates haute-couture ensembles with names like "Frontière chinoise" and "Maison de thé." At the House of Chanel, Karl Lagerfeld designs a coat dress with embroidery motifs from a Coromandel screen. The Roman couturier Valentino has envisioned some of his most luxurious creations in the chinoiserie style. John Galliano did an entire collection for Christian Dior based on the idea of Shanghai in the 1930s. Indeed, ever since about 1993, the cheongsam has appeared regularly on French fashion runways.

When Hong Kong was returned to China in 1997, Chinese styles proliferated throughout the West, just as they had in the 1970s with the advent of "ping-pong diplomacy." This time, however, it was not Mao's China which inspired fantasies, but China as depicted in the films of Zhang Yimou. If Galliano's ready-to-wear collection (Spring/Summer 1997) was quintessential Shanghai, his couture collection that season mixed Asian and African influences. Similarly Dries van Noten deliberately aims for "a young fashion where cultures intermingle."[1] One season it might be the Silk Road through Central Asia, another season the road south from China to Vietnam. In his Mongol Collection (Fall/Winter 1994–5), also called the Eskimo Collection, Jean Paul Gaultier was inspired by Mongolia, ethnic diversity, androgyny, and the image of "barbarian" jewelry. Meanwhile, in New York, where fashion is more minimalist, Donna Karan was inspired by Chinese work clothes to create modernist uniforms. Perhaps most significantly, a new generation of Chinese and Chinese American designers, such as Vivienne Tam and Han Feng, have begun to draw on their own cultural heritage.

The current fashion for chinoiserie is sometimes criticized as a form of cultural stereotyping. Is it possible for western designers to draw inspiration from Asian dress without engaging in neo-imperialistic appropriation? In her essay, "Artificial Flavour: Asian Identity & the Cult of Fashion," Ingrid Chu asks, "What does it mean to take objects from foreign and non-industrial cultures and integrate them into an expression of twentieth-century Western culture?" When incorporated into contemporary fashion, she argues, Asian designs are stripped of any obvious connections to history and tradition, being empty symbols of exoticism.

41 William McGregor Paxton, *The New Necklace*, 1910. Oil on canvas. Zoë Oliver Sherman Collection. Courtesy Museum of Fine Arts, Boston.

So what else gets conveniently left out when fashion designers appropriate the look of another culture into the Look-of-the-Moment? . . . Extracting only aesthetic elements, or the cultural code, from other countries creates a mysticism about foreign regions without a true understanding of the culture itself. Often times, an entire look is "lifted" without the designer ever being conscious of the specific time and place of its origin, its history lost . . . We buy into the fantasy and whatever exists behind the glossy exterior is lost in the translation.[2]

At one level this interpretation is indisputable – and yet the very same criticism could be made *whenever* designers are inspired by *anything* beyond their immediate lives. Relatively few fashion designers have more than a cursory knowledge of the history of western dress. Moreover, many Chinese also have only a very vague sense of their sartorial history. A Chinese newspaper, for example, offers this very confused description of Zhang Yimou's film *Shanghai Triad*: "When Gong Li vamps on screen in the Qing dynasty court dress with slit skirt and Mandarin collar known as a cheongsam (qipao in Mandarin), it will no doubt fuel a revival in this sexy silk garment, popular in China at the turn of the century." As Antonia Finnane points out, the Chinese description of Gong Li's dress shows both "a sense of dislocation from history and . . . a desire to be reconnected with it."[3]

How, then, are we to interpret the fashionable appropriation of Asian themes? Is it "the result of a naive appreciation of other peoples," asks Chu, "or a gross expression of condescension"?[4] Although there may be elements of both attitudes, such a negative assessment is simplistic. Only a few years ago some observers believed that "Exoticism is dead or dying." As information and images circulated ever more rapidly, it seemed that "the mythic dimension of others" was disappearing. Yet far from fading away, exoticism has become ever more entrenched as an element of cuisine, decoration, tourism, and fashion. Is this phenomenon just a "banal and frivolous" manifestation of the power of marketing in an age of global capitalism? "Or does it reflect more profound aspirations?"[5]

As society and culture have become increasingly international and multicultural, so also has fashion. Chu is certainly right to argue that the more we know about our collective history, the better. Yet it is also necessary to realize that fashion is not *about* the accurate historical reconstruction of past styles. To say that fashion involves the creation of *fantasies* is not a valid criticism, although it is certainly true that the fantasies expressed in fashion may be subject to critical deconstruction.

Part of the appeal of exotic consumerism is its supposed relation to a set of values, including authenticity and artistry. Objects that appear to be made by hand or that seem connected to cultural traditions may exert a powerful appeal on modern urban individuals. Exotic fashions, for example, may function both to embellish and to evade everyday life. Since very few people dress completely

in an exotic style, the resulting melange of influences alludes simultaneously to several referents. It is therefore impossible to say that Asian-inspired fashion has any one single meaning. Sartorial chinoiserie might, in some cases, signify a reaction against minimalism and a renewed taste for ornamentation and color. It might also or alternatively reflect an experimentation with a different identity, whether from the desire to belong to another culture, or from a belief that every human being is a citizen of the planet.[6]

Already by the time of the Roman Empire (or, from the Chinese point of view, the Han dynasty), there existed an active trade between the Mediterranean world and what the Romans called Serica, the land of silk. Luxurious textiles far superior to anything produced in the West were brought overland along what became known as the Silk Route. Eventually, sericulture was imported to the West and by the fourteenth-century silk weavers in Lucca were busy imitating Chinese designs of dragons and phoenixes.

The sensuous, expensive material predictably aroused the ire of moralists. Seneca, for example, was disgusted by the gauze-like transparency of fashionable silk textiles: "I see silken clothes, if you can call them clothes at all, that in no degree afford protection either to the body or to the modesty of the wearer, and clad in which no woman could honestly swear she is not naked."[7] Moral arguments, however, carried little weight with consumers who readily appreciated the tactile and visual characteristics of silk. The trade in silk flourished, as did the production of silk in Europe and later America. Nevertheless, this uniquely smooth and lustrous material retained an aura of degenerate, exotic effeminacy. As a result, after the eighteenth century the use of silk tended to be reserved for women's apparel.

China was also famous as the land of porcelain, and European monarchs competed in acquiring Ming dynasty porcelain vessels. Already by the sixteenth century, Chinese potters were producing blue-and-white wares expressly for the European market. The mania for collecting china repeatedly swept Europe. Other consumer items, such as lacquer and calico, were also brought back from the Orient in ever greater amounts, triggering new enthusiasms and resulting in attempts by European craftsmen to imitate these fashionable objects.

Then, as later, little or no distinction was made between the cultures of China, Japan, and India. Various non-European styles were blithely combined to produce a fantastic exoticism. Chinoiserie pavilions and pagodas were erected all over Europe. Fashionable ladies in eighteenth-century England decorated at least one room of their homes with beds and chairs made in the style known as Chinese Chippendale – and filled those rooms with innumerable smaller objects, such as clocks, tea pots, and figurines in the Chinese style. Wallpaper depicted the inhabitants of Cathay coursing the air on dragons or strolling over delicately arched Chinese bridges amidst a wild profusion of giant peonies and exotic little temples. Outside the house lay Anglo-Chinese gardens, adorned with their own little fretwork bridges and kiosks. In the

evening, people of taste attended chinoiserie plays and operas, or dressed up in chinoiserie masquerade costumes.

In the eighteenth century, although westerners tended to be both ignorant and imaginative in their depictions of Oriental themes, the Far East was generally perceived in a favorable light – one need only think of such pretty images as François Boucher's *Chinese Fishing Party* (1742; Museum Boymans van Beuningen, Rotterdam). When European travellers actually ventured to the celestial kingdom, however, "instead of viewing an enchanted fairy-land, [they found], after all, that China is just like other countries."[8] When the Jesuit missionary Matteo Ricci arrived in Beijing in 1601, after having lived almost twenty years in the Chinese cities of Macao and Nanjing, he still asked the whereabouts of Cathay. It took some time to convince him that he was already there or, rather, that Cathay was only a western fantasy.

By the nineteenth century, however, when European imperialism and colonialism came of age, the Orient was increasingly demonized. No longer conceived of as the peaceful abode of philosophic mandarins, China was reimagined as a decadent and vicious country, full of degraded, treacherous coolies, who dined on rats and were addicted to opium. In reality, of course, opium addiction on a mass scale began in China only *after* the British deliberately promoted the drug as their main export from India to China. Even uglier stereotypes developed in the United States as Chinese immigrants competed for jobs within the context of a racist society.

Negative stereotypes about Asians did not, however, prevent westerners from being influenced by Asian sartorial style. Both men and women often chose to incorporate individual Asian garments into their wardrobes (fig. 42). Thus, dragon robes served as dressing gowns, and Chinese ladies' jackets were worn in place of European-style jackets. Japanese kimonos were even more popular. Asian clothing also inspired Parisian couturiers. Indeed, as Florence Winterburn wrote in her 1914 work, *Principles of Correct Dress*, "Europe is almost thrown into the shade by the temptation of the Orient, that fairy land which seems to have captivated the imagination of the Western people lately, and of which they cannot have enough to satisfy their desires."[9] (Notice the sexualized vocabulary she uses.)

The great French couturier Paul Poiret was especially influenced by oriental design. His famous "Confucius" evening coat of 1906 provided the prototype for a host of later coat designs. He also frequently decorated his clothes with medallions of Chinese embroidery, and used Chinese-style "frog" fastenings. His "Mandchou" tunic of 1921 was made of gold lamé and was adorned with the Chinese character *fu*, meaning "to expel" or "oppose" or "brush away." Poiret was, of course, also inspired by Japanese, Indian and Middle Eastern dress. At his 1001st-night party, he dressed as an Ottoman sultan with Madame Poiret as the harem favorite. Although few fashion designers were as deeply committed to exoticism as Poiret, most of them at least dabbled in orientalism.

42 Cover illustration, *Le Miroir des Modes* (July 1921). Collection of Valerie Steele.

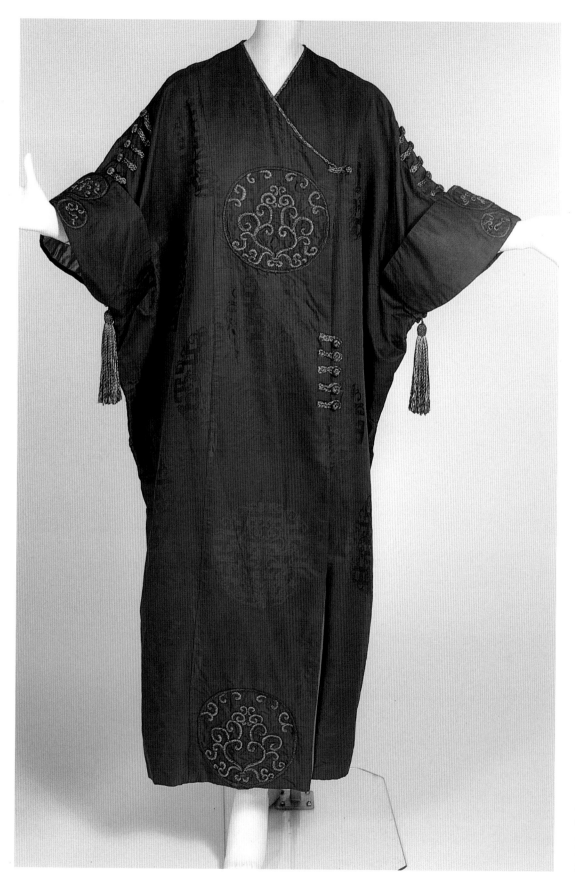

43 Liberty of London, Chinese-style evening coat, 1900–1920. The Museum at F.I.T. 90.190.11. Gift of Mr. and Mrs. Max Toberoff. Photograph by Irving Solero.

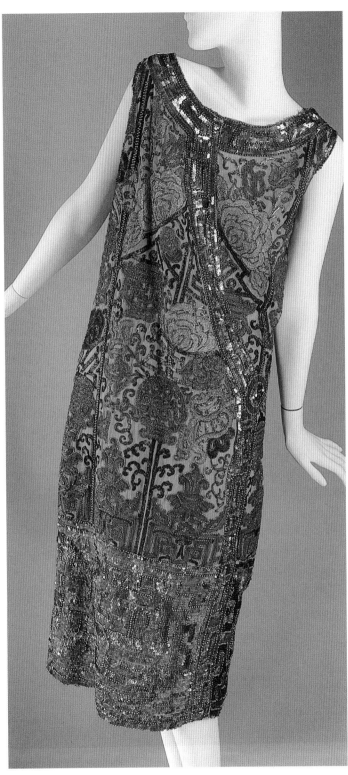

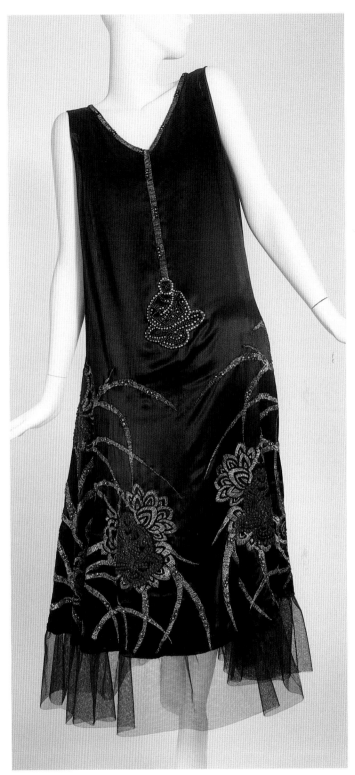

44a Beaded and sequinned evening dress with Chinese design, c.1925. The Museum at F.I.T.81.12.23. Gift of Mrs. Cora Ginsburg. Photograph by Irving Solero.

44b Satin dress with design of Buddhas in rhinestones and beads, c.1928. The Museum at F.I.T. 70.6.2. Gift of Mrs. Louise McCormick. Photograph by Irving Solero.

Meanwhile, in Hollywood also, orientalist themes were popular. Costume designer Travis Banton, for example, created a magnificent dragon dress for the Chinese American actress Anna May Wong (fig. 45).

Nevertheless, throughout the first half of the twentieth century, the dominant western attitudes towards Asia were contempt (epitomized in the term *wog*, which stood for "westernized oriental gentleman") and fear (the "yellow peril"). In the 1930s, when Japanese militarism encroached violently on Chinese national integrity, the cartoon image of Ming the Merciless was born. Although Ming was intended to represent the Japanese threat, his name was Chinese and he resembled an earlier fictional Chinese villain, Fu Manchu.

Positive images of China and the Chinese competed with these negative stereotypes. As long as Chinese people stayed in China they could still be seen as exotic and mysterious, even if racist laws prevented them from emigrating to America. China was seen in part as a victim of catastrophe and exploitation, a country in need of charitable aid; many idealistic young Americans became missionaries or aid workers in China in response to what they saw as a noble calling.

With Japan's attack on Pearl Harbor in 1941, however, China's image in America improved dramatically. China became a cherished ally in the fight against fascism. Madame Chiang Kai-shek (Song Meiling, sister of Madame Sun Yat-sen and daughter of one of China's richest and most prominent families) made several speaking tours of America in the 1930s and 1940s. Well educated, highly articulate, adept at using the news media to her advantage, and equally beautiful in a cheongsam or a western-style dress, she was a very effective ambassador for nationalist China. But with the victory of the communist revolution in 1949, followed by the Korean war, old stereotypes of the treacherous and cruel Chinese were again widely propagated.

At the same time, international travel became much easier, with the result that both fashion designers and consumers became more familiar with foreign dress. Throughout the 1950s and early 1960s western fashion designers occasionally utilized Chinese dress styles and design motifs. The cheongsam, in particular, achieved a certain popularity in the wake of the movie *The World of Suzy Wong* (1960). Fashion photographers also increasingly employed exotic settings. Yet there remained an ambivalence. Francesco Scavullo's beautiful photograph from 1962, *Antonia at the Star Ferry*, for example, gives the visual impression of a human wave of Chinese surrounding a lone white female.

Although mainland China remained behind "the bamboo curtain" during the Cultural Revolution, Hong Kong was increasingly integrated into the international fashion world. Not only were many garments produced there, but a few Chinese designers also emerged. Dora Wong, for example, left the People's Republic of China in 1957, and in 1960 began her own business in Hong Kong. When the Hilton Hotel opened in 1963, she moved her retail outlet into the arcade and launched an export business, specializing in hand

45 Anna May Wong wearing a dress by Hollywood designer Travis Banton. Archive Photos.

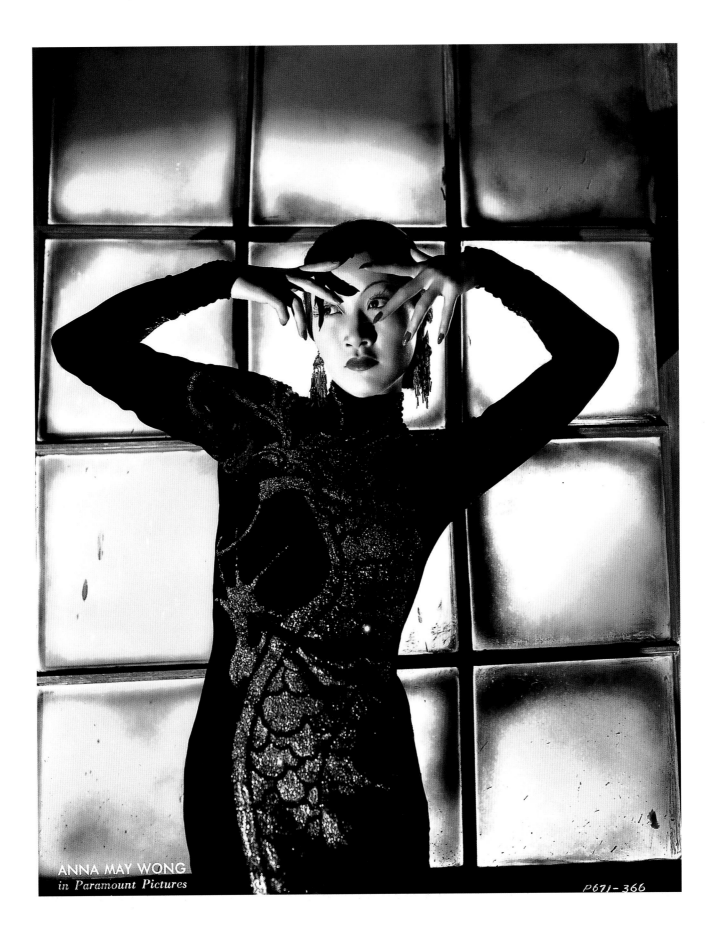

ANNA MAY WONG
in Paramount Pictures

P671-366

46 Dora Wong, Hong Kong fashion designer, visiting the U.S. in 1966. Courtesy of Dora Wong.

beaded garments. During a visit to the United States she told a Dallas journalist, "I sell Hong Kong fashions to America, but I also buy American fashions for Hong Kong"[10] (fig. 46).

In the late 1960s "ethnic" and "retro" fashions became increasingly popular in the West as young people looked to long ago and far away for inspiration. Mod fashion gave way to hippie anti-fashion, and the hippies traveled widely, especially to places like India and Morocco. Following the hippies, fashion designers also began creating their own high-style versions of "ethnic" apparel. There were soon a wide variety of fashions at all price points inspired by – or directly borrowed from – Africa, India, the Middle East, and the Far East. However, Chinese clothes played a relatively minor role, compared with, say, Native American or West African styles.

The popularity of "The Chinese Look" in the 1970s was partly a result of the growing normalization of relations between the People's Republic of China and the West (and particularly the United States). Young French fashion editors began sporting anti-fashion work uniforms imported from the People's Republic of China, and *Time* described the latest fashion trend as "Mao à la Mode." (fig. 47) The Chinese influence on French and American designers embraced both what designer Marc Bohan called "poor Chinese and rich Chinese styles." On the one hand, designers were inspired by uniform-style tunics and trousers and quilted jackets. On the other hand, they also went "from paddy to palace, digging deep into the treasure chest of Imperial China. Result: high-collared mandarin robes, silk jacquard jackets, sable-lined evening coats of old damask and golden scrolled pyjamas, all done up in posies of color pirated from the Orient."[11]

Clearly, the discourse on Chinese fashion in the western press was problematic. There were innumerable references to racist tropes such as "the mysterious Orient" and "inscrutable" Asians. Peasant-style jackets were invariably referred to as "coolie jackets," and there were even jocular references to looking like "a cool coolie." The notion of "political correctness" had not yet achieved wide currency; many people were still insensitive to casual, unthinking racial slurs. Qipaos were "Suzy Wong" dresses. The "rich Chinese" or "mandarin look" was said to reflect "the luxurious side of old China," or rather – not China but "ancient, faraway Cathay, the promised land of Marco Polo."[12]

Certain fashion designers were more interested in ethnic styles than others. Yves Saint Laurent was probably the supreme exponent of exotic fashion. Over the course of his very long and successful career, he created extraordinarily

beautiful fashions inspired by Africa, the Middle East, India, Russia, and China. A year after Saint Laurent's world-famous Ballets Russes Collection of 1976, he produced another major collection inspired by imperial China, which in turn launched the next wave of fashionable chinoiserie.

"Let's face it. Russia is out, and China is in," declared fashion journalist Eugenia Sheppard. "Yves Saint Laurent switches to mad Mongolians, ferocious female samurais and Chinese Empresses for his new fall collection" (fig. 48). *Women's Wear Daily* called the collection Saint Laurent's "pipedream of faraway places." Or as the newspaper put it on another occasion; "Yves Saint Laurent is headed for China, but it isn't the somber China of Deng Xiaoping. Yves Saint Laurent's Orient has bright colors, slit trousers, and daring bustiers."[13]

48 Yves Saint Laurent, silk damask evening gown with stylized cloud pattern; worn with a blue silk damask underskirt. Fall/Winter 1977/1978 Haute Couture Collection. The Museum at F.I.T. 88.73.1. Gift of Lynn Manulis. Photograph by Irving Solero.

49 (*facing page left*) Christian Lacroix, "Frontière chinoise." Multicolored floral brocade parka with green mink facing, black jersey skirt, platform shoes. Fall/Winter 1992/1993 Haute Couture Collection. Courtesy of Christian Lacroix.

50 (*facing page right*) Christian Lacroix, "Maison de thé." Embroidered lace patchwork sheath dress. Fall/Winter 1992/1993 Haute Couture Collection. Courtesy of Christian Lacroix.

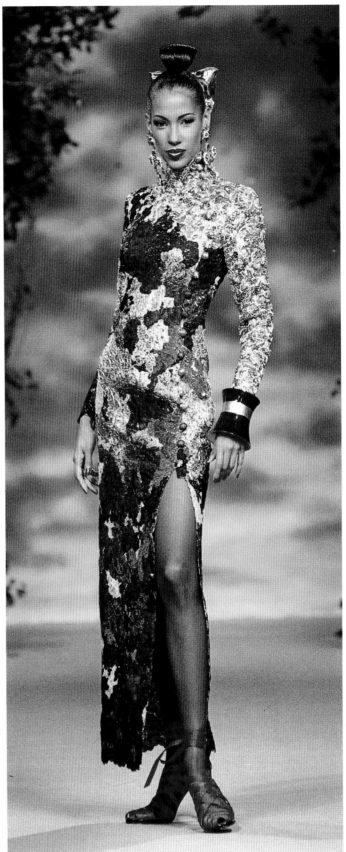

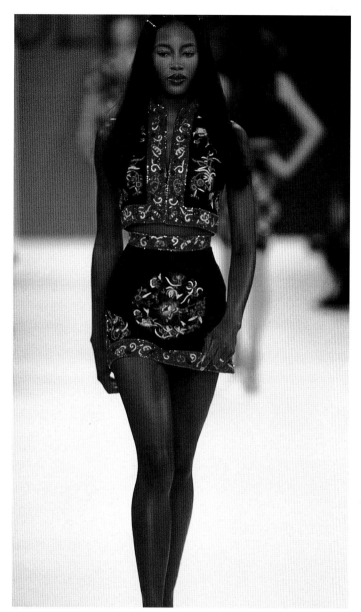

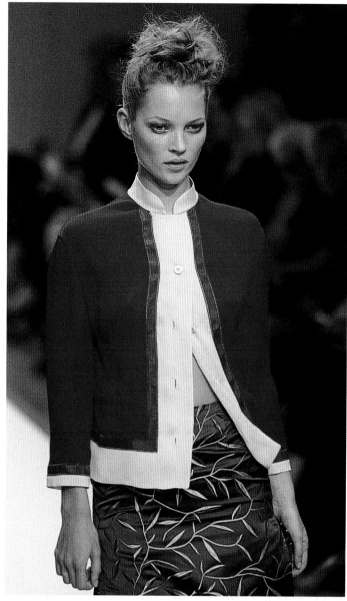

51 (*above left*) Todd Oldham, embroidered and beaded mini-skirt and top, Spring 1995. Photograph by Corina Lecca. Courtesy of Todd Oldham.

52 (*above right*) Prada, skirt and jacket, Spring 1997. Courtesy of the photographer, Rudy Faccin Von Steidl.

"Splendour and luxe . . . reached its most seductive heights in the ravishing Chinoiseries of Saint Laurent," declared *Vogue* (October 1977) in a report on the Paris couture. "The essence of things Chinese at Saint Laurent" included items such as a lamé dinner dress with "Mandarin opulence of fabric and coloring and . . . cheongsan [*sic*] simplicity of line," as well as pyjamas in wisteria satin and a jacket shaped like "a big, curved bias cocoon of crimson satin." Perhaps most spectacular, however, were his "fabulous Kublai Khan jackets in gilded peacock-blue brocade all lined and hooded in black mink . . . over matching satin pants and his sensational high-heeled leather boots, wrapped and tied with tasseled silk cords."[14]

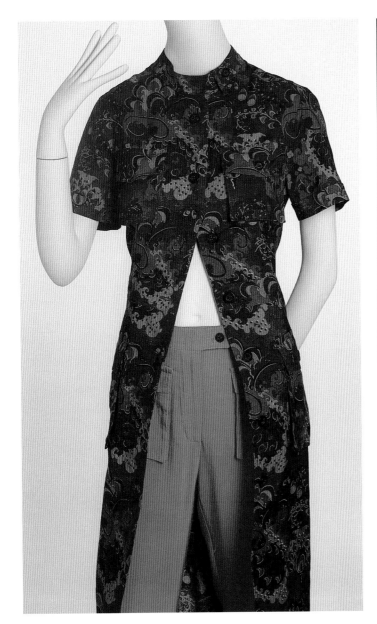

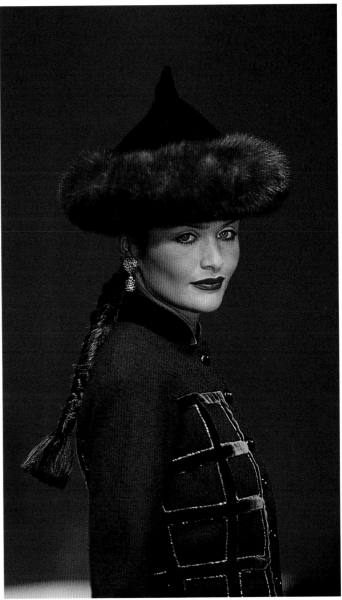

In 1980 Yves Saint Laurent launched his new fragrance "Opium" with an advertising campaign that featured a voluptuous and semi-conscious young woman. The advertisements were controversial, mostly on the grounds that they "glamorized" drugs. Some Asian critics also argued that the advertisements implicitly evoked racist images of opium fiends and white slavers. Such an interpretation is indisputable at one level. It is important to remember, however, that decadence was in fashion in 1980, and another perfume was called "Poison."

Despite the popularity of the scarlet silk mandarin version of chinoiserie, there was also an alternative vision of a blue cotton workers' China. Workers'

53 (*above left*) Dries Van Noten, dress styled as a Chinese robe/Mao jacket with military pockets, in silk shantung printed with an abstract lotus design in shades of purple, with coordinating orange trousers. Summer 1997. The Museum at F.I.T. 98.28.1. Gift of Dries Van Noten. Photograph by Irving Solero.

54 (*above right*) Valentino, Haute Couture Autumn/Winter 1993/1994. Photograph by P. Biasion. Courtesy of Valentino.

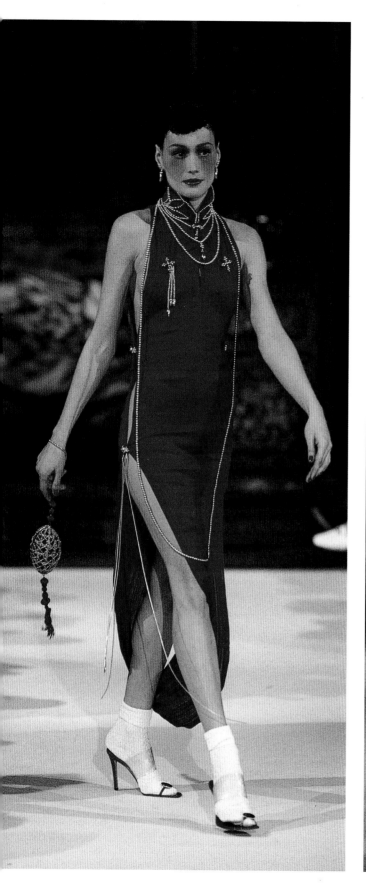

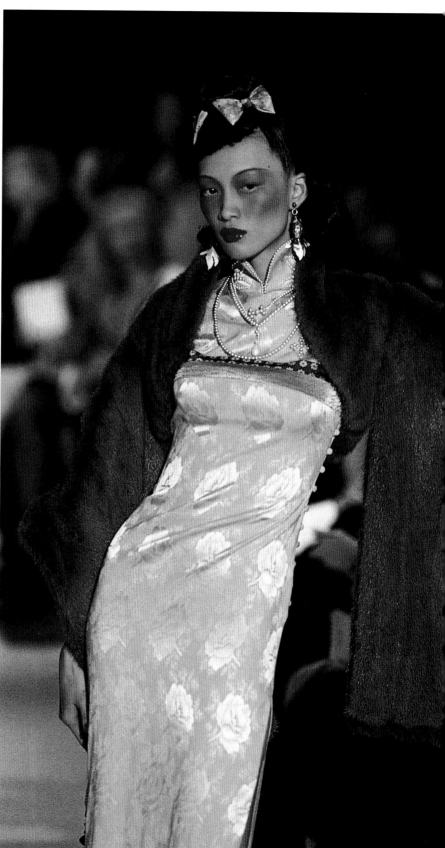

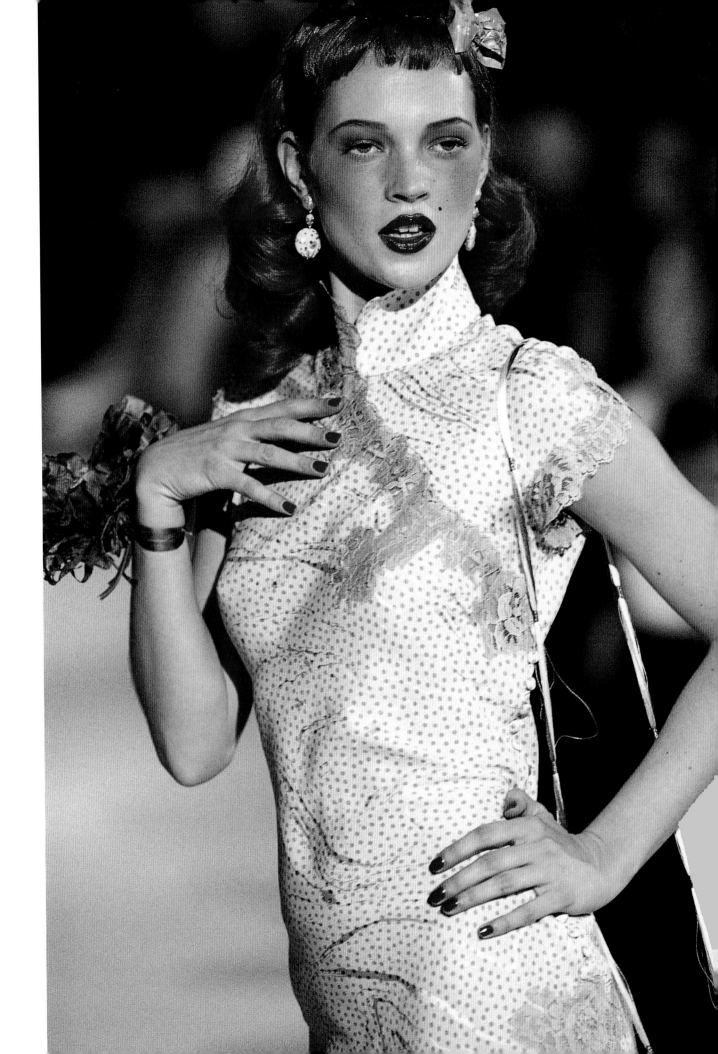

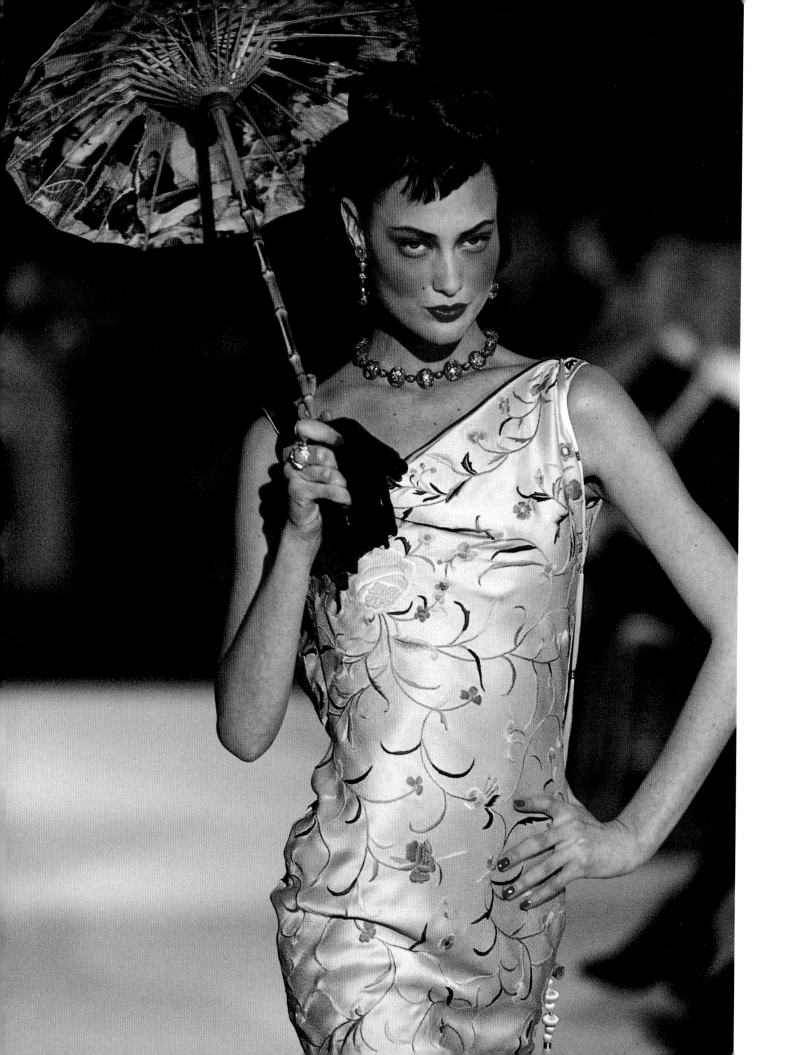

People, Gossip and Fashion

FASHION almanac

COUTURE MAGIC

BEAUTY

ORIBE
BOBBI BROWN
BACKSTAGE
SECRETS

SWIMWEAR

JULIE BROWN
EXCLUSIVE

DISPLAY UNTIL Aug. 27

72 >

0 71896 49082 4

U.S.A. $3.50 CANADA $4.95 U.K. £2.95

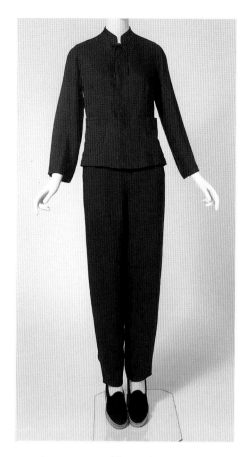

57 Donna Karan, blue "Chinese worker" jacket with matching pants and Chinese-style canvas shoes. Spring 1995. The Donna Karan Company. Photograph by Irving Solero. Courtesy of The Museum at F.I.T.

55 (pages 84–6) John Galliano for Christian Dior, Autumn/Winter 1997/1998 Pret-à-Porter Collection. Courtesy of the photographer, Rudy Faccin Von Steidl.

56 (previous page) Dress by Dior on the cover of Fashion Almanac (Summer 1997). Courtesy of Amedeo Angiolillo, publisher of Fashion Almanac.

clothing has appealed to segments of the aesthetic avant-garde since the early twentieth century. When Paris was filled with ardent Maoists, the workers' uniform was associated with leftist, anti-colonial politics. The romanticization of the Orient continued, in other words, but along with the old fantasy about opulent Cathay, there was a new western fantasy about the workers' paradise. For the most part, however, Maoist fashion in the West had more to do with an enthusiasm for uniforms and techno-chic than with any political message.

"Chinese dressing is utilitarian and clean," declared Charlotte Du Cann in her book Vogue Modern Style.

> Mao suits in working blue, crisp schoolgirl shirts with pleated skirts and red scarfs, straight trousers in black silk worn with white cotton socks and flat Chinese black plimsolls. A cap is worn at all times. In winter an indigo padded jacket. This look has no truck with Suzy Wong.[15]

A photograph by Alex Chatelain for British Vogue taken on location in China (and featuring Chinese-inspired Italian clothes) showed a western fashion model holding a bicycle and looking up at a big character poster plastered on the wall. The text of this poster is a menacing government directive, warning Chinese citizens not to criticize the state. Thus, a western fashion photograph accidentally reveals a glimpse of the real China.

Beyond proletarian style, there is revolutionary chic, which for many westerners is a sexy look. Admittedly, Mao himself did not have the movie star looks of Che Guevera, nor is the Maoist uniform as chic as the clothing of the Black Panthers. Nevertheless, as the French fashion designer Thierry Mugler wrote in 1985, "I am amazed by the austerity, the simplicity, the great elegance of the Maoist uniforms." Of course, Mugler had to admit that "Today, in the cities, the Chinese have abandoned Maoist clothing."[16] Yet he was clearly nostalgic for the look, which he tried to recreate in the fashion photographs that he took for Vogue Homme. Revolutionary chic is also closely related to another major fashion trend: military uniforms. Usually western fashion designers reference their own history of military styles, but they are also inspired by "enemy" uniforms, which can seem more powerful – and therefore sexier. Thus, in 1993 Helmut Newton photographed Jane March wearing not much more than a green People's Liberation Army cap decorated with a red star (fig. 58).[17]

Chinoiserie is often assimilated to the generic category of "ethnic dressing." Thus, Vogue Modern Style begins with the announcement that "Ethnic dressing comes from the hot and sultry East whose gorgeous fabrics have been bartered and fought over for centuries by Western traders."[18] Edward Said would have a field day with this image of the reified Orient implicitly characterized as a sexually ardent (hot) yet passive female, whose booty has been bought and fought over by active western males. The author exhibits no awareness that Asian fabrics are also used within Asia and traded by Asian merchants. Asian fashions are also created by Asian designers.

Asian fashion designers and retailers have become increasingly well known. Fashion designers of Chinese origin include Vivienne Tam, Yeohlee, Han Feng, Amy Chan, Anna Sui, Zang Toi, and Nautica's David Chu. There are also several high-profile Asian retailers, such as Joyce Ma of Singapore, who owns a chain of stores in Asia and a magazine called *Joyce*; Dickson Poon, of Hong Kong's Dickson Concepts, whose name became known to New Yorkers when he considered buying Barney's; David Tang, who recently opened the Madison Avenue boutique Shanghai Tang; and Kin Yeung of the Fifth Avenue boutique Blanc de Chine. When people like these draw on Chinese inspiration for their work, it implicitly means something rather different than when westerners do so.

Vivienne Tam was born in Hong Kong and studied fashion design at Hong Kong Polytechnic University, where one of her teachers was Valery Garrett,

58 Helmut Newton, *Jane March*. Courtesy of Helmut Newton.

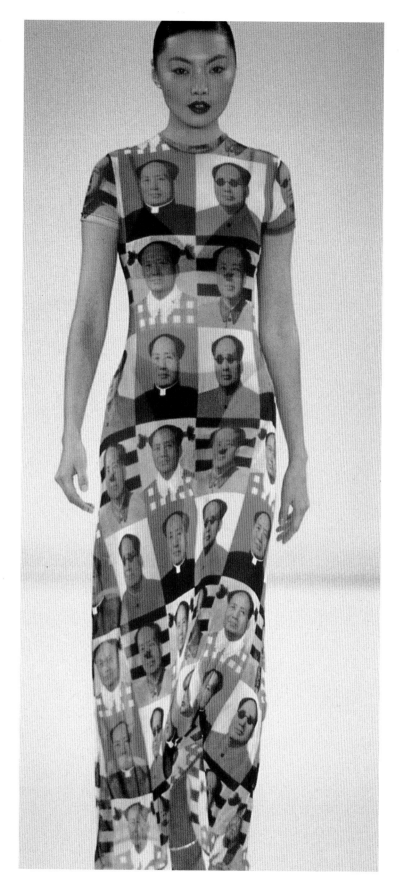

the author of several important studies of Chinese dress. Although familiar with Chinese fashion history, Tam did not immediately begin incorporating Chinese themes into her own work. Over time, however, she has become probably the most famous contemporary creator of Chinese-inspired fashion. Many of her garments allude to recognizably Chinese motifs.

Tam draws on the imagery of traditional Chinese art to create clothing for modern life. The coiled dragons formerly emblazoned on imperial robes appear today on her dresses and tee-shirts, while the ink paintings of Chinese literati inspired another series of dresses. A number of her garments are decorated with religious imagery, such as the goddess Guanyin or Buddhist scriptures. Indeed, Tam is very much concerned to express spiritual values in her work and, in particular, what she sees as a traditionally Chinese philosophy of nature.

Tam's Spring 1998 collection, for example, was inspired by traditional Chinese cosmology, which divides the universe into five elements or phases: Metal, Wood, Water, Fire, and Earth. Through her use of natural imagery, she implies that the universe is organic, and that everything affects everything else. Whether or not everyone who wears her clothes is conscious of a spiritual dimension to her work, it undeniably exerts an appeal that is simultaneously delicate and strong. Tam also reminds us how much art relies on the kind of traditional craftsmanship that is in danger of dying out. Throughout her work, she utilizes traditional Chinese decorative techniques, such as delicate embroidery and beading, which have historically been associated with women's artistic work. Even the textiles of which her clothes are made show the hand of skilled artisans. Thus, for example, she has made clothes from a special type of oiled cloth produced only in south China.

Yeohlee Teng was born in Malaysia, where there is a significant Chinese minority population. At the age of eighteen, she came to the United States to study at the Parsons School of Design. The designer, who goes by her first name professionally, is best

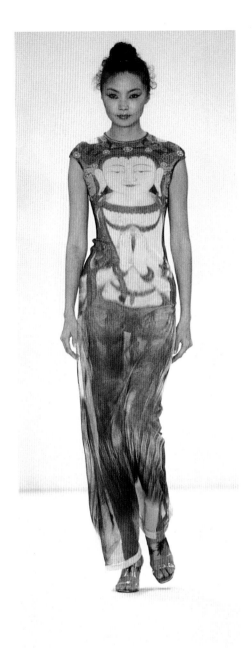

known for her elegantly engineered coats. Her clothes, which often utilize technologically advanced fabrics, tend to be monochromatic in color and deceptively simple in shape. She is not inspired by Chinese design motifs or decorative techniques. She has, however, been influenced by the form and construction of traditional Chinese garments, and perhaps also by traditionally Chinese ways of thinking about clothing.

Yeohlee is an extremely intellectual designer, whose work is a form of intimate architecture. She believes that clothes not only cover the body, but also define the space around it. The proportions and drape of clothing can thus

62 Yeohlee, black stretch velvet mandarin
dress. Fall 1996. Photograph by Dan Lecca.
Courtesy of Yeohlee.

65 Chinese man's silk velvet vest, *c.*1900. The Museum at F.I.T. 69.218.9. Gift of Jack Lenor Larson. Photograph by Irving Solero.

63 (*far left*) Yeohlee, black/gold sequin mandarin top with side slits and brown silk satin pants. Fall 1997. Photograph by Dan Lecca. Courtesy of Yeohlee.

64 (*left*) Yeohlee, navy rib velvet vest and navy nylon pleated pants. Fall 1996. Photograph by Dan Lecca. Courtesy Yeohlee.

impart certain feelings both to the wearer and the viewer. "Clothes have magic," says Yeohlee. "Their geometry forms shapes that can lend a wearer power."[19] Intrigued by "the embodiment of geometric forms in ritualistic dress," Yeohlee believes that the layered robes, mantles, and crowns worn by emperors, priests, and judges help them obtain "a state of detachment and repose." As she puts it, "I'm fascinated by strong shapes. I try to make clothes that have a certain presence – clothes that empower the wearer."[20]

Thus, although Yeohlee obviously differs from the emperors of China inasmuch as she eschews most forms of surface decoration (whereas they were

66 Amy Chan, handbag with embroidered dragon motif, 1998. Amy Chan, Inc. Photograph by Irving Solero.

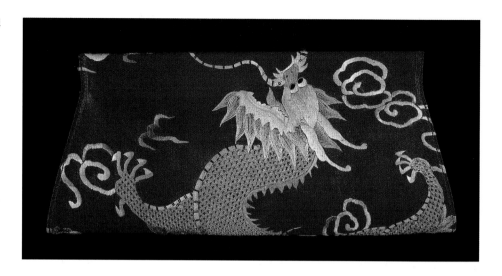

67 Amy Chan, mini-qipao with zipper fastening, 1998. Amy Chan, Inc. Photograph by Irving Solero.

68 (*facing page*) Anna Sui, dress inspired by a qipao. Spring 1993. Photograph by Raoul Gatchalian. Courtesy of Anna Sui.

very much concerned with iconography), she shares with them the belief that there is more to clothing than material phenomena, such as production processes and manufacturing costs. Clothing also has tremendous symbolic, even moral, power. While Yeohlee's clothes are extremely modern and urban, they also draw on forms which have stood the test of time. Her Urban Nomads Collection of fall/winter 1997, for example, was inspired by the perception that we, too, are travellers, like the nomadic people of Mongolia and the Gobi Desert. We also need clothes that are multi-functional – and that convey a certain presence.

If Vivienne Tam draws on such Chinese iconography as the Buddhist goddess Guanyin, and Yeohlee marries strong shapes and high-tech fabrics, creating garments such as a stretch velvet cheongsam, other designers take inspiration from still other aspects of the Chinese design heritage.

Amy Chan is best known as an accessory designer. When the Guggenheim Museum held its exhibition *China: 5000 Years*, the gift store sold all of Chan's brocade purses. Chan says that she likes the contrast of a traditional Chinese luxury fabric (like brocade) used in a sleek, modern handbag. "Chinese brides change their costume five times [during the wedding], and the traditional Chinese wedding dress is red with a dragon and phoenix. My clutch has a dragon and phoenix, too; I love using the classical brocade in something so modern."[21] Chan has also designed clothing, including a mini-cheongsam with the traditional fastenings replaced by a zipper.

Anna Sui also takes a playful approach to her Chinese heritage, mixing ethnic and historical references with gay abandon. A first generation Chinese-American, Sui grew up in Detroit during the 1960s and attended the Parsons School of Design in the early 1970s, where she was influenced by New York's Punk Rock scene. Like her friend Vivienne Tam, Anna Sui designs for a young, hip clientele that appreciates an irreverent mixture of cultural

influences. Not only does Sui frequently allude to the iconography of rock-and-roll, she also draws upon other aspects of popular culture, such as retro fashions.

"The inspiration for the China group was my favorite aunt, Juliana," recalls Sui. "She came from China and had the most beautiful qipaos with matching jewelry and shoes. One was blue satin with black irridescent beading, and others were made of devoré velvet." Years later, when Sui was a designer, she found a supply of devoré velvets and remembered her Aunt Juliana. "It was the time when grunge was in style," says Sui, "and I wanted to juxtapose that with these beautiful dresses." Certainly, her Chinese-style dresses successfully combine glamour and grunge.

Born in 1962 in Nanjing, Han Feng grew up during the Cultural Revolution, but you would never know it from seeing her vibrantly colored silk fashions. One of the most brilliant colorists in the New York fashion world, she confidently plays with jewel-like shades of emerald, ruby, and amethyst. After studying painting and sculpture at the Zhejiang Academy of Fine Arts in Hangzhou, she came to New York in 1985. By 1989 she was creating her signature pleated scarves, and four years later she presented her first line of women's clothing.

In addition to her use of color, Han Feng is known for her creative

69 Han Feng, velvet mandarin collar tunic over charmeuse trousers. Autumn/Winter 1997/1998. Photograph by Dan Lecca. Courtesy of Han Feng.

treatments of fabrics. Although Chinese influence is not conspicuous in her clothes, their presentation often draws on Chinese themes. Her collection of Spring 1998, for example, was held in her loft, where waiters served tea and the clothes were announced by striking a gong. Later that year, Han Feng traveled to China, where she had her clothes photographed in classically Chinese settings, and worn by ordinary Chinese people.

"It has long been my desire to create a collection of apparel that would not only reflect the outward aesthetic of Chinese designs but also a certain spiritual aspect of my Chinese culture," writes Kin Yeung, the chairman of Blanc de Chine. Over the course of time, "Asian details like frog closings, drawstring ties, knotted buttons and mandarin collars have become elements in western fashion's vocabulary." In addition, "the beauty, simplicity and practicality of Asian garments are accepted by cultures the world over." With the Blanc de Chine collection, he tries to fulfill the demands of "both beauty and function in fashion . . . with simple purity and . . . integrity of design."[22]

Asian motifs have been part of the western design vocabulary for hundreds of years. What may be new in our own time is the intention on the part of many designers to integrate Asian shapes, fabrics, iconography, and other design elements into western fashion, not simply as yet another resurgence of exoticism, but as a genuine expression of broadening cultural horizons around the world.

71 Blanc de Chine, silk denim tunic with hand-knotted closures and signature stitching at collar and wrist, 1997. Photograph by Eric Richards. Courtesy of Blanc de Chine.

70 (*previous page*) Han Feng, padded coat of white silk damask with feather trim and matching hat, 1998. Courtesy of the photographer, Michael Mundy.

72 Han Feng, red coat, 1998. Courtesy of the photographer, Michael Mundy.

Following pages: Detail of a Han Chinese woman's jacket with applied "Cloud Collar" in silk satin with multicolor embroidery. China, nineteenth century. The Museum at F.I.T., New York, Gift of Adele Simpson, 73.6.284. Photograph by Irving Solero.

Part II

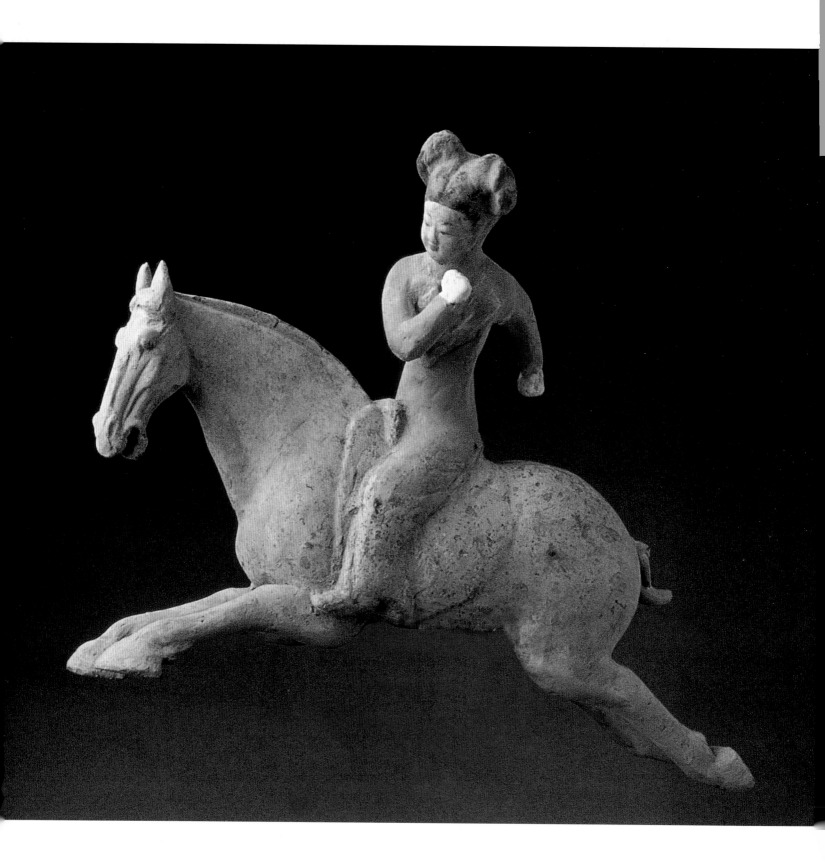

Chapter 5

"Our Women are Acting Like Foreigners' Wives!" Western Influences on Tang Dynasty Women's Fashion

SUZANNE E. CAHILL

DURING THE TANG DYNASTY (618–907), Chinese wealth, territory, and civilization reached fabulous heights. Contact with westerners along the Silk Route increased, and Chinese interest in the exotic occident grew. Foreign influences, including foreign styles of dress, entered Chinese material culture. Even though clothing was restricted by custom and regulation in medieval China, Chinese men and women in the capital cities began to adopt western fashions. Women began to dress their hair and apply makeup in imitation of exotic models. Tang women wore foreign men's as well as women's costumes. Resources for the study of medieval Chinese womenswear are rich, including archaeological and textual evidence. This chapter uses both excavated and written materials to examine Tang women's adoption of western dress in cultural context. I try to uncover their reasons for donning outsiders' attire, including the special case of female transvestites, and speculate that in addition to enjoying the novelty and luxury of new fashions, Tang women also sought foreign clothes as a means of expressing creativity and freedom within the social restrictions of their time and place.

The Tang Empire represents a high point in Chinese culture. With a succession of effective emperors on the throne, a huge economy, and vast territory, China experienced a great age of prosperity and international prestige. For much of this era, government power rested on a secure tax base in agriculture and trade, a well-organized bureaucracy ran the country, a mighty and well-equipped military kept peace along ever-expanding borders, and ordinary subjects of the emperor enjoyed a relatively high quality of life. The Tang is considered the golden age of poetry, the arts, and sciences. The principal capital city of Chang'an, home to the imperial family and center of government and commercial activity, was the biggest city in the medieval world with over a million people. Chang'an was also the most cosmopolitan city of its time. The population of the capital, with its many foreign residents and visitors, was diverse and multicultural.

The sophisticated international culture of Chang'an was founded on its location at the eastern end of the Silk Route, a loosely connected set of roads

73 Female polo player. Funerary figure in buff ceramic with applied pigments, Tang dynasty, late seventh–early eighth century. Courtesy of the Schloss Collection, New York.

leading from Chinese cities in the Yellow River plains, across the mountains and deserts of Central Asia, to western kingdoms such as Persia and India, and eventually to the Mediterranean. Active for over a thousand years, these roads had long been the main conduits of trade, travel, military conquest, and the exchange of ideas between China and points to the west. Chinese exports along these Central Asian routes before the Tang dynasty consisted of silk, high-value manufactured goods, and medicinal substances; imports included jade, horses, and, around the first century C.E., Buddhism. During the seventh through the tenth centuries, travel, war, and commercial activity along the trade routes grew in volume and importance. Tang wealth and intellectual creativity was directly related to trade and contact with other peoples along the Silk Route.

Although ideas, products, and technologies had been entering China across western borders for centuries, Tang culture was open to foreign influence to a degree that had never been matched. Perhaps because the Tang rulers were so confident about their riches and power, and perhaps because so many of the ruling elite (including the imperial Li clan) had foreign roots, exotic elements were welcomed and incorporated into medieval Chinese life. Foreign influences were many and diverse. Wealthy people in Chang'an ate Turkish food, listened to Uyghur music, watched Sogdian dancers, painted Indian women, and coveted Persian jewels. One early Tang prince preferred the Turkish language to Chinese and was criticized for sleeping outside in a blue felt tent on the imperial palace grounds. The vigorous and sometimes dangerous game of polo, probably a Persian import, became popular in Chang'an, with exam graduates, emperors, street children, and even palace ladies forming teams. A tomb figure of the early eighth century from the Chang'an region shows a young lady polo player in foreign clothing turning in her saddle and holding a now-lost mallet (fig. 73).

The ancient Chinese technologies of weaving and metallurgy were especially enriched by new knowledge of Persian crafts. Chinese metal craftsmen added novel foreign techniques to their native arts of casting bronze in clay molds, experimenting with granulation, hammering, stamping, openwork, repoussé, and other processes. The traditional bronze mirror into which a Chinese woman might gaze as she adorned herself was transformed by the addition of these new methods. One handsome eight-lobed bronze mirror of the period bears animal and floral patterns that have a western pedigree, executed in repoussé and gilded silver. The hairpins our Tang lady wore became ever more elaborate in design and fabrication under the influence of foreign metalwork. A fine painting on silk attributed to Zhou Fang shows palace ladies with delicate filigree hairpins in their elaborate coiffures (fig. 74). Silk textiles, one of China's greatest contributions to world culture, experienced an explosion in variety of pattern and weave during the Tang after encountering western fabrics. Persian designs, often featuring a mythic animal

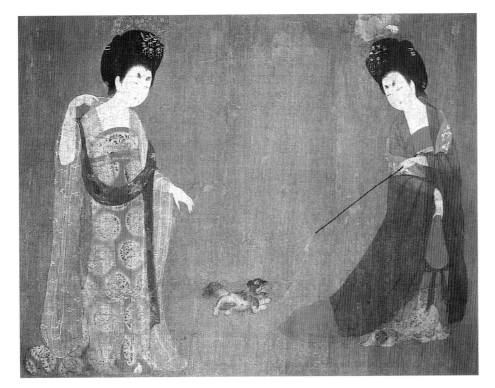

74 Attributed to Zhou Fang, *Court Ladies with Hairpins and Flowers*. Painting on silk, ninth or tenth century. The silk fabric of the gown worn by the woman on the left has a typical Persian pattern of roundels; she also wears an long-sleeved over-garment of netted gauze. Courtesy of the Liaoning Provincial Museum.

at the center of a round medallion surrounded by pearls, became regular features of the silk clothing worn by wealthy Tang women. A weft-faced compound twill weave of silk found in Sogdiana, showing two birds facing each other, was used to make an eighth-century child's pair of trousers. And wealthy people in the urban centers developed a special taste for foreign dress.

Foreign styles of clothing were not entirely a Tang innovation. At least one emperor of the Han dynasty (206 B.C.E.–220 C.E.) liked to dress as a westerner. Several states of the era of division following the Han dynasty were ruled by minority peoples, and people of many ethnicities have always made up what we call China. These rulers and people wore many different types of costume, but western influence on men and women's fashion in the Tang was greater than ever before. This influence was both wide and deep, reaching from the western borders to the ancient capitals, and from aristocratic lineages to the common people. The range of new styles, derived as they were from many different cultures along the Silk Route, was enormous. Specific elements that made up the western look in Tang fashion also changed with time, with different aspects of exotic attire prevalent in different eras.

The "Treatise on the Five Elements" in an official dynastic history known as the *New Book of Tang* records that "at the beginning of the Heavenly Treasure reign period [of the Emperor Xuanzong; 742–56], both nobles and commoners loved to wear foreign clothing and foreign hats. Ladies stuck 'step-shaker' hairpins in their hair, and the sleeves of their garments became narrow

Lady wearing a short jacket, long skirt, and high-toed shoes. Drawing after a Tang dynasty painting from Asatana, Turfan, northwestern China. Xinjiang Museum, courtesy of Xinjiang Publications.

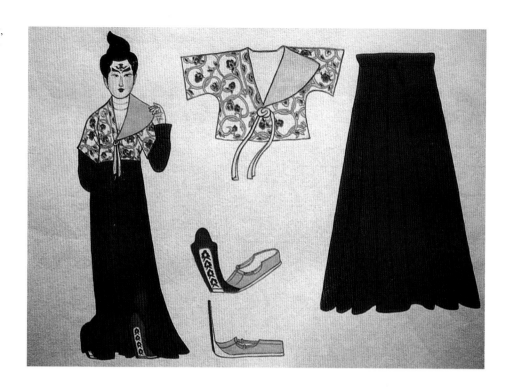

and small." The historian, writing several centuries after the events he was describing, and at a time when the descendants of these foreigners were conquering huge chunks of Chinese territory, considered such sartorial habits ill-omened.[1]

The Tang "foreign look" affected a woman's entire outfit, extending to her garments (cut and style), hat, makeup, hair, and accessories such as shoes, jewelry, and belt. Some lasting elements of western dress for women were short, fitted jackets worn over long, pleated skirts, or tunics over loose trousers gathered at the ankle. Collars were round or crossed, with necklines cut quite low or worn unfastened. Short sleeves, known as "half-sleeves," were popular in the short jackets that were often worn over close-fitting, long-sleeved undershirts. Tight belts emphasized the waistline. Hair pulled off the face and knotted into a tall chignon, perhaps with the help of a wooden frame underneath, and pierced through with an elaborate hairpin, over faces dusted with ruddy powder and dotted with flower-shaped beauty spots were *en vogue*. Turkish boots or shoes with turned-up toes completed the ensemble. The lady in a wall painting from Gaochang at the heart of the Silk Route (fig. 75) and a pottery tomb figure from Turfan exemplify this style in its original western form; another tomb figurine from Chang'an (fig. 76) and the leisurely court ladies painted by Zhou Fang (fig. 74) show that the same style has invaded the capital.

Poetry reveals the intrusion of foreign fashions into the everyday life of the official classes. The eccentric Li Ho (791–817) wrote "Tang Er's Song" for

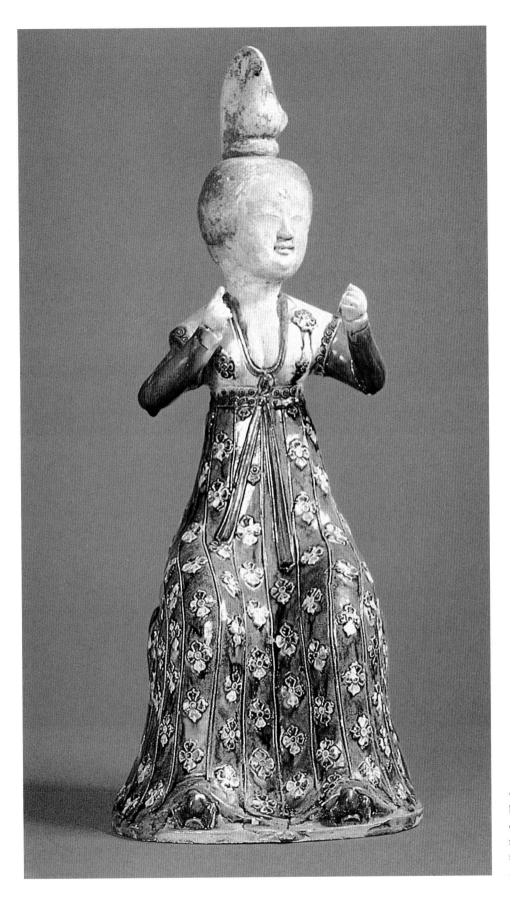

76 Seated woman. Funerary figure in buff ceramic with *sancai* glaze, Tang dynasty. She wears a long-sleeved undershirt, a short-sleeved bodice, and a long skirt. Courtesy of the Shaanxi Provincial Museum, Xi'an.

Tang Er, son of Duke Du Huangtang. The song praises the youth, whose mother was a Tang princess, for his beauty and charm. Li Ho takes for granted and for native the short or literally "half-sleeves," which originally came into China from the West. Describing Tang Er, he writes, "Silver simurghs, glittering and radiant, prance on his short sleeves."[2] The simurgh design, depicting a magical bird similar to a phoenix, also came to China from Persia. Short sleeves appear in women's wear as well (figs. 75 and 76).

Hats were especially vulnerable to foreign invasion. Tang men and women both favored western hats, especially when riding horses. Different types and shapes of hats were imported into China from the many peoples along the Silk Route; admitting foreign styles increased the choices presented to a fashion-conscious person of the capital. Styles in millinery changed over time. According to the "Treatise on Vehicles and Clothing" in the *New Book of Tang*, early Tang equestriennes wore a modest and protective hat with a long veil. After the seventh century, riders replaced this with a "curtain hat," originally part of the riding kit of Turkish nomadic men and women. The veil of the "curtain-hat" was short and sheer, protecting the head from wind and dust, but leaving female wearers open to charges of immodesty. Palace women of the eighth century favored this fashion, and soon everyone was imitating them (fig. 77). Some equestrienne tomb figures from Turfan wear such hats; another is found on a figure from Chang'an. A bit later women abandoned the veil altogether and donned small caps or tall hats of felt (a fabric imported from the nomads) and other materials. A female rider of Tang three-color ware excavated from a tomb in Liquan, in the Chinese heartland, wears just such a fancy tall hat (fig. 78). All these styles from outside China proper were considered inauspicious by the conservative author of the treatise.[3]

Cosmetics, an old art in China, was transformed dramatically under the influence of styles and materials from the Silk Route. As with garments and hats, techniques of making up the face derived from peoples encountered along the trade routes through Central Asia provided Chinese women in faraway cities with new notions of beauty and chic. What the discriminating considered stylish in makeup, like hats, seemed to change every few years.

A poem by Yuan Zhen (779–831), a connoisseur of women's appearance, takes foreign styles of makeup and hair for granted. He describes a solitary woman painstakingly adorning herself for another night alone in "I Regret Completing My Makeup." Arising at the crack of dawn, she carefully organizes her cosmetics, applies layers of powder and blush, arranges her hair in "soft coils that hang down her back and neck," and traces her eyebrows with dark color. For finishing touches,

> She passes a small comb through her full head of hair,
> in the center of her forehead placing a round dot.[4]

The dot, sometimes in the shape of a flower or a lozenge – a species of beauty

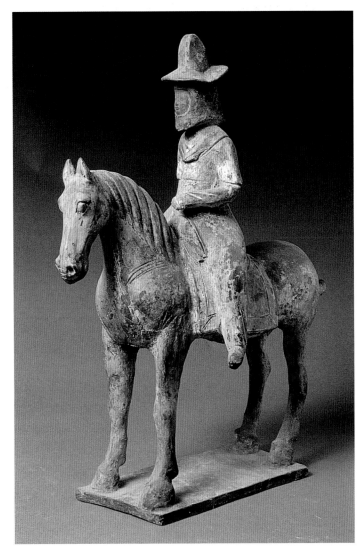 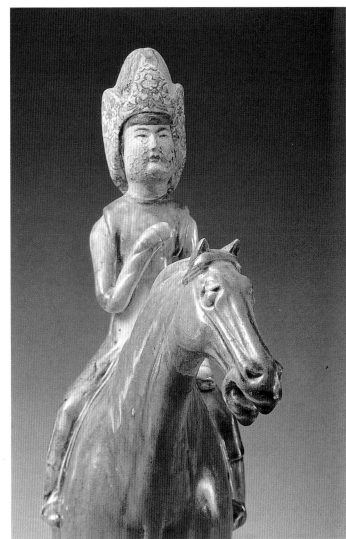

mark – was a favorite Tang imitation of women's styles from the western regions. Tang silk paintings and tomb figurines from Chinese Central Asia, at the westerly end of the portion of the Silk Route under Chinese control (fig. 75), and from the urban heartland (figs. 74 and 76) show similar styles of makeup. Not everyone liked the new styles or approved of them. Conservatives longed for the pure Chinese clothing of the good old days. (Such purity never existed, of course; Chinese clothing was influenced by foreign dress from the earliest times.) Yuan Zhen, writing in a different vein, laments the contemporary passion for all things foreign. He complains that women in the two capitals, Chang'an (an older name for which was Xianyang) and Luoyang, slaves to fashion, imitate women from the exotic occident:

> Ever since foreign horsemen began raising dust and dirt,
> Fur and fleece, rank and rancid, have filled Xianyang and Luoyang.

77 (*above left*) Horsewoman wearing a broad-brimmed hat and veil. Funerary figure in gray ceramic with white slip and pigments, early Tang dynasty. Courtesy of the Schloss Collection, New York.

78 (*above right*) Horsewoman wearing an elaborate high headdress. Funerary figure with *sancai* glaze, Tang dynasty. Excavated from the tomb of Li Zhen of the Tang dynasty (718 C.E.), Liquan County, near Xi'an. Courtesy of the Zhaoling Museum, Shaanxi Province.

Our women are acting like foreigners' wives, studying foreign makeup;
Entertainers present foreign sounds, servants to foreign music![5]

Yuan Zhen's friend, Bo Juyi (772–846), also describes female dress and cosmetics. The two carried on a lively correspondence about traditional Chinese dance and costume, especially when Bo was trying to establish a female ballet troupe in Hangzhou. Bo Juyi's "Styles of the Times" heaves a sigh over fads from the western regions that were overwhelming native Chinese fashions. Foreign styles spread from ladies of the cosmopolitan capital cities to the whole country. Bo finds this new look unattractive, uncultivated, and even frightening. Sounding a little like an American father of the nineties horrified by his teenage daughter's body piercing and spiked hair, Bo Juyi details his conservative critique:

Styles of the times! Styles of the times!
Emerging from urban centers, are transmitted to the four quadrants.
What's popular at the moment does not distinguish far from near;
Cheeks don't show vermilion, faces aren't powdered.
Dark lipstick emphasizes lips, lips seem plastered;
Pairs of eyebrows painted to make a drooping symbol for "eight."
Beauty and ugliness, black and white, lose their basic attitude;
Makeup completely finished, they look as if suppressing a shriek of
 lamentation.
Round haircoils without sidelocks: heaped up chignon-style.
Inclined towards pink, used immoderately: ruddy face powder.
Formerly I heard that hair hanging down the back, along the Yi River,
If you're unfortunate enough to see it, always signifies western tribes.
These fashions and hairdos of the Primal Harmony period [806–821] you
 capture in your record:
Hair in heaps and ruddy faces are not Chinese customs![6]

The "Treatise on the Five Elements" in the *New Book of Tang* describes ninth-century Chinese women copying western models in painting their faces and arranging their coiffures. They sound just like the fashionable ladies described by Yuan Zhen and Bo Juyi. Omitting traditional decorative sidelocks and vermilion face powder, and using dark pigmented ointments to bring out their lips, fashionable ladies' faces looked garish and grief-stricken to those unfamiliar with the latest styles. They piled their hair in buns like the women in Dunhuang, and reddened their faces like women in Turfan. (Dunhuang and Turfan are two important sites along the Silk Route in China's far western regions, where many representations of women in foreign dress have been found.) The historian harshly criticizes these fads, calling them bad omens for the future of the Tang dynasty.[7]

Looking at all these substantial Central Asian women, it is difficult to resist positing foreign influence on the body type that came to be considered ideal

79 Plump, aristocratic woman with a high chignon. Funerary figure, buff pottery with buff glaze, Tang dynasty, mid- to late eighth century. Courtesy of the Schloss Collection, New York.

during the Tang dynasty. The middle Tang period has long been known for its depictions of beautiful large women (figs. 74 and 79). Ideal women portrayed in art and described in literature of the preceding and following periods are much thinner and more delicate looking. Popular tradition explains that the ideal of the big woman, which arises so suddenly in the middle Tang, originates in the appearance of the Emperor Xuanzong's beloved concubine Yang Gueifei, who was rather plump. I wonder if the grand size and powerful appearance of these eighth- and ninth-century women also follows the model of the confident queens of Central Asia. Two Uyghur princesses from a ninth-century wall painting at Bezeklik are a fine example (fig. 80).

Why did the Chinese women of the court and the countryside wear foreign fashion? We can speculate about their motivations. Many members of the official class in the Tang had the wealth to afford luxurious dress and to change styles often. The period is characterized by confidence, curiosity, and a desire

80 Two Uyghur princesses. Mural from Bezeklik, ninth century. Courtesy of the Museum für Indische Kunst, Berlin.

for novelty, all reflected in fascination with foreign cultures and products. Nomadic cultures, with their expert horsemanship, military prowess, and apparently more egalitarian notions of gender, had special prestige. The nomads traded products of advanced metallurgy and textile technologies from nations further to the west, increasing their own reputation for technical prowess and nearly magical abilities. Once the desire to dress in beautiful and constantly changing clothes was present, along with attraction to exotic commodities, the city of Chang'an provided the ideal place for these elements to come together. The Tang capital may have been the world's first true center of international culture, where people of diverse types met and exchanged ideas. In that heady atmosphere, people with surplus wealth and leisure time could select what they wanted from different cultures served up to them "cafeteria style" in the great capital. They could take a little Buddhist philosophy from India, a little math from the Arabs, and fashion from all along the Silk Route. Many aspects of this international culture, which today we might characterize as the global village, were available only to the elite.

Fashion is a supreme example of the global village for the elite at work. The mechanism of borrowing is basic to fashion. Tang fashion, like that of today, absorbed influences from all over, especially from exotic outsiders or the popular culture of the lower classes, transformed it, and created a commodity. People buy this commodity and it catches on, becoming fashionable. The film *Unzipped* shows a recent example of this process. The film follows designer Isaac Mizrahi through one fashion cycle during which he imagines basing a whole season's designs on the Eskimo costumes in the movie *Nanook of the North*, then executes his own vision of those styles in modern fabrics and colors, and finally puts on a successful runway show with supermodels. Some mechanism like this was operating in Tang Chang'an as foreign styles were imported, transformed, and recreated as novel and expensive commodities. Once the court ladies of the palace wore the latest style, ordinary housewives and servants would make or buy cheaper knock-offs. Then the whole cycle would start again.

But the hunger of fashion for new raw material to exploit and the prestige of western cultures in medieval Chang'an are not the only attractions operating here. Foreign styles also appealed to Tang people because they allowed their wearers to bypass strict codes of gender and class that were applied to clothes in the Chinese tradition.

Like everything else in Chinese social life, dress was regulated. Clothing regulations were very ancient, growing out of a set of values called "Confucian" that are central to traditional Chinese civilization. These ideas are codified in ancient canonical texts known as the Five Classics. (Among the Five Classics, the *Record of the Rites* actually contains clothing regulations.) Confucian values revolve around obsessions with family and bureaucracy that form part of the oldest core of Chinese culture. The family was patriarchal, the bureaucracy organized and hierarchical. Ritual, the activity that separated

humans from animals, and Chinese from foreigners, regulated and defined all human relations and activities. Confucian teachings emphasized filial piety within the family and loyalty to the state. Women showed filial piety and loyalty by obeying their husbands and by producing sons for their husband's lineage and for service to the state. Chinese women remained legal minors all their lives, taking their social class and identity first from their fathers, then from their husbands, and finally from their sons. Separate rites governed men and women. Rites expressed a woman's place in her family and class. Ritual regulations, and sometimes even laws, restricted women's clothing and lives in ancient China.

Dress continued to be regulated during the Tang dynasty. Ideas from the *Record of Rites*, adapted to changing times, appear in the essays on dress in successive dynastic histories. The "Treatise on Vehicles and Clothing" in each of the two official histories of the Tang set forth detailed regulations concerning menswear appropriate for various occasions: public or private, court or ritual, formal or informal. Social class and official position also played an important part in clothing laws. Designs, fabrics, and colors were all restricted. The finest silk weaves, for example, were restricted to the upper classes. In medieval Chinese poetry, "cotton-clad" means a commoner. Men's clothing regulations reflect a society that is stratified and bureaucratic. The same restrictions applied to women's clothing. In addition, her clothes reflected a woman's marital status and family position. Contemporaries could identify each other by what they wore. Clothes made the woman, or at least indicated her wealth, class, and marital status. For example, in Tang poetry, a "green-clothes" is an unmarried servant girl. She is what she wears: an anonymous Chinese working woman. (In contrast, goddesses in Tang poetry might wear gowns cut from trailing clouds of dawn.)

Not all Tang ladies were happy with this regulated state of affairs. An angry poem by the Daoist priestess and courtesan Yu Xuanji (844–68) shows that she identifies herself with her clothes, and her clothing with the restrictions placed on women during her lifetime. She wrote a short piece commemorating her visit to a Daoist temple in the company of a group of young men who had just passed the imperial examination, an achievement that would open the doors of fine official careers for them. As she watches them, one by one, inscribe their names on a tablet celebrating their success in an exam she could never take despite her prodigious talents, she vents her feelings on her clothes:

> Involuntarily, I resent the netted-gauze silk robes that hide my lines of
> poetry;
> Lifting my head, vainly I envy the names on the list.[8]

Her beautiful garments remind her of gender restrictions which exclude and silence her. She expresses her rage over the opportunities she can never have in useless anger at her beautiful clothes. (For netted-gauze silk clothes, see fig. 74.)

81 Drawings of serving women in men's attire from stone relief carvings in the tomb of Tang Princess Yongtai (706 C.E.), Qian County, Shaanxi Province. Qianling Museum, courtesy of the Shaanxi Provincial Museum.

Despite strict regulations of dress outlined in official histories, expected in society, and resented by Yu Xuanji, foreign styles entered Tang China and became part of the mainstream. Western clothes profoundly altered Chinese dress. After the Tang, styles that originated in the west became accepted as "Chinese." Both men and women wore these clothes at first for activities like horseback riding that were not particularly Chinese and so escaped the restrictions of the *Record of Rites* and its many descendants. Later they may have been worn specifically to evade, at least in imagination, the ritualization and constrictions of every day life. Fashions from the western regions may have become signs of freedom from ritual and social constraint.

Women in Tang art sometimes wear foreign men's as well as women's clothing. Murals in the tombs of a Tang prince and princess from the early eighth century just outside Chang'an show how central this image had become (figs. 81 and 82). Tomb figures show women in foreign men's clothing engaged in nontraditional activities such as riding horses and playing polo (fig. 73). Like the teenage girl Mulan of the Han dynasty, China's most famous transvestite, who donned a man's armor and pulled her hair up in a topknot to go to war, Tang women may have worn men's clothing to do men's work. Both Central Asian men and women are shown wearing tunics and trousers; both are also shown wearing long robes and jewelry. Perhaps in some cultures activity more than gender determined dress. At first Tang women might have put on "masculine" trousers and tunics for functional reasons of comfort and convenience. Later they may have seen cross-dressing as an escape from limitations of their gender role.

Women in men's clothing are often seen in art, but rarely mentioned in texts; the relative lack of textual reference may be due to the fact that what was remarkable to a medieval Chinese observer about a woman in foreign male dress was the outlandishness of her clothes, not her cross-dressing. The important boundary between categories she transgressed was Chinese vs. foreigner, not woman vs. man.

One reference to women wearing foreign men's attire occurs in the "Treatise on the Vehicles and Clothing" in the *New Book of Tang*. The historian reports that "after the reign of the emperor Zhongzong [705–07], when palace women went out riding . . . there were those who dressed in men's clothing and wore boots like the attire of the Khitan or Xi people [tribespeople skilled at handling horses who lived on China's northwestern frontiers]."[9] The fact that they are transvestites bothers the historian less than the fact that they are wearing the outfits of China's traditional nomadic enemies. Like some of the poets cited above, the historian Ouyang Xiu is critical of these foreign fads. He goes a step further, fearing that women dressed in foreign boots reveal something rotten at the heart of the Tang that will lead to future collapse.

An intriguing and enigmatic image of a male and female figure in nearly identical dress appears over and over again in the art of Turfan. The subject

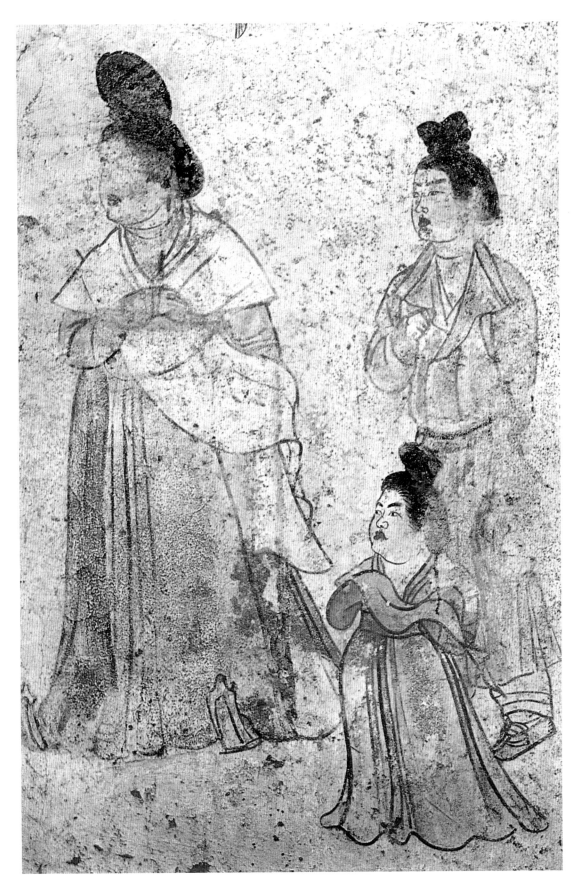

82 Aristocratic woman and attendants, including one woman in male clothing and one female dwarf. Mural from the tomb of Li Xian, Prince Zhanghuai of the Tang dynasty (706 C.E.), Qian County, Shaanxi Province. Qianling Museum, courtesy of the Shaanxi Provincial Museum.

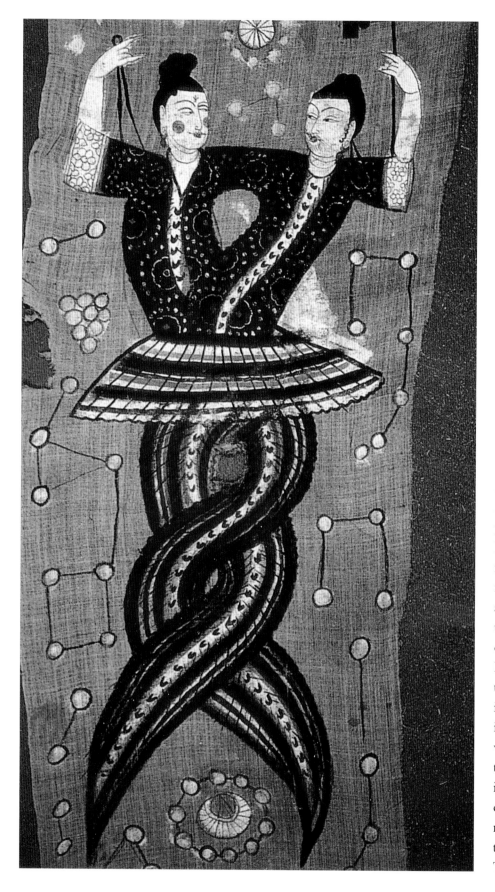

depicted is the brother–sister, husband–wife primal creator and culture hero pair: Fuxi and Nüwa. The god and goddess look like humans from the waist up and like intertwined snakes from the waist down. This subject was found in tomb carvings in the heartland of China during the Han dynasty, and Fuxi and Nüwa are mentioned in several cosmological texts from that time; the closely similar appearance of the two figures, and their intertwined tails, seem in that context to symbolize the balance of *yin* and *yang* forces needed to maintain cosmic harmony.[10] The motif disappears from the archaeological record for a few centuries, and then is found again during the Tang dynasty at Turfan and only at Turfan. In a funeral banner (fig. 83), the male and female figures are dressed virtually identically, and are distinguished mainly by their facial features and attributes. This image is rich with possible meanings, but so far no texts have testified to an accurate reading of its significance for contemporaries. It may suggest a happy, companionable, and sexually fulfilling marriage. It is tempting to speculate that this image of intertwined deities combines the Han dynasty concept of completeness through androgyny with some sort of image of equality and companionship in relationships between men and women. The image, as it appears in the Turfan materials, never reappeared in the center of China, but some echo of its equal treatment of *yin* and *yang* may be part of the statement made by the cross-dressing women of the Tang.

Conclusions

This chapter merely scratches the surface of a fascinating topic with implications concerning several aspects of Tang culture. It raises more questions than it answers, and ignores important distinctions such as the frequent changes in both Chinese and foreign styles during the period, as well as differences in dress and society among the different groups of people living along the Silk Route. It also slights the crucial question of class distinctions. But we have seen how foreign fashions fit into the general process of foreign influence during the Tang dynasty. Foreign material culture provided inspiration for the ever-changing fashions of the Tang. Tang culture was open to outside influence as never before. People were confident, curious, and hungry for change. Chang'an, with its diverse population, was perhaps the first truly international city in the world. The combination of Chinese and western elements that was Tang women's fashion itself became an international style, traveling to Korea and Japan. Examples are preserved today in the Shōsoin imperial treasury in Nara, Japan. The wealth of Chinese urban centers, derived in part from trade and conquest along the same Silk Route, provided elite Chinese with the means to buy the new styles and to keep buying them as they changed. Despite criticism from conservative thinkers and regulations imposed by the government, people still wanted to wear foreign fashions. These clothes had the appeal of the exotic, the other, the strange, and the somewhat dangerous. They were original and luxurious. And they implied, even if they could not grant, freedom from restrictions.

83 The cosmogonic brother-and-sister deities Fuxi and Nüwa, wearing nearly identical tight-fitting, short-sleeved jackets and sharing a single pleated skirt. Funerary banner, color on silk, Tang dynasty. Excavated at Asatana, Turfan. Xinjiang Museum, courtesy of Xinjiang Publications.

Chapter 6

Military Culture and Chinese Dress in the Early Twentieth Century

ANTONIA FINNANE

CHINESE CULTURE IS OFTEN THOUGHT OF as favoring literary over martial skills – hence the saying "good iron is not beaten into nails; good men are not made into soldiers." But during the Cultural Revolution the army had extraordinary prestige in the eyes of young Chinese. Every red-hearted youth wanted to become a soldier and military uniform was the height of fashion, perhaps especially among young women. Few owned real uniforms, but home-made facsimiles that looked more or less authentic abounded. Great care was taken with the choice of cloth, for while the color scheme was restricted, getting just the right shade of blue or green was critical to the overall effect. Close attention was paid to other sartorial details: the overcoat was ideally a skirt coat, nipped in at the waist; and the trousers had to be full and long, the same width at thigh and calf.[1]

Dressed thus, a young woman could deport herself with considerable self-assurance. She personified the fulfillment of Mao's early hopes to rid Chinese women of the skirts and jewels that symbolized their enslavement; hopes that he had aimed, even in 1919, to realize through the creation of a women's revolutionary army.[2] Half a century later, the entire population of China looked more or less like an army (see fig. 32 above). During the Cultural Revolution more clearly than at any other time in the twentieth century, the militarization of Chinese society was visible in what people wore.

This was the final, overblown manifestation of the relationship between military culture and Chinese civilian dress in the twentieth century. The modification of indigenous dress – which finally led to its disappearance – began in the opening years of the century. Already in the first decade, which was simultaneously the last of Manchu rule, the imprint of militarism on Chinese clothes can be observed. There was at this time no sharp rupture in civilian wear, but rather a steady undermining of established vestimentary codes as the once despised figure of the soldier gained in social prestige and political importance. In this first decade, the ground was laid for an association between military culture and Chinese dress which was periodically to be reaffirmed over the following decades.

What was chic in China at the turn of the century? In a country burdened by debt and staggering from one political crisis to the next, this might seem a

84 Girls wield dumbbells and boys provide the beat in this late Qing woodblock print of a school engaged in the project of national "self-strengthening." The text urges people to buy the print, stick it up on the wall, and discuss it with the whole family in the interests of strengthening the nation. The boys' uniforms are comparable to those of the pupils shown in fig. 86, but the figured cloth worn by most of those in the foreground – including the most prominent girl student – show the prestige still attached to rich fabrics. Plain fabrics gained in popularity in the early twentieth century, especially for everyday wear. From Wang Shucun, Li Fuqing, and Liu Baoshan, eds., *Sulian cang Zhongguo minjian nianhua zhenpin ji* [A compilation of rare Chinese popular New Year prints held in Soviet collections], fig. 199.

matter of small importance, but dress in fact had a part to play in the making of the new China. "Clothes maketh the man," goes the English aphorism, and Chinese manhood was at issue in the multifaceted struggle over national sovereignty in the late Qing dynasty. The defeat of the Chinese armed forces in a succession of battles from the Opium War onward had raised questions about the source of national weakness, and one of the prescribed cures was to reform Chinese dress.

Dress had an established political significance in Qing China. In the middle of the seventeenth century, as seen in chapter 1 above, Chinese men had been forced to alter their hairstyles and dress as a sign of allegiance to the new Manchu rulers. When the country was again under threat in the nineteenth century, what people in China wore inevitably assumed fresh importance. In 1892 abandonment of existing forms of dress in their entirety was urged by one reformist scholar, who argued that "if we wish to alter the bureaucracy, establish a parliament and reform the examination system, we must begin by changing to western dress."[3]

Japan set the example. Its emperor and armies were now to be seen in European-style military uniform, and its citizens – or some of them – in Victorian dress. After China's defeat by Japan in the war of 1894, the pressures for wide-ranging institutional reforms in China intensified. The scholar-official Kang Youwei, who inspired the failed reform movement of 1898, never abandoned his own scholarly robe but he did articulate a relationship between dress and politics: "At the present time the myriad nations are all in communication and are as one moving towards veneration for oneness. It is just in our country that clothes are different, so that sentiments cannot be close and friendly relations between nations cannot be achieved."[4] Kang Youwei embraced an ideal of universal civilization, in which the many nations would be as one, but the modification of Qing dress styles was finally prompted by the opposite imperative: the need to defend the particular nation of China. It was fitting that the first large-scale vestimentary changes should occur in the military domain.

Efforts to reform China's governmental institutions were renewed in 1901, and entailed the reorganization of the armed forces. In 1904 the so-called "New Army" emerged, composed of soldiers who, like their Japanese counterparts, were drilled according to German practice and dressed in German-style uniforms. The loose trousers of infantrymen were replaced by narrow-legged pants tailored in the western style. The loose jacket was supplanted by a body-fitting coat. The cone-shaped hats with their red tassels gave way to peaked caps. For officers, the change was even more marked: their adoption of dress uniform in the European style meant a radical departure from the generous, concealing robes of the Chinese gentry class, to which they belonged. The entire undertaking signified the manifestation of a streamlined, efficient body that matched the modern arms with which – when they were available – the soldiers were equipped (fig. 85).

The reforms in military dress were neither universal nor irrevocable: a conservative official might demand a reversion to indigenous dress codes, as happened in 1907 when the minister of war demanded that officers of the division he was inspecting wear Chinese robes.[5] Nonetheless, the effects were widespread and lasting. Reforms in military uniform precipitated a long-term secular change in Chinese dress, which altered beyond recognition over the course of the century. In the short term, these reforms destabilized established forms of dress and had both direct and lateral influences on new styles emerging in the years leading up to the 1911 Revolution.

The changes in military uniform meant that the defensive "self-strengthening" strategy adopted by late Qing reformers was extended into the domain of Chinese culture. The "essence" [*ti*] of China had hitherto been strategically separated from the purely useful or technological aspects of reform [*yong*], such as development of modern armaments and industry. Conservative reformers had fondly imagined that modern cannon, steamships, trains, and industrial machinery could simply be tacked on to Chinese culture as they knew it. In terms of dress, this strategy was encapsulated in the figure of the old-style soldier carrying an imported gun, perhaps even of a young woman in conventional dress riding a bicycle.

85 Military uniform in transition, *c.*1904. Officers in the foreground are wearing the customary robes and cone-shaped hats of the Qing military; the cavalry in serried ranks behind are in western-style uniform, but their headwear appears to be the boater rather than the peaked cap commonly associated with New Army troops. From Wan Renyuan, ed., *Yuan Shikai yu Beiyang junga* [Yuan Shikai and the Beiyang militarists] (Hong Kong: The Commercial Press, 1994), p. 37.

The inevitable linkage between the essential and the useful became apparent in the new century, when the reform of the armed forces proceeded arm in arm with reforms in the education system, with concomitant changes in the dress of students. Education, the acquisition of literacy, was central to the Chinese idea of the formation of the mature (male) adult. In China it was said "esteem *wen* [literary skills]; make light of *wu* [martial skills]." But educational reform in late Qing China entailed military training. Reform proposals of 1901 included the suggestion that primary-school boys were to be trained in calisthenics and middle-school boys in military calisthenics; there was to be a military drill ground in every school.[6]

These criteria eventually entailed changes in the dress of pupils attending the new-style schools. In place of the long robe of the Manchu era, male students began to don trousers and jacket, a form of dress that generically had been associated mostly with the peasantry or the uneducated rank and file of the old-style armies.[7] Straw boaters replaced the traditional round cap (fig. 86). School uniforms were often modeled directly on military uniforms, and commercial suppliers of military uniforms also touted for custom among schools.[8] Again, the changes in dress were not universal through the system, with different classes even in the same school showing variation between Chinese and western-style dress.[9] But three interrelated dichotomies central to shifts in dress styles were now in place, involving tensions between Chinese and western, backward and modern, civil and military respectively.

Militarism noticeably intensified after 1905, a significant turning-point in

86 Pupils in a Beijing school in the late Qing, ready to mark time to drum and bugle. The short jacket and trousers marked a departure from the customary long robe, and was influenced by military dress styles. Note the peaked cap of the senior student on the far right, no doubt a mark of his elevation in rank above the boatered boys who form the rank and file. From Wan Renyuan, ed., *Yuan Shikai yu Beiyang junfa* [Yuan Shikai and the Beiyang militarists] (Hong Kong: The Commercial Press, 1994), p. 34.

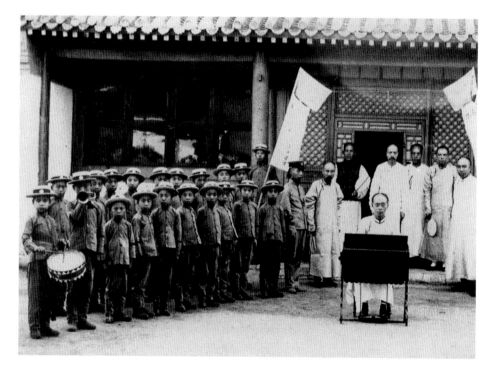

Chinese history. This was the year in which Japan defeated Russia in a short war conducted over control of Manchuria and the Korean peninsula, and also the year of a failed revolution in Russia. Both events attracted attention in China, the former because it illustrated the potential of an Asian power to gain ascendancy over a European one; the latter because it demonstrated the possibility of popular revolt against imperial rule. Both served to heighten the prestige of the martial ideal. In 1906 "everyone," according to the military attaché at the French embassy in China, wanted to don military uniform and undertake military drill.[10]

In 1905, also, the old examination system which had served as the pathway to bureaucratic office was abandoned. The resulting vacuum in the education system was partially filled by new military schools, so popular that they were forced to turn away thousands of disappointed applicants. In 1909 new education regulations promulgated by the Qing dynasty explicitly promoted an ideal of military citizenship – *junguomin zhuyi*.[11] And by 1911, George "Chinese" Morrison was able to note that "there is a steady growth of military spirit, a steady uplifting of the profession of arms. Sons of high Chinese Princes and officials are proud to hold commissions and swagger about in uniform."[12]

Under these circumstances, a man could feel some satisfaction in appearing in military dress. Li Zongren entered the Military Elementary School in Guangxi in 1908, and later recalled his uniform with some pride:

> One of our uniforms was made of very fine quality wool and the others of ordinary wool. Each of us was also provided with a woolen overcoat . . . Although dressed in modern uniforms and leather shoes, most of us still wore our long queues, an incongruity that was considered handsome in those days [fig. 87].[13]

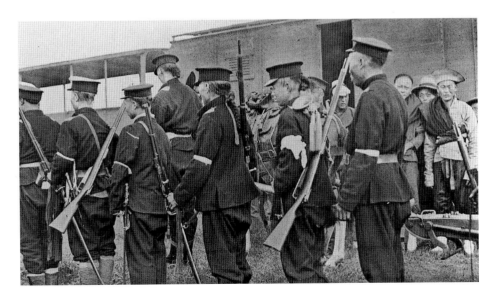

87 Soldiers off to battle for the Republic in 1911 still had queues, sometimes worn tucked up under their cap. Civilian observers in the background show the variety of hats worn in the late Qing, western styles included. From J. O. P. Bland, *Recent Events and Present Policies in China* (London: William Heinemann, 1912), facing p. 352.

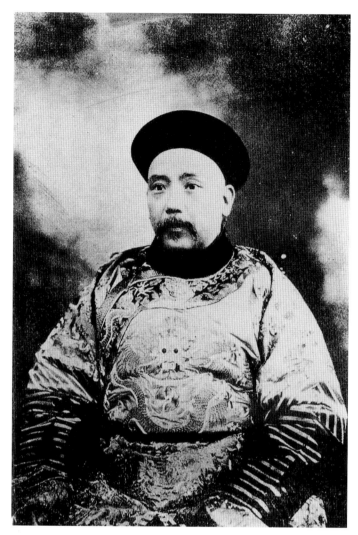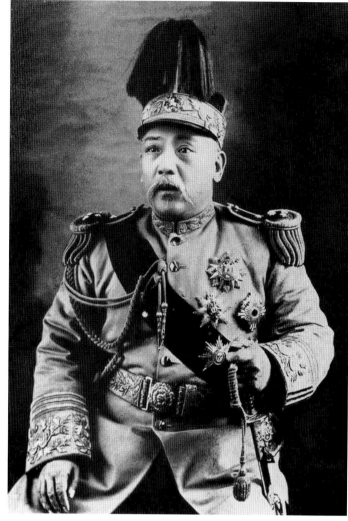

88a and b Yuan Shikai in Qing ceremonial dress as Governor-General of Zhili and high commissioner of military and foreign affairs in north China, *c.*1901 (a), and in dress uniform as President of the Republic (b). Western observers occasionally made derogatory comments about the elaborate style of dress worn by Chinese men of the elite classes, but the military regalia of the Western powers rivalled that of China for decorative effect. From Wan Renyuan, ed., *Yuan Shikai yu Beiyang junfa* [Yuan Shikai and the Beiyang militarists], (Hong Kong: The Commercial Press, 1994), p. 36; and James W. Bashford, *China: An Interpretation* (New York: The Abingdon Press, 1916), facing p. 450.

Circumstances had changed since Yuan Shikai, the most redoubtable of the late Qing military leaders, felt more comfortable portrayed as a civil than as a military official. As President of the new Republic of China, Yuan donned military attire which gave sartorial substance to comparisons later made between him and Bismarck (figs. 88a and b).

Under the Qing, the changes in military and school uniforms were the most visible, the best documented, and also the only changes to be sanctioned by the imperial government. But parallel to these changes were modifications in civilian wear. Sun Fuyuan, born in 1894, remembered clearly the dress of his boyhood years:

The young man of that time was done up in many coloured splendour: a robe of almond yellow Huzhou crepe, a jacket of sky-blue Nanjing silk; a sash of snow-coloured Hangzhou silk; shoes with whited soles, embossed with flowers and clouds green as sunflowers or red as dates; what with

trousers, ankle straps, paper fan, spectacles cord, little melon-skin hat topped with a precious stone – looked at with modern eyes, one wonders what he was on about! Of course I mention these colours and materials haphazardly, but I think they were common, not exceptional. And if a young man dressed like this, even more so was it the case for a young woman.

But from 1900 things began to change: "In the ten years between the turn of the century and the year of the revolution, the clothing worn by the young bit by bit changed from red and green to black and white. Starting with the top of the head, the use of oil gradually became less frequent . . ."

Hairdress became simpler: tassels disappeared from the end of pigtails, until finally the pigtails themselves began to disappear. Dress became more sober. The white soled embroidered cloth shoes gave way to brown leather shoes, where they could be afforded.[14] These changes are readily confirmed by references to photographs of the time. Among officials, the predominance of the white robe and black or dark colored jacket is especially evident.

These subtle changes in civilian dress bespeak the militarization of Chinese society in the late Qing as clearly as the radical reforms of military dress. The military ethos demanded a new sort of man and more generally a new sort of citizen: the move towards a relative sobriety of dress – darker colors, narrower cut – was a response to and expression of the nationalist-cum-militarist imperatives of the time. There were sartorial modes of plainly declaring a political position in the late Qing. To cut off one's pigtail or to don a suit meant open rejection of the Manchu dynasty.[15] The modification of established dress forms was more general, and revealed a deeper current affecting the world outlook of people in China, or at least of people in the elite stratum. For these people, the psychological processes of and social strategies for being Chinese were alike under review.

Sheng Cheng, who passed his childhood in the late Qing and his youth in the chaotic years of the early Republic, summarized the cultural significance of the transformation of Chinese dress in the following words:

> Civilized China is a woman with her feet unbound, passing freely in and out of the house. Barbaric China is a woman who keeps to her woman's apartment, nursing her beauty and shaping her feet until they are like lilies of gold. Civilized China is a man with short hair, wearing a grey cap or a black felt hat, going to meetings, singing the song of revolution and crying: "Long live the Republic!" Barbaric China is a man in a pigtail wearing satin slippers, shutting himself up in his Ivory Tower, passing his time in reading the canons of old and kneeling before the shadows of the past.[16]

Sheng Cheng's image of civilized China was a civil rather than a military one, but in 1911 he himself shocked his grandmother by appearing before her in military uniform: it was as a soldier that he personally ushered in the new era.

92 (*facing page top*) The daughters of the Chinese Ambassador to Great Britain, wearing the stright tunics and tousers which were popular wear for adolescent girls in the last years of the Qing. A decade earlier the feet of girls of this age would have been bound and a shirt would have been worn over the trousers, especially for a photograph or any formal occasion. In this stratum of society, only small girls wore trousers without a skirt (cf. fig. 89). The very high collars seen in this photo became a feature of Chinese fashion around 1908 and remained in vogue for at least ten years. From *Lady's Realm* (May 1911). Collection Laruelle, tome 81, Ne 63 Fo 1, Bibliothèque Nationale, Paris.

The slouch cap which became popular around the time of the 1911 Revolution was arguably appropriate to the man in mufti, ready to take up arms in defense of the Republic.

The nexus between the rise in militarism and the changes in civilian dress is even clearer in the case of women's dress. In the first decade of the twentieth

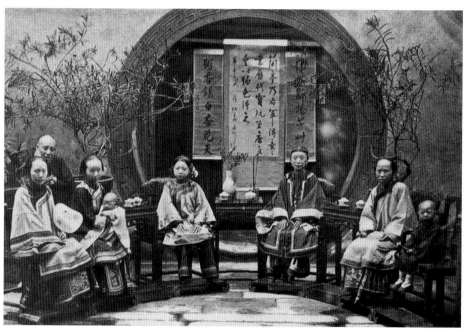

89 and 90 Family photos from the late Qing period. The generous cut and neat neckbands of nineteenth-century dress, shown in the portrait of an unidentified Sichuanese family (*top*) gave way during the first decade of the twentieth century to the narrow cut and clearly defined collars of robes and tunics worn by the children of future premier Tang Shaoyi (1860–1938) (*bottom*). It is possible that these photos were nearly contemporaneous, with the Sichuanese family still wearing dress in the old style. From William Elliot Griffis, *China's Story in Myth, Legend, Art and Annals* (London: Constable and Co., 1911), facing p. 190; and J. O. P. Bland, *Recent Events and Present Policies in China* (London: William Heinemann, 1912), facing p. 204.

century a very intriguing development was taking place in Chinese women's fashions. The commodious cut of clothes worn by women until very late in the nineteenth century was suddenly abandoned and close-fitting styles of dress came into vogue. Jackets were fitted tightly to the body and in the second half of the decade collars became exceedingly high (figs. 90 and 92). The narrow cut was attributed by the revolutionary Jin Tianhe to western influence, of which she did not approve, but these changes did not in fact involve the European fashion of "compressing the waist and protruding the bosom" – on which Jin also looked askance.[17] They resulted rather in the presentation of a trim, streamlined figure: the breasts were undoubtedly flattened by a breast cloth, and continued to be so until the anti-breast-binding movement, the introduction of the brassiere and the rise of the qipao during the Nanjing decade (1927–37). Skirts and headpieces continued to define women's dress as gender specific, but especially where skirts were not worn the female figure thus presented was very boyish (fig. 92).

In these same years new social roles were being envisaged for Chinese women. Unlike their menfolk, Manchu and Han (ethnically Chinese) women in Qing China had continued to be differentiated from each other by dress; hence the saying, often cited with reference to dress practices in the Qing, "the old submit, not the young; the men submit, not the women; the living submit, not the dead."[18] Towards the end of the dynasty, as the court moved toward dismantling distinctions between Manchu and Han, there was some blurring of vestimentary codes used by these two groups (fig. 91), but essentially, skirt,

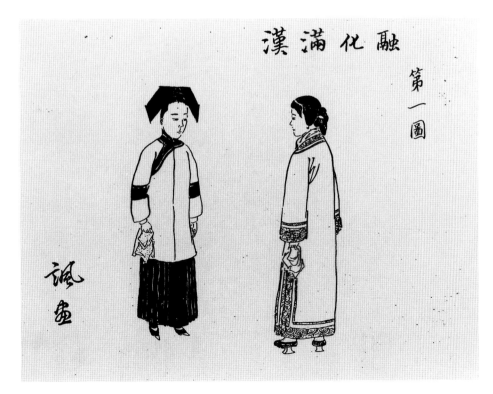

91 Cartoon commenting simultaneously on politics and vestimentary codes in the last years of the Qing. The caption reads "The Blending of Manchu and Han." The Chinese (Han) woman, right, is depicted wearing Manchu robe and shoes. The Manchu woman, identifiable by her distinctive headdress, is wearing the tunic and pleated skirt of a Chinese woman, and her feet are bound. From *Shishi huabao* [Current affairs pictorial] (Canton), 8 August 1907, no. 9, p. 179.

trousers, and jacket continued to provide the basic elements of Han women's dress, while Manchu women wore a long robe.

In the late nineteenth century the position of women in Chinese society, long regarded by western observers as a sign of China's backwardness, was coming under the scrutiny of Chinese reformers. Campaigns were mounted to educate Chinese women and unbind their feet, on the grounds that half the country's population was unproductive, and that strong, educated women were needed to mother a strong generation, capable of curing China of its current malaise. In girls' schools the students wore boaters and leather shoes and ran races for the good of the nation. Woodblock prints, bought by every family to paste up on doorways and within the house to celebrate the new year, served to popularize new images of Chinese women. Girl students practicing calisthenics, girls riding bicycles, and finally girls in, albeit bizarre, military uniform, practicing military drill, were all portrayed in this popular art form. (figs. 84, 93 and 94).[19] In 1911, the time of the revolution, women in formal military dress could be seen in Shanghai, where an Amazon corps had been founded in the service of the revolution (fig. 95).

Military uniform did not become common dress for women any more than it did for male civilians, but one feature of both men and women's dress encapsulates the relationship between the civil and military dress. This was the

93 (below left) "Modern girl on bicycle" – a late Qing woodblock print from the town of Mianju, in the western province of Sichuan, where the sight of a girl on a bicycle was undoubtedly rare. Flowers, butterflies, and fan in association with the female figure were conventional elements in this type of print, but the bicycle and the strong impression of mobility were new to the representation of women in this popular art form. From Lü Shengzhong, ed., *Zhongguo minjian muke banhua* [Chinese popular woodblock prints], (Changsha: Hunan meishu chubanshe, 1900), p. 178.

Deux femmes capitaines d'infanterie en costume, aux côtés d'une Chinoise restée attachée aux anciennes coutumes.

high or so-called mandarin collar, which finally became a signifying feature of Chinese dress. The genealogy of the collar in Chinese clothing remains obscure, but it was not a common feature of costume before the twentieth century. The robes and jackets of the Ming and Qing periods were round necked, occasionally sporting a neck band, rarely anything more. An impression of collars may be gained from portraiture and photographs, but it is likely that this is because of the use of a separate piece of cloth or fur, used like an abbreviated scarf for warmth in the winter months.

By the beginning of the Republican period, however, the collar had become an established element in Chinese dress. For women, it was the defining feature

of the long jacket which they wore over either skirt or trousers, and it remained so through the first few years of the Republic. There are few contemporary commentaries on women's fashions from the early twentieth century but graphic representations suggest that the rise and rise of the collar can be dated to the years following 1905, or in other words to the years in which the military schools were gaining increased popularity and men in uniform were coming to exemplify the height of fashion. Collars in civilian wear resonate with the high-collared uniforms of the recruits to the new style military and police forces. Atop the close-fitting jacket of a Chinese woman, the high collar undoubtedly declared the wearer's sympathy with her times.

When the Qing dynasty fell in 1911, confusion reigned in the world of Chinese fashion. A journalist on the Shanghai daily *Shenbao* reported bemusedly in 1912 that "Chinese are wearing foreign clothes, while foreigners wear Chinese clothes, men are adorned like women and women like men, prostitutes imitate girl students, and girl students look like prostitutes."[20] The vestimentary regime of the early Republic was indeed rather unstable, a state of affairs entirely attributable to the cultural and political uncertainties of the period. Sun Yat-sen, the "Father of the Nation," wore these uncertainties on his back, changing from western suit to Chinese robe and back again, and even coming up with a style of his own – the Sun Yat-sen suit. Although Sun is one of the few prominent leaders in twentieth-century China not to be associated with military exploits, the sustained significance of the military figure in the early Republic is apparent from his wardrobe. When he arrived in Nanjing to a triumphant welcome on January 1, 1912, he was clad in khaki;[21] and in 1917, as head of the military government in Canton, he rivaled Yuan Shikai in

96a–c Sun Yat-sen in (a) a lounge suit, which he wore as revolutionary-in-exile during the late Qing; (b) in khaki, which he donned as provisional President of the Republic in 1912; and (c) in full military dress as head of the breakaway military government in Canton in 1917. After the failed experiment of 1917 he was most commonly to be seen either in the Sun Yat-sen suit or in a long robe. The Sun Yat-sen suit was modelled on military dress, the jacket looking much like that of the khaki uniform in which he is pictured here, except that the collar is turned down. The high collar of his 1912 uniform points to military inspiration for comparable collars in civilian wear in the same period. From J. O. P. Bland, *Recent Events and Present Policies in China* (London: William Heinemann, 1912), facing p. 54; and Frederick McCormick, *The Flowery Republic* (London: Murray, 1913), facing p. 258; and Wan Renyuan, ed., *Sun Zhongshan yu guomin geming* [Sun Yat-sen and the Republican Revolution], (Hong Kong: The Commercial Press, 1994), p. 47.

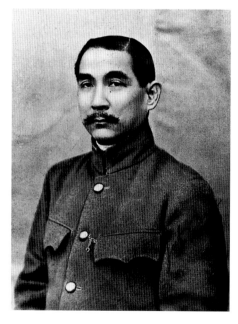
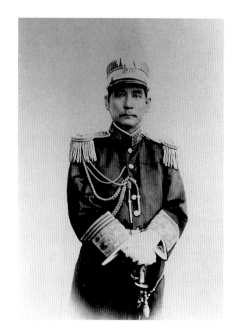

Prussian splendor. The Sun Yat-sen suit, which became *de rigueur* for young revolutionaries about town in the 1920s, was itself inspired by military uniform (figs. 96a–c).

The relationship between military culture and Chinese dress observable in the period leading up to the 1911 Revolution was further affirmed in subsequent phases of China's revolutionary history. Like the 1911 Revolution, the Nationalist Revolution of the 1920s was marked by a pronounced change in indigenous dress styles, this time giving rise to the qipao. And the qipao, which in the 1930s and 1940s did sterling service as China's national dress for women, was eventually displaced by the dress of the women's revolutionary army.[22] The green and blue army and naval suits sported by Mao Zedong's teenage fans during the years of the Cultural Revolution were thus not a quixotic or aberrant fashion, but rather a logical product of a process of dress reform which had its origins in new uniforms for the soldiers in the service of the Manchu dynasty.

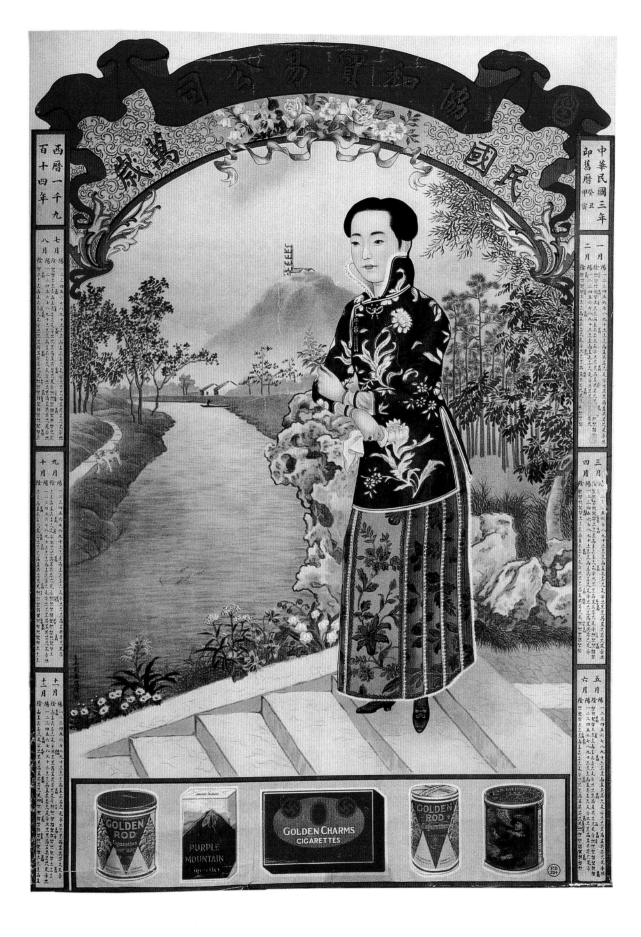

Chapter 7

"A Woman Has So Many Parts to Her Body, Life is Very Hard Indeed"[1]

MARTHA HUANG

IN THE FALL OF 1927 the Chinese writer Lu Xun suggested that in order to avoid controversy, young women students should have "long hair, bound breasts and half-bound feet." He wrote, "I have not heard a single word against this type of woman."[2] When Lu Xun made his list of body parts, he was cataloguing an almost two-decade-long debate over what a New Woman was supposed to be and what she was supposed to look like.

The early Republican period (1911–24) coincided with the emergence of women in the public sphere, and thus marked the beginning of thinking about modern women's fashion in China. Fashion consciousness came out into the open as women came out of the inner chambers. To look for fashion during this period is to look at the intersections of new public spaces: physical spaces like the school campus, the street demonstration, the public park, the boulevard; and new imaginary spaces, including newspapers and periodicals, calendar posters, new fiction, and cinema. Two types of public women emerged as fashion leaders: the woman of style, who could be a socialite, but was more often an entertainer or prostitute; and the girl student. While the woman of style had traditional antecedents and the girl student was a totally new phenomenon, the images of both were manipulated and disseminated by new media technologies like the calendar poster and the periodical press. Both also came to represent what the sociologist George Simmel termed a "desire for destruction"[3] by challenging the accepted order, the first by indulging in the sybaritic decoration of the *demi-monde*, the second by engaging in acts of political and social reform. Interestingly, the silhouettes adopted by both groups were similar, although the woman of style's clothing was marked by a much higher degree of decoration and variation in color.

The clothing of women of style can be seen in the calendar posters of the period and in stills from the very earliest period of Chinese cinema. Styles range from the trouser suits of teahouse entertainers and the delicate skirt and blouse sets of well-to-do women, to the westernized hybrid fashions of the would-be Chinese flapper.[4] When we turn from pictorial sources to the written record, however, we find that the intellectual discourse about fashion concentrated on the girl student, whose character represented the heroic ideals of the modern age, but whose body constituted the ground for intense contestation.

97 Calendar poster for the Xiehe Trading Company, by Zhou Moqiao, 1914. The male model is dressed in a highly decorated blouse and skirt, and western leather high heeled shoes. Private collection.

The transformation of traditional feminine models into the girl student represented not only the remaking of Chinese womanhood but the remaking of Chinese society at large. In the 1915 inaugural issue of *New Youth (Xin Qingnian)* magazine, the most influential intellectual periodical of the period, editor Chen Duxiu called for women's suffrage and observed that the traditional Confucian system crushed women's natural spirit. That same year, *Women's Magazine (Funü zazhi)* was launched, with articles ranging from "On the Undervest and Girls' Physical Education," to "The Ideal Girl Student." Here could be found regular columns on "feminine hygiene" and home economics, including recipes for homemade beauty creams and fabric dye (complete with chemical formulas) and advice for infant and children's hygiene. Many of the authors were female principals of the elementary and secondary girls' schools then opening in and around such coastal cities as Shanghai and Guangzhou. Occasionally work was translated from western sources, such as the piece by the Russian ballerina Anna Pavlova on beauty and exercise which ran early in 1916. The image of the girl student which emerged in this and other magazines was still a relatively conservative one: although educated, she was still focused on child-rearing and nurturing the health and growth of the body politic.

The figure of the girl student became more radicalized when resentment against what was perceived as the unfair treatment of China in the Versailles peace talks ballooned into a series of street protests, labor strikes, and consumer boycotts in the spring of 1919. What became known as the May Fourth Movement marked the starting point of a new reform culture driven by western ideas and Chinese patriotism. In the manifesto he composed for *New Youth* at the end of the year, Chen Duxiu wrote, "We believe that respect for women's character and rights is already a real need for today's social progress, and moreover hope that all women will be thoroughly awakened to their social responsibility."[5] When it came to women's dress, the movement had several major effects. Materially, the upsurge of patriotic feeling and the resultant boycotts of Japanese and other foreign goods meant a retreat from western fashions and a reworking of traditional Chinese style. This could be seen primarily in the shapes – the neckline (the high mandarin collar) and blouse closures (the asymmetrical closing from neck to underarm, and the use of cloth fastenings instead of foreign buttons) – and the return to native-made fabrics. More generally, the May Fourth Movement accelerated changes in the social position of women. One of its most powerful strategies was to encourage women's education, advocating universal coeducation at both the secondary and tertiary levels. Taking women out of the home and educating them was seen as the most effective way of challenging the traditional family system. The girl student was the prototype for the New Woman of China, and came to represent the potential for profound social change and self-liberation, evolving into a major icon of the May Fourth imaginary.

In part, this was because male intellectuals often identified their own personal liberation with the liberation of women. This was a projection that allowed these men, many of whom had themselves been forced into arranged marriages with uneducated women, to call for freedom from family ties without confronting the problem of abandoning their own responsibilities. In any case, the elision resulted in hundreds of essays, stories, and letters devoted to women's issues in the intellectual journals of the 1910s and 1920s, and also helped to explain the vehemence of the conservative response to the new girl student and how she looked. The consequences for women who tried to change their appearance, even into the late 1920s, were not negligible. "These seem to have been unlucky years for the young, especially for the fair sex," observed Lu Xun. "The newspapers described a district where short hair was encouraged; but another army came in, and whenever they found a bobbed-haired woman they would slowly tear out her hair and cut off her breasts." Such extreme reactions, he went on to explain, "prove that whereas it is generally recognized that men may wear their hair short, women may not follow suit. The breasts were cut off to make women look more like men, and to punish them for wanting to look like men."[6] Lu Xun's analysis emphasizes that the dilemma of how to look was inescapable for young women, and that the topic of fashion was closely imbricated with issues of politics and gender.

That said, most intellectual writing about the girl student during this period had to do with education and equal rights between the sexes. The president of Peking University, Cai Yuanpei, for instance, argued in a series of lectures and articles that women, who constituted half the population and were responsible for the health and well-being of the nation's children, were entitled to an education and should be allowed to study on college campuses. The need for women to break away from feudal family structures was also a major theme. *New Youth* ran a translation of Ibsen's *A Doll's House* in March of 1919; and the figure of Nora, who leaves her husband and home to find self-fulfillment, quickly became the symbol of individual liberation for young men and women students alike.

Prompted by such western works, modern Chinese drama and fiction also turned to images of the girl student. *The Greatest Event in Life*, a one-act play written in 1919 by Hu Shi, a leader in literary and political reform, depicts the plight of a young girl student who has fallen in love with a well-to-do returned student. Her parents try to forbid the marriage on the advice of fortune-tellers and clan regulations, but in the end the couple elope. The heroine Yamei is described in the stage directions: "She is twenty-three or twenty-four, dressed for outdoors in an overcoat. Her face has the look of a woman with something on her mind."[7] Hu Shi uses the overcoat as a symbol for Yamei's place outside the home. She arrives from school in her coat to defend her engagement, wraps herself up in it again when she leaves with her fiancé, and the garment's absence is her parent's first indication of her disobedience.

Hu Shi was not specific about what Yamei wore under her overcoat, but in the pages of other stories written in or about the period we can see the standard uniform of the girl student. In the 1919 short story "Going Abroad" by the writer Bing Xin (then a girl student herself), the sister of a young man who returns to China after seven years abroad arrives late from a school basketball game for his homecoming. She enters the room with a basketball in her hands and white canvas shoes with rubber soles on her feet. She wears a white blouse and blue skirt, very plain makeup, and has "a very lively appearance."[8] Chin, the heroine of the novel *Family,* written by Ba Jin in 1931 but set in the early 1920s, begins the story as a third-year student in a provincial girl's school. She appears early on wearing a

> pale blue silk padded jacket and a dark blue skirt. There was a faint dusting of powder on her cheeks; a strand of hair curving down beside each ear flattered the oval configuration of her face. Beneath the neat bangs on her forehead long eyebrows arched over large eyes set on either side of a well-formed nose. Those eyes were exceptionally bright and penetrating: they shone with a warmth that not only added a glow to her enthusiastic vivacious face, but seemed to light up a room the moment she came into it.[9]

In "Regret for the Past," a short story by Lu Xun written in 1925, the protagonist waits for his lover, a girl student, to visit: "The tapping of high heels on the brick pavement, cutting into my long, restless waiting, would galvanize me into life. Then I would see her pale round face dimpling in a smile, her thin white arms, striped cotton blouse and black skirt."[10]

In story after story, the girl student is plainly dressed in a light-colored blouse, collarless or with a mandarin collar and usually with a side closure, and a dark mid-calf skirt of either black or dark blue. Her shoes are modern and in western style, emphasizing her unbound or natural feet. If the girl student's clothing is only lightly sketched, it is because her personality requires little adornment. Her eyes flash, her smile is clear, she is lively, smart, and brave. In contrast, more decorated women do not fare as well. Again, in *Family,* the elderly patriarch is accompanied by his scheming concubine, "a heavily made-up woman who always reeked of perfume and simpered when she talked."[11] In "Two Families," another short story by Bing Xin, the wife of a successful returned student wears an elaborate hairstyle and makes herself up heavily before going out to play mahjong. The housewife appropriates the rhetoric of women's liberation to justify her pleasures outside the home, but in the end her neglect of her children and household leads indirectly to the death of her husband.[12]

Despite these descriptions, to a certain degree modern Chinese intellectuals devoted so little space to fashion because they were suspicious of it. Although Lu Xun was a keen observer of women's fashion, he was ultimately dismissive of its power. In an essay, "What Happens after Nora Leaves Home?" he asked,

98 After graduating from Yanjing University in 1923, the writer Bing Xin spent three years studying in America. In 1924, at Wellesley College, she still felt comfortable in the light blouse, dark skirt, and modern footwear (here, saddle shoes) of the modern Chinese girl student. Photograph courtesy of Bing Xin.

"What has she taken away with her apart from her awakened heart? If she has nothing but a crimson woolen scarf of the kind young ladies are wearing, even if two or three feet wide it will prove completely useless."[13]

In the contrasts writers drew between traditional and modern women in their fiction, the concept of decoration itself emerged as old-fashioned, corrupt, and even destructive. It was no different when they turned directly to the subject of fashion, as essayists. "Women must give up adornment," wrote Hu Huaishen in a 1920 issue of the *Women's Magazine*, "just about everyone knows this." The problem was that it was difficult to do so. Old habits were hard to change, traditional social pressure was too strong, and love of beauty was a natural trait: "Whether male or female, no matter what form . . . one always likes praise from others." Dressing up was no different. Hu suggested that giving up decoration might be easier if women considered its dangers. Decoration wasted time and money, she argued, its practices were unhygienic, obscured natural beauty, and made a woman look cheap. From her list of what constituted adornment, it is possible to see the beauty regimens popular at the time: hair oil, talcum powder, foreign soap, and perfume; as well as the accessories, which included gold and jeweled rings, bracelets, pearls, mercerized cotton belts, fashionable hats and shoes and, for the latest in modernity, a gold watch and gold wire-rimmed glasses. The key strategy, according to the author, was to organize a movement that allowed women to support each other in their quest for plain dressing. Hair could be combed in a bun or braided, but was best cut short. Clothing was to be plain, in solid colors.[14]

In real life, convincing women to give up decoration was difficult. Describing her attempt in 1918 to run a girls' school in the far away northwest province of Qinghai, the young secondary school graduate Deng Chunjin despaired over her students' preoccupation with fine clothing, jewelry, and bound feet. She herself was quite clear about what they should wear. "Why should there be multicolored clothing to catch the attention of others?" Instead, she reasoned, the clothing of girl students "should do no more than cover the body and keep it warm – in two colors, black and white – the white will deflect the sun's rays in the summer and the black will absorb the sun's rays in the winter."[15] Yet a year later Deng had still failed to persuade her students. "Aiya! If they stubbornly cling to ancient ways, I deeply fear that even though we call them daily to class, there will finally come a sad day when schools will no longer be any good to society – Thinking it over, it is impossible not to break out into a sweat."[16]

Other writers took the anti-adornment strategy even further. Instead of simplifying women's clothing, some suggested that it might be better to do away with it altogether. In his 1920 essay, "Women's Dress," the writer Xu Dishan asserted that, "if women want to be active in new society, they must first reform their clothing."[17] Xu was extremely utilitarian in his analyses: current women's fashion, he argued, was still dominated by what he termed

99 Miss Yao Chin Chu with bobbed hair and wearing a blouse with a very high collar, *c*.1920–25. Courtesy of Dora Wong.

100 Girl student in a man's long scholar's gown *c.*1921. For women to wear men's clothing in the early 1920s was a political act, but it was also a turning point in the evolution of the ultra-feminine cheongsam. Illustration by Zhang Ailing for *XXth Century*, 1943.

"primitive" styles. Skirts were pre-evolutionary remnants from a time when men had not yet learned to sew trousers; jewelry, whether pierced earrings, bracelets, or anklets, were slave accessories, symbols of "eternal servitude;" and long hair only evolved, Xu hypothesized, as a necessary cushion for carrying things on the head. "The making of hair ornaments probably came afterward," he wrote,

> the types of hair ornaments are extremely varied, and came about after women became the dependents of men and had nothing to do at home but spend a lot of time adorning themselves. Various forms of tying buns and braids are all the result of an unstimulating life. Today many girls who love dressing up spend most of the day on their hair, is this not because they have too much free time?[18]

Like other writers on the subject, Xu argued that traditional women's dress was too unhealthy: "Bound feet, corseted waists, bound breasts and pierced ears are naturally unhygienic [*bu shengli*]." It was also too confining: "Skirts and long hair inhibit movement . . . if girls spend half the day dressing themselves, their work will never be equal to that of men." Finally, women's fashions were too provocative: "Women's dress today has a direct connection to sex. Many girls deliberately dress very seductively, which is no more than treating oneself as a plaything."[19]

To overcome all of these deficiencies, Xu proposed one simple remedy: "the dress of men and women should be the same." His logic was simple: equal dress would mean equal work, "gender differences" (*xing de qubie*) would be erased; "class obedience" would be discarded, and much time and energy would be saved. As for those men who worried that women might become uncouth, and those women who worried that men might not want to marry them, Xu's reply was simplicity itself. If men could be genteel in their clothes, then so could women, and "if all women dressed like men, there would be no need to worry that no one would want to marry them."[20]

Xu Dishan's advocacy of what was essentially cross-dressing was interesting on several counts. Recent precedents for women dressed as men were rare, but did exist. For instance in the early 1900s the female revolutionary martyr Qiu Jin sometimes dressed in a western man's suit, complete with cap and walking stick. "The sleeves were too long," remembered one observer, "and from her cuffs one could see just her white, delicate hands."[21] Xu Dishan would have approved of her reasons. "My aim is to dress like a man!" Qiu Jin is reported to have said, "I want somehow to have a mind as strong as a man's. If I first take on the form of a man, then I think my mind too will eventually become that of a man."[22] Interestingly, historians at the Museum of Revolutionary History on Tiananmen Square have chosen to preserve her "feminine" side, and a photo of her in a Japanese hairstyle and kimono lies behind glass, along with a tasseled shawl made of crocheted strips of black velvet.

Men dressing as women, on the other hand, was a much more common phenomenon. When *The Greatest Event in Life* first appeared in the pages of *New Youth*, for example, the girl student Yamei epitomized the New Woman. The work was immediately well-received, and student groups often presented the play to publicize the cause of women's liberation and free love. But in performance the part of Yamei could be played only by men, because in 1919 women were not yet allowed on stage.[23] Similarly, in the early calendar art of the period, the young women depicted as women of style were dressed in the latest fashion, but were actually modeled by men – usually opera performers who specialized in playing women's roles.[24] Moreover, since it was understood that any real woman posing for such a poster would be a prostitute and not a positive image, there was actually an incentive for the poster artists to make sure that their mannequins did in fact look like men in drag. The calendars were a new phenomenon; as advertising, their distribution was wider than any book or magazine could hope to achieve, and the men in them may be seen as China's first fashion models.

Thus, we see that in the early Republican period the images of the New Woman, whether girl student or woman of style, were for the most part conceived, expressed, and even embodied, by men. Even Xu Dishan, whose fiction was most famous for its sympathetic portraits of women caught between tradition and modernity, was himself trapped within the structure of this dialectic. In "Women's Dress," he advocated the liberation of women through new forms of dressing which would erase secondary sexual differences between men and women, so that in the end, it was really men who were to be liberated, and women who were practically erased.

This did not necessarily concern women themselves. When the few of them who dared did dress in men's clothing, they generally wore the trousers and *changshan*, or long gown, then popular among male students. A decade and a half later, this would become the streamlined cheongsam or qipao, cut to reveal every feminine curve.[25]

"Do you think that when women get together, they talk about men?" Bing Xin asked in a memoir of her school days. "When my friends were together, we usually talked about women, and we often discussed and judged whether a girl was pretty or not."[26] In other words, they talked about fashion. Bing Xin offers the example of an "unforgettable" girl who is a combination of charisma and style. She is noticed first in a sea of uniform white blouses and dark skirts – because she has chosen to dress in a blouse of starched light blue cotton. Although Bing Xin does not explicitly say so, for her, fashion was part of a woman's beauty arsenal – one that allowed for personal idiosyncrasies and self-expression. This is in fact how fashion developed in modern China, as women, with the help of their tailors and outside the written discourse, manifested their own tastes and preferences in personal dress.

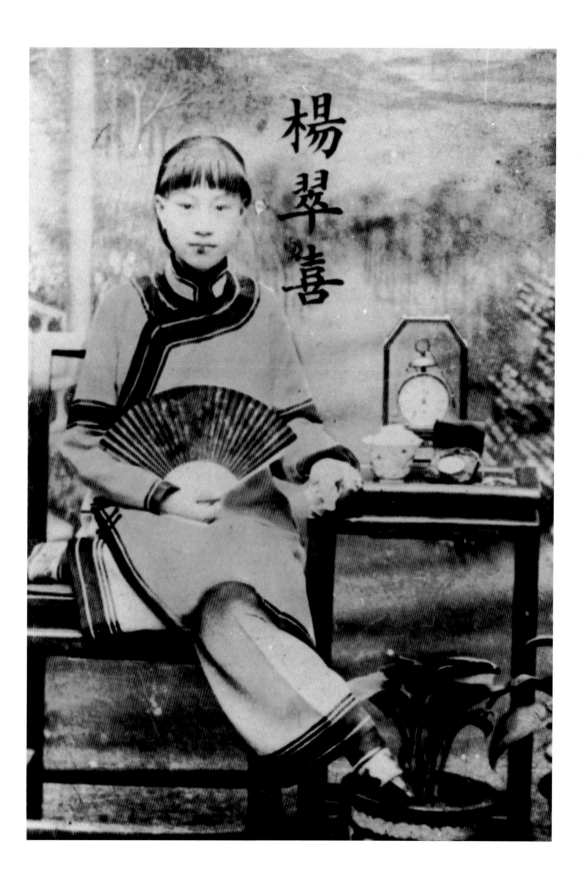

楊翠喜

Jazzing into Modernity:
High Heels, Platforms, and Lotus Shoes

DOROTHY KO

THE NAME OF THE CLASSIC CHINESE SILENT FILM *Wild Rose* (1932) reflects the personality of its main character Little Phoenix, a country girl as prickly and unsullied as the film's title suggests. Played by Wang Renmei, China's Greta Garbo, the unaffectedly beautiful Little Phoenix hops and skips on dirt roads in bare feet. From the first scene, director Sun Yu's camera directs our gaze to the emblem of her innocence: white, unadorned, and unbound feet. Throughout the film, the state of feet and style of footwear are visual clues to such abstract values as modernity, freedom, and nationalism. When Little Phoenix's thatched hut burns down, a sympathetic Paris-trained painter takes her to Shanghai. For permission to stay in his family mansion, she has to impress his bourgeois father by refashioning herself. But Little Phoenix is miserable in the girdle, silk stockings, and high heels bought from a fancy department store. Having literally fallen flat on her face, she casts off the heels, lifts up her skirt and adjusts her sagging stockings in front of a roomful of elegant guests. When the father kicks her out of the house, the camera zooms in on the castoff high heels on the floor.

Director Sun Yu used the contrivance of high heels and stockings to send many messages about class divisions in China's domestic and foreign relations: as decadent objects from the bourgeois West, they had to be tried on and then discarded before the heroine and hero can run off to the slums to join the urban poor. In addition, the contrast between the natural beauty of countryside and corruption of the metropolis finds a poignant material expression in the form of female footwear. This valorization of village simplicity is romantic and utopian, comparable to the European yearning for the pastoral in the industrial age, but the fixation on female feet exposes a cultural idiom and sensitivity that is uniquely Chinese. At stake here is not just a utilitarian critique of adornment as decadence, or condemnation of a consumerism piqued by imported goods displayed in department stores. Among the urban reading public and in a distinctly non-intellectual language, conversations on what women should wear constituted a popular discourse on the composition and moral fiber of the nation, its place in the world and the shape of Chinese modernity.

No wonder that debates over the proper shape and size of female footwear raged in 1930s China in both official and non-elite venues, in government

101 Portrait photograph, *c.*1905–10, of a young woman, probably a courtesan or entertainer, identified in the photo's caption as Yang Cuixi. She is Chinese and has bound feet, but wears a Manchu-style tunic over a matching long-sleeved under-blouse and wide trousers; her outfit is an early form of the modern qipao. Courtesy of Glenn Roberts.

proclamations and the writings of intellectuals and novelists, as well as in women's magazines, pictorials, and tabloids. This chapter examines the conversations in the popular media about the cultural meanings of three styles of ladies' footwear: footbound slippers, high heels and Manchu platform shoes. Previous scholars have studied Chinese modernism and discourses of modernity by focusing on the works of such leading novelists and thinkers as Lu Xun. The views from the streets presented in this essay do not necessarily contradict such lofty intellectual discourses, but the focus on fashion and footwear highlights the power of the material and the visual in shaping people's perceptions of the modern beyond the written word.

The Nation, the Feminine, and the Space in Between

Shoes are objects loaded with absurdly serious meanings in modern China because mobility and speed are synonyms for progress, freedom, and the wealth of nations. Every child today is still schooled in a national history wrought of metaphors of journeying and racing: immobilized by tradition and crippled by imperialism, China has fallen behind in the industrial age and has to race to catch up. The pursuit of speed, to outpace the pack simply to catch up with the advanced nations, was the paramount national obsession in the twentieth century. The script and the pathos is social Darwinian but with a twist: opponents in the struggle for survival were located not in the same jungle but in disparate time zones, with China always lagging behind. Parity means China achieving the same goal – such as making an atomic bomb or attaining a certain per capita GNP level – at a later day. Chinese modernity is in this sense mimetic.[1] Brisk steps and speedy traveling – the reduction or conquest of space – were metaphors for not only personal liberation but also national salvation. Hence the founding myth of the People's Repupblic is the Long March. It is also no accident that the famous, or infamous, campaign launched by Mao Zedong in 1958 was termed the Great Leap Forward. As the Chinese shot satellites into space and watched production figures soar through the sky, they were feasting on a delusion that China could outpace the West by a sheer act of collective will. As long as the Chinese nation is marching onward, this view implies, time is linear, space can be conquered, and history is purposeful. This national obsession with acceleration means that fashion and in particular the style of footwear are vested with political meanings beyond the aesthetic or utilitarian; the visual and the material belong to a realm that borders on the utopian.

The place of woman in this national march is paradoxical, at once central and peripheral, as evinced by the curious fixation on her footwear. In particular, the attention on her high heels exposed a deeply ambivalent relationship between modern femininity and historical time. Fashion was far

less problematic for the modern masculine subject, even though it was male attire and hairstyle, as badges of political rank or allegiance, that was revolutionized almost overnight. Cutting the queue was a public statement of support for republican ideas in the first decade of the twentieth century, and after 1912 for the new Republic itself. In popular novels, a modern man who turned his back on the imperial past is depicted in a western-style hat and leather shoes. An example can be found in one of the illustrations (fig. 102) for a novel set in these tumultuous transitional years, *Wenming xiaoshi* (A short history of civilization). A licentiate scholar has just shed his mandarin robes which failed to keep him warm; already dressed in short jacket, pants, and leather shoes, he is pictured in the process of hiding his queue under a felt hat.[2] In practice, there was great latitude in terms of what men wore. Out of habit, older men from the countryside or remote areas were seen with queues into the late 1910s; the western suit was the norm only among the educated class in metropolitan cities.[3] But the symbolic meaning of male headgear and footwear was straightforward – or, to be more precise, the symbolic meaning of men fashioning western-style attire was uncomplicated, representing as it did a sign of progress in the Nationalists' and the reformers' eyes.

Not so for female attire. How to dress the modern woman became a contentious problem after the dethroned Manchus ceased to be arbiters of taste. Reviving indigenous dress was out of the question; all other considerations aside, the billowing sleeves of extravagant Ming robes seemed ill-suited for the industry required of women as productive citizens. The female look had to be invented from scratch, and yet imported styles stirred controversies. The bobbed hair adopted by schoolgirls, a new social category, provoked accusations of moral degeneracy from the start.[4] The western-looking woman was suspect for having compromised the cultural identity of her people, a charge seldom levied on her male counterpart. In turbulent times, woman became idealized as the custodian of a nation's cultural authenticity, a sphere of inviolability that is beyond the vicissitudes of change. The demands placed on the modern woman are thus inherently contradictory: as a member of the nation she is to race time and march forward; as a woman she is to remain static, if not outside temporality altogether – or at least give the illusion of stillness; herein lies the import of dress in altering the viewer's experience with time.

The volatility of female appearance as a symbol, sign, or stand-in for something else is not unique to China, but it constitutes a peculiar cultural dynamic through which the entire history of Chinese modernity can be viewed. As visual metaphors, the styles of female hair and shoes provided a concrete material language in which conversations about morality, national spirit, and China's place in the world could be conducted. The symbolic import of female wear to national identity ensured that women would not be left alone to decide these issues for themselves. The indeterminacy of signs, however, means that women had room to contest national priorities and values

102 A young scholar dressing in western clothes for the first time. Woodblock illustration from Li Boyan's novel *Wenming xiaoshi* (A short history of civilization), *c*.1910.

by inventing hybrid styles. Every day they made myriad decisions on what to tailor, purchase, wear, and what not to wear. The fluid space in between the nation and the feminine, or the distance between the surface of the female body and the viewer's eyes, allowed the woman to fashion her Self with considerable creativity. Ironically, in the land of mimetic modernity stylistic hybridity was less a choice than a necessity.

As inventive as they were, the women – like the Chinese nation – had to work within pre-existing material realities and with available fabrics. Fashion in the land of the catching-up worked by mangling disparate schemes of time or mashing incongruous mediums. Hence, fashionable footbound women in the cities of the 1920s forsook traditional binders to slip on cotton socks woven of super-fine yarn (*yangwa*, western socks), or silk stockings (*shiwa*, understood to be an imported product of superior machinery). These socks were available in emporiums in an assortment of sizes ranging from four-and-a-half to six-and-a-half inches. Some women were even more creative in playing with the old and the new: first the flat binders, then a pair of sewn cloth socks piped with red lacy borders, finally nude-colored stockings that allowed a glimpse of the piping. The most daring let the flesh of her bound feet peek through a pair of sheer black silk stockings.[5] Or imagine the slightly awkward glamour of a footbound lady who walked into a dance hall in Shanghai wearing leather Parisian dancing shoes no more than four inches long.[6] In the turbulent 1930s as today, when a woman in China displays the dated and the à la mode at the same time and on the same surface, she is manipulating an essential tension in the national fabric that constitutes the enduring appeal of China chic.

High Heels: The Seduction and Revulsion of Imported Desires

If the only value a modern woman was expected to embody was the inviolability of native culture, then imported high heels would be over-whelmingly condemned. Yet Fashion – the domain of Change – acquired positive meaning as the spectacle of the Modern. The concept of fashion was in fact not alien to China; witness the fashion cycles in the styles of dress and facial makeup of Tang dynasty (618–907) women. But in the twentieth century fashion was widely presumed to be a western import, which made it at once appealing and objectionable. Whereas the materiality of fashion – fashion as clothes and shoes – found an unproblematic translation in the word *shizhuang* (current attire), the Chinese had more difficulty with finding a name for the concept of fashion.[7] In the 1920s, when Chinese reconfigurations of the terms of fashion led to the outdating of *shimao* (current mode), the term that rose to take its place is *modeng* (modern). This substitution of a borrowed English word for a borrowed French word bespeaks the fact that the West-as-foreign is always stylish in China.

When high heels first made their debut in the early years of the Republic, they were associated with such nascent ideals as women's education, physical freedom, and superior technology. In a series of a hundred drawings of fashionable ladies produced around 1915, a Shanghai commercial artist named Ding Song used fashion as an idiom through which the new womanhood could be visualized. In contrast to the virtual omnipresence of leather high heels on calendar girls in the 1920s and 1930s, in this early series the footwear appeared in eleven – a mere 10 percent – of the drawings, suggesting its relative novelty.[8] One of these drawings depicts a young lady clad in medium-high heels strolling on an urban street (fig. 103). Her hair is loosely held back and gathered under a large bow at her nape; the sleeves of her top are casually cropped and pushed up (that is, with *tuxiu*, bald sleeves) to reveal her lower arm. The relaxed and leisurely air is completed by a pleated skirt that reveals her ankles. The schoolgirl-look outfit would be replaced by the one-piece qipao in the next decade, but in the 1910s heels were part of a new look that celebrated leisure, movement, and urbanity.

Also significant is the association of heels with foreignness, hence the newspaper or handbill with "foreign words" in the young lady's left hand. Indeed, the accouterments of imported leisure appeared in many of the drawings: tennis racket, binoculars, the speaker horn of a phonograph and stacks of phonograph records.[9] It is remarkable that in an age of anti-colonial and nationalistic fervor, these foreign objects were inserted into the domestic interiors and pastoral exteriors of the drawings without traces of violence. Literature scholar Shu-mei Shih has suggested that a process of bifurcation prevalent among the May Fourth generation of intellectuals (1915–24) may help explain this ease of incorporation. In distinguishing the West as a source of cultural enlightenment from the West as an agent of imperialism, this bifurcation sanctioned the everyday adoption of foreign shoes, books, and technologies without compromising one's national identity.[10] In such a way of thinking, "the West" does not refer to a specific country or geographical entity, but functions as a discursive category. As such, "the West" would not maintain a stable meaning, nor would the reception of imported goods and styles remain unchanged.

Even when they were made in China, heels and leather shoes retained the image of imported goods and their implied technological edge. Native foot-wear, male or female, was hand-sewn from cloth as a product of women's handiwork in the household economy. In contrast, foreign-styled shoes were less pliant and often glossy, wrought as they were from a new material, leather. The female high heels were not stilettos; for the most part they were sensible mid-heel pumps with a round toe. Their generic name *gaogenxie* (high-heel shoes) draws attention to the fact that they were foreign in design and often in production and material, not to their actual height. Slippers for bound feet were, in fact, also high heeled, especially in northern regional styles, fortified

103 Woodblock print by the Shanghai artist Ding Song, *c.*1915, showing a young woman strolling in western-style high-heeled shoes.

by cloth-covered wooden soles that culminated in platform heels an inch or two high. What distinguished them from the new high heels was not the elevation but the novelty of leather as well as the two economies of production and circulation.

We have seen earlier that "leather shoes" (*jialü*) were a telltale sign of reform-minded men in late Qing novels. As time went on, however, the foreign origin of leather shoes appeared more menacing even as they became increasingly commonplace articles of attire. The contrast was increasingly being seen as that between two systems of commodity production, one self-sufficient and the other import-dependent. (Later we shall see that leather high heels came to signal the loss of Chinese sovereignty in the 1930s.) The simultaneous allure and repulsion attached to high heels in particular and leather shoes in general epitomizes the love–hate relationship with itself and the Other that a nation bent on catching up with the West experienced.

It is important to note, however, that the growing popularity of high heels in the late 1910s and early 1920s was largely a result of their perceived foreign origins and novelty. As such they played a very useful role as the antithesis of and substitute for footbinding. When China came under the judgmental eyes of the global community in the late Qing, the antiquated practice became a national shame because it signified decay, degeneracy, and bondage. As a cultural icon in the new republic, a pair of leather high heels acquired meaning by standing the trope of footbinding as bondage on its head. The image of footbinding as dated, painful, and Chinese provided a vocabulary and, indeed, made it possible, to attach such values as modernity, leisure, and cosmo-politanism to the new shoes. The paired opposites constructed each other. As the negation of high heels, footbinding became the phantom of modernity.

The logic of mimetic modernity means that China builds its modern identity on the imaging of two Others: at the same time that it looks to "the West" as the desirable Other, it looks to its own past as the loathed Other. "Hybrid" chic, such as the tiny pigskin heels or bare bound feet clad in sheer silk stockings mentioned above, however, reminds us that transgressions ruled the messy domains of practice and embodiment. In using the word "hybridity" I evoke the transgressive potentials of mixing styles by displaying A + B + C; I do not intend to suggest that A, B, and C are necessarily fixed entities. Herein lies the significance of hybrid styles as enacted in everyday wear, not on designer's sketchpads: in playing with disparate styles, the fashionable woman embodies the many contradictions that China experiences in its march to modernity. In so blatantly displaying them, the woman uses the singularity of her body to lend the incongruities a reprieve. Surely, this reprieve has often been called an illusion that constitutes fashion's appeal everywhere. But in China the implication of this "illusion" in the national project gives fashion a reality and an urgency that further complicates the iconography of the fashionable woman.

Stylistic hybridity and personal transgressions could seem insignificant in an increasingly polarized country. The regional differentiation of China into "footbound" and "natural foot" areas in surveys produced by government agencies and social scientists reinforced the temporal bifurcation of the old and new by way of spatial mapping. Following campaigns of late-Qing reformers, the republican authorities and various provincial regimes, the feet of girls in the coastal cities were no longer bound by the 1910s and 1920s, even as the practice persisted in some peripheral areas until the 1950s. The Chinese fashion regime thus bifurcated in the initial decades of the Republic, with Shanghai the colonial and metropolitan city setting trends and the rest of the country trying to catch up.

High Heels as Footbinding: The Return of the Native

The semiotic relationship between leather high heels and footbinding as opposites that constructed each other underwent subtle changes during the Nanjing decade (1927–37). This change is part-and-parcel of the intellectual and cultural transitions that had been inherent in successive and unstable attempts, since the late Qing, to catch up with the West by following western trends. Shu-mei Shih has written about a Chinese return gaze at the West, cast by the modern girl in semicolonial Shanghai, whose bobbed hair earned her the appellation of "the Chinese flapper." Willful, confident and thoroughly materialistic, she was fully in control of her life and her men, active in sports, and promiscuous sexually as well as culturally. The Chinese modern girl had attributes of the Hollywood actress and the Japanese *moga* (a Japanese–English word shortened from *mo*dan *ga*ru [modern girl]), but she was less an imitation of anything than an one-of-a-kind creation. Born in the space in between East and West, she wore westernized clothes that did not exoticize the oriental; she was at home in China without submitting to the male-centered discourse of the nation.[11] The glamor of the Chinese modern girl was captured on vivid full-colored calendars from 1920s and 1930s Shanghai produced by commercial artists such as Ding Song. Their technique was innovative and hybrid, combining the soft shading of charcoal sketches with "wet" colors similar to the Technicolor colors later associated with the animation films of Walt Disney.[12] These advertisement portraits are all too familiar, thanks to their revival in an explosion of post-colonial nostalgia in Taiwan and Hong Kong in the late 1990s. Towering beauties clad in qipao, wearing high heels of elaborate designs and colors, or semi-nude in swimsuits and sometimes with their breasts exposed, were plastered on souvenir boxes, pencil cases, or cigarette lighters. Recently they were exported to New York as quintessential icons of China chic via the corporate image and namesake of the fashion concern Shanghai Tang. This circulation of colonial or semicolonial imageries in a post-colonial

age generates new meanings that merit analysis in a separate essay. Suffice it to note here that the current popularity of the Chinese modern girl image attests to her ability to update herself. The ambivalent cultural milieu that celebrated hybridity, materiality, and speed, but demanded no allegiance – the forces that produced China chic in 1920s Shanghai – remain fertile ground for the production of new meanings.

If the 1915 drawings of Ding Song depicted high heels as a nascent fashion trend amidst cloth flats, by the Nanjing decade the modern girl that graced the giveaway calendars that hung on the urban consumer's kitchen walls was invariably clad in fancy high heels. Surely these same calendars and posters advertised cloth shoes with flat rubber soles or sneakers as worthwhile footwear (the shoe box announces *wenming xie*, civilized shoes), but for a model to look the part of the fashionable icon, she would have to display her feet in leather heels even as she was sitting in a canoe, riding a bicycle, or ascending a hiking trail. Increasingly in the late 1920s, the artists and their audience had come to expect high heels – two-piece pumps, sandals or slingbacks – as the perfect complement to the ankle-length and form-fitting qipao, the latest uniform of China chic.[13] Both qipao and heels are hybrid styles, fashioned as they were from "traditional" motifs and idioms in distinctly modern combinations. Seen against the backdrop of the birth of the modern girl as an expression of semicolonial Chinese agency discussed above, the popularity of qipao and high heels was the product of a new cultural politics centered in Shanghai. No longer contained by the dynamics of mimetic modernity and the catching-up mentality, this self-assertive pose expressed its self-confidence in the return of the native and an overt critique of the West.

It is in this atmosphere that high heels became equated with footbinding, an equation that seems so instinctive to feminists in the U.S. that the early favorable reception of high heels in China seems all the more remarkable. We are not surprised, therefore, to encounter a long critique in a 1931 women's journal entitled "From the Golden Lotus to High Heels." The author's linear progressive thinking is reflected in the phrasing of the title, "from . . . to . . ." and is also amply reflected in his reasoning. The middle-school teacher was so indoctrinated in social Darwinism that his criticism of the fashionable woman was that she has become "the stumbling block of social evolution." He pondered the psychology of women who are so foolish that they would embrace this fad of "footbinding in disguise":

> Behold! A pair of bright and shiny shoes on her feet, soaring through the dark clouds. With heels like an ingot of money and a height that tops the sky – this is a pair of high heels, what modern women deem the latest look, the only way to stand tall like a crane in a crowd of chickens. Hack, hack! You handful of ladies who think that you are on the cutting edge, your hearts are in fact stuffed with vanities. Many people say, "these days grade school graduates want to marry middle school graduates; middle school graduates

want to marry university students. And those university students, they would not marry a man who had not traveled in a foreign [*yang*] country, studied in a foreign school, or who does not speak a foreign tongue, eat foreign meals . . . in short a foreign doctorate who smells foreign head to toe . . ." You wouldn't think these words are too harsh?[14]

There is more than a grain of truth in his diagnosis that women torture themselves, in the past and in modern times, to attract men in order to marry up. The author has in fact pinpointed the reason for high heels' popularity: the seduction of foreign lifestyle and power. Hence, even as he equated high heels to footbinding in their cruelty, it was clear that high heels were everything that the bound foot was not. Criticisms like this should not detract from the fact that high heels were "must-haves" in an urban woman's wardrobe. High heels were, in fact, losing their dangerous and erotic connotations from overuse.

Thus the fashion trendsetters experimented with a new style of footwear — nudity. Bare feet with or without sandals appeared sporadically in the calendar girl portraits in the late 1920s, and by the early 1930s a pictorial editor, Yao Lingxi, observed that on the streets of treaty ports,

> the look of baring legs in the summer has been in vogue for several years. But these days the modern girls [*modeng nülang*] not only bare their ankles but also their feet. The high-heel leather shoes they wear have no fronts, merely several thin strips of crisscrossing leather that brush against the toes. The pattern wrought by the strips is intriguing, and the two feet as smooth as jade and white as snow suddenly reveal themselves. They are now fully visible. Moreover, the toenails are coated with French-made "nail polish" [original in English] ointment. They are colored bright red, so bright that they seize the gaze.[15]

Yao went on to compare "French" nail polish to a traditional Chinese cosmetic practice of staining nails with the juice of garden balsam blossoms, but its novelty is evinced by the use of English words and the awkward reference to "ointment." No moralist, the observer seemed shocked by the visual pleasures of this sudden revelation of first female legs and then the ankles and toes. The methodical description of the straps of the leather sandal, white smooth flesh and then glossy red nails conveys both the risqué delight of the male observer and how unprecedented the disclosure was in the cultural repertoire of the iconography of eroticism.

With the threats of Japanese invasion and a civil war between the Nationalists and Communists looming large, in 1930s China a pair of bare feet was more than an erotic symbol. Its signification of unsullied rustic simplicity we have already seen in the image of Little Phoenix in *Wild Rose* (fig. 104). By extension, it became a mark of manual labor, the pain and pride of the urban industrial masses. In the literature and plays of the 1930s, an increasingly leftist-leaning intellectual sensitivity led to a celebration of the barefoot working class

as the embodiment of humanity and democracy. This critique of the urban bourgeoisie whose heroine was the materialistic modern girl found its last incarnations in Mao Zedong's barefoot doctors after the establishment of the People's Republic.

Against the gathering political storms in the 1930s, the erotic appeal which such urban connoisseurs as Yao Lingxi found in the bare foot appeared petty and obsessive. Today we may observe, with an academic detachment, that this modern and urbane erotic interest in the bare foot in fact derived its potency from a longstanding tradition of late Ming erotic prints. It is no accident that Yao was a renowned authority on the late Ming erotic novel *Golden Lotus*. The bare modern toes varnished with red "French" nail polish were the supplement of these traditional tiny-footed beauties, always clad in anklets, leggings, and shoes. It was the slipping off of these fabrics of concealment that supplied the erotic appeal of bare feet. The resurfacing of the native as the concealed and its final unraveling placed the native and the modern in a temporal continuum. But this gesture of turning May Fourth iconoclasm on its head, however culturally significant, went largely unnoticed as the nation braced itself for war.

The Manchu Platform Shoes, or We Chinese Invented Everything

In another guise of the return of the native, the vanquished Manchus, the last emperors and enemies of the nation, returned to claim the laurels of being the

most modern Chinese. In a tongue-in-cheek essay couched in the format of a memorial, a writer mused in 1934:

> High heeled leather shoes cost several to scores of dollars a pair. Some statistics show that this fad results in a net drain of over a million dollars every month. That makes a deficit of over twelve millions a year, a shocking figure. Therefore these days people are shouting, "down with leather shoes!" But the fashion is already well entrenched, how can it end with a mere slogan? Thinking that it is best to replace high heels with national products, I make this suggestion regarding Manchu shoes . . .[16]

The author's scheme rests on his observation that women like imported high heels not because they are addicted to leather, but because the elevation improves their gait. Why not, then, promote Manchu platforms for the same effect (fig. 105)? Their advantages over imported high heels: first, they make a better match with the stylish qipao, both being ethnic costumes from the fashionable Manchus; second, high heels cramp the toes and restrict circulation, hence are as unhygienic as the arched shoes for bound feet; third, Manchu platforms are less restricted by their medium than leather high heels, which makes them more amenable to updating and invention. The author suggested insetting pearls and diamonds on the shoe, a watch on the platform sole and perhaps even a portable radio. Both decoration and function would be served. He concluded: "In short, replacing leather high heels with Manchu platforms makes hygienic and aesthetic sense. The recovery of our national sovereignty

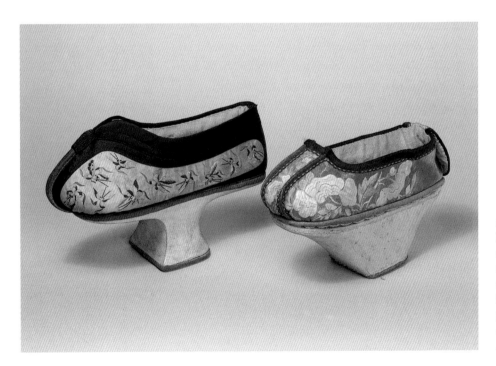

105 Manchu shoe platforms were known colloquially as "flower-pot soles." Made of hard wood, the platforms averaged between one and two inches in height, and often remained intact after the cloth shoes they supported had worn out. Young fashionable ladies often decked themselves out in platforms as high as four inches. Photograph courtesy of the Trustees of the Victoria and Albert Museum.

rests on one gesture of lifting up her feet. My dear aunties and sisters, are you ready?"

The author's criticism of both high heels and footbinding as unhealthy was commonplace in the 1930s, as we have seen. His valorization of the Manchus, too, reveals how far sensitivities in the 1930s had departed from the early Republican years, when "Chinese" nationalism took the form of an anti-Manchu fervor. In the author's eyes, the Manchus were not only sensible in their footwear but were also the most stylish as compared to the Han Chinese and the Euro-Americans. Since hygiene and the ability to update oneself by adapting to new inventions and fads are essential signs of modernity, the Manchus were presented as the most modern people in the world. This suggestion, however incredible, managed to hold the reader's interest momentarily because the prime enemy against which Chinese nationalism established its legitimacy had shifted to the Japanese; the Manchus had ceased to exist as a political problem or a distinct "race." Even as the Japanese installed Puyi, the last emperor, as the patriarch of their puppet state in Manchuria, the farce failed to impress most Chinese. The author made a nod to the event, but the Manchus were not to be feared. They had, in fact, become part of this ever-evolving people called Chinese, even as the author harped on their ethnic distinctiveness in the form of qipao and platform shoes.

There has never been, of course, a typical Manchu dress just as there is no unequivocally "Chinese" or "Western" style. It should be clear by now that in this speedy and hybrid world called China chic, there are no stable identities but only powerful markers that broadcast the illusion of essentialized identities. The invention and popularity of the qipao, the tongue-in-cheek refashioning of Manchu platform shoes as modern *and* Chinese, like the return gaze of the Chinese modern girl, represent a return to native ideals in China's frustrated march toward modernity. However impractical and even slightly cynical, the suggestion of reviving Manchu platform shoes is an ingenious cultural move. Building on the prevailing mood of promoting native industries, it created a critical space for the simultaneous rejection of the modern West and old China.

What I refer to as "the return of the native" is not a conservative restoration, nor a circular motion of history repeating itself. The Chinese nation continues to reinvent itself by incorporating and rejecting new elements; the very idea of the native itself is a modern invention. That it was possible to reimagine the Manchus as Chinese, or rather, as the carrier of incipient modern elements in Chinese history, demonstrates how fast the imperial past had been relegated to the dustbin of history and how committed the Republican Chinese were to the modern artifact of a linear and progressive national narrative.

★ ★ ★

Epilogue

The spectrum of cultural alternatives in twentieth-century China is represented in these three forms of female footwear. High heels as the symbol of imported modernity are enticing, but their visibility on the streets provokes fears of loss of national sovereignty (fig. 106). Manchu platforms sound hygienic, stylish, and modern in the abstract, but as vestiges of an imperial past and an emblem of a minority ethnicity, they have no place outside the museum display case. How ironic that they were the only attractive option from China's recent past.

No matter how one sizes up the problem of footwear, one thing is clear: footbinding is loathed universally. Its very negativity, bound as it was to the materiality of the flesh, lends concrete meanings to such abstract aspirations as freedom and speed. Its function as the phantom of modernity means that it would not so easily disappear from everyday life and from speech, even though the modernizers were eager to erase the shame and to start with a clean slate. They would have to go slow and be patient.

106 Neon sign for a ladies' room in Chengdu, Sichuan Province, c.1979. The high-heel pump, a perpetual icon of femininity, resurfaced as a symbol of foreign chic in the era of the Four Modernizations. Photograph by John S. Major.

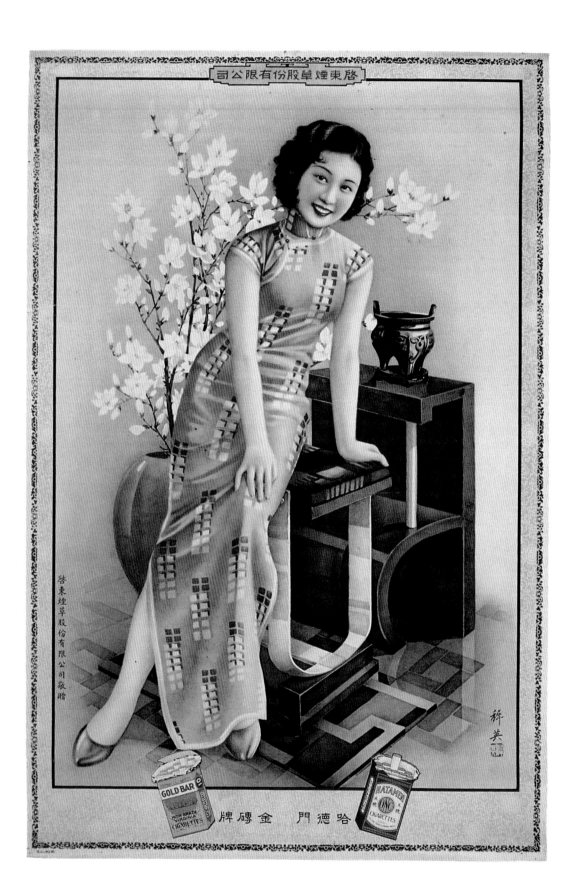

Chapter 9

The Cheung Sam:
Issues of Fashion and Cultural Identity

HAZEL CLARK

Introduction

THE CHEUNG SAM[1] HAS GAINED SPECIAL ASSOCIATIONS with Chinese women during the twentieth century. Introduced at the end of the Qing dynasty, in the late nineteenth century, its history is bound up with social, economic, and political change, and with patterns of migration. In mainland China its popularity has risen and fallen, but Chinese communities outside the mainland have ensured its continuity. This is especially true of Hong Kong, where it has become the equivalent of a "national" dress.

The fall of the Qing dynasty in 1911 concluded almost three centuries of Manchu rule (1644–1911). Originally semi-nomadic herdsmen from the northeast of China, the Manchus wore a long loose-fitting robe, which covered their feet and had an overlapping front flap that fastened with loops and toggles at the right shoulder. Side vents allowed the freedom of movement essential for walking and horseback riding. The long sleeves covered the hands, for warmth and for propriety, as showing the hands was considered impolite. The female version of the robe was known as the *qipao* or "banner gown" after the women associated with the Manchu banner regiments which were stationed in major cities to control the population. The cheung sam entered China, paradoxically, therefore, as a foreign garment representative of an invading culture (fig. 108).

There was a natural resistance by the indigenous Han Chinese to the adoption of a foreign form of dress. Nevertheless, on a functional level the one-piece gown was more practical and less restricting than the two- and three-piece outfits it gradually replaced. Such forms of dress were no longer regarded as appropriate when the overthrow of the Manchus and the formation of the Republic (1912–49) brought about a general movement towards female emancipation. Foot binding was outlawed and it became acceptable for women to wear less restrictive clothing. Skirts rose above the ankles and were worn with a jacket that was slimmer than its predecessors, ended just below the waist, and had side-slits, tight fitting sleeves and a very high collar. As an alternative to the old formal ensemble of jacket, skirt, and trousers, young and unmarried women wore narrower trousers, especially in informal situations where the skirt could be discarded.

107 Advertising poster for the Qigong Tobacco Company showing a fashionable women wearing a cheung sam. Color lithograph by Hang Zhiying, made in Shanghai, China, during the late 1930s. Courtesy of the Powerhouse Museum Collection, Sydney.

108 Manchu woman's purple robe (*changyi*). Silk embroidery on silk satin, made in China in the early 1900s. The upright collar and the narrow form of the robe indicates its late date. Courtesy of the Powerhouse Museum Collection, Sydney. Gift of Mr. and Mrs. Joseph Mikulicic-Rodd, 1971. Photo by Penelope Clay.

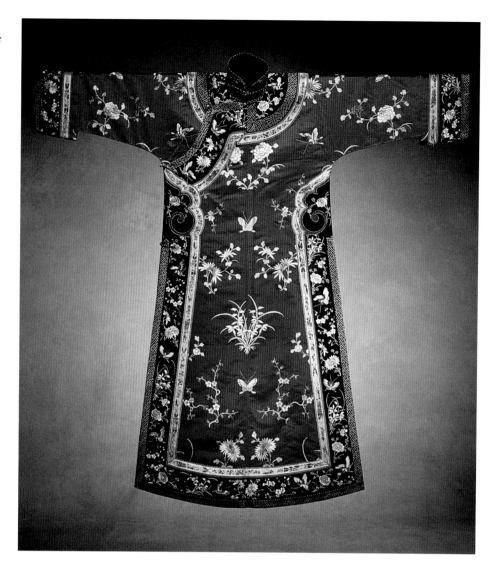

Initially, the qipao was worn by wealthier women, such as the wives of government officials. Female university students were also probably some of the first wearers of what was a loose fitting garment that closely resembled the male *changshan* or long gown; for, as education for girls developed quickly in the 1920s, it was necessary to adopt an appropriate uniform for students. The gymslips and short skirts worn by western schoolgirls were frowned upon as unfeminine and immodest by school authorities and parents.[2] The loose qipao, falling well below the knees, offered the alternative of a simple, indigenous garment. It was adopted for wear by both teachers and pupils in southern China and then in Hong Kong, usually in Protestant Christian schools, some of which still retain it as their uniform today.[3]

★ ★ ★

In the 1920s and 1930s the qipao began to gain popularity and came to signify modernity. The opening up of China brought western fashion influences to the garment (which hereafter will be referred to as the cheung sam, to distinguish its modernized form). The garment was no longer made in the traditional manner from a single square piece of fabric, but became more shaped and fitted. This modern version began to be fashionable in the early 1920s.[4] The port of Shanghai became China's modern trading city, populated by foreign business people, and a center of fashion and style, as represented by the local movie industry. Female screen stars favored the cheung sam in their daily life and on screen. By the end of the decade it was the regular wear for middle-class women in urban centers, such as Beijing, Shanghai, and Hong Kong, as is evident from contemporary photographs, advertisements, and fashion magazines. The image of the cheung sam became pervasive in China and overseas when it was used to advertise a variety of different types of commodities on calendar posters produced in Shanghai and Hong Kong.

Calendar posters had been a popular art form in China since the late nineteenth century and could be found in most homes. Originally hand painted, the introduction of lithographic printing in the early twentieth century made them cheaper and more commonplace.[5] They were distributed throughout China and in Hong Kong to celebrate the lunar New Year. In the 1920s and 1930s their varied images of fashionable Shanghai women must have helped to promote the fashion for wearing cheung sam throughout China. The images bore the signifiers of "modernity," such as Art Deco-style settings for the women, who sported modish permanent waves, high-heeled shoes, and western makeup (fig. 107).

Because the Shanghai posters captured the internal market, the posters printed in Hong Kong were responsible for sending the image of the cheung sam overseas. These posters were purchased, then distributed by local hongs (commercial corporations) to promote their products to customers abroad, or were exported to Southeast Asian countries with settlements of overseas Chinese.[6] As early as 1906 the Hong Kong daily newspaper, the *South China Morning Post*, reported on the

> beautiful lithographic calendars designed and executed in 14 colors by the "South China Morning Post" Limited. This is a new industry in the Colony, executed formerly for local orders in London or Germany . . . The calendars are much appreciated by the Chinese at New Year time, and find their way all over the Empire and in fact to every port of the world where Chinese are located.[7]

The circulation of these images contributed to the cheung sam being identified as typical "Chinese dress" overseas. In their often very revealing portrayals of the female body, the posters drew overt attention to the merchandise for sale,

but covertly projected an image of Chinese women as "exotic" and desirable consumables. Accessorized with silk stockings and high heels, or a fur stole to enhance the sexuality of the wearer, the cheung sam, as it appeared on the posters, became a vehicle for the identification of Chinese women as a whole. The addition of these imported accessories showed knowledge of international fashion trends, but also acted to reinforce conventional feminine stereotypes and to objectify the wearers.

The image was a product of colonization. After the First World War knowledge of western fashion was disseminated in China, as elsewhere, by Hollywood movies. Not surprisingly, the cheung sam appeared in films between the wars when it was used as a signifier of "Chineseness." Lam Chor Chor, the first Chinese actress to appear on screen, wore one in a movie made in Canton in 1925.[8] But the westernization of the cheung sam was not restricted to the image. The garment itself changed. This was probably most immediately evident in Shanghai. There, fashionable society women and film stars were amongst the first to wear the new modern cheung sam as a sign of sophistication and a signifier of a leisured life-style.

The popularity of cinema in China in the late 1920s provided a vehicle for the spread of western customs and fashions. Chinese film actresses were in the vanguard of the movement towards wearing western styles. As an illustrated periodical of the time remarked, "It is interesting to note the tendencies of Chinese movie stars to imitate the foreign way in exposing their limbs."[9]

During the 1930s the western fashion for bias cutting caused the cheung sam to become more fitted and waisted. Seasonal variations were introduced to the length of the side slits and the height of the collar, creating additional fashion interest. As the hemline dropped to floor length, the slits became longer and more revealing, often reaching the thigh. Posters illustrate how silk stockings and western-style underwear were worn with the cheung sam to enhance the image of female sexuality. Freedom of movement was restricted by the tightness of the skirt, both with the knee length and with the longer versions. Added to this, the discomfort of the stiffened collar, especially in hot weather, emphasized the fact that it was worn increasingly for fashion, rather than for functional reasons. Wide sleeves, cut above the wrists, gave way to slimmer versions, variously styled above the elbow or as cap sleeves; sometimes sleeves were entirely absent. Narrow satin piping was used extensively to trim edges. Collars and flaps were fastened with knotted buttons and loops, which remained the enduring characteristic of the older style of qipao. The poster artists depicted very stylish versions of the garment, which would have served as a fashion reference for modern Chinese women. But, in reality, most women would not have worn the very fitted or revealing versions depicted in the posters. The poster images, were, like the movies, nevertheless influential on what the ordinary woman would wear, or, at the very least aspire to, through their reference to contemporary life.

From 1934 onwards, under the direction of the Chinese Nationalists, the New Life Movement aimed to reinforce male and female roles based on conventional sexual stereotypes. Posters echoed this by showing women in home and family situations. Some were shown as wearing western styles of dress, but the majority were depicted in seemly versions of the cheung sam. Attempts were made to ensure that throats, arms, and legs were decently covered. However, the posters confirm that the boundary between femininity and overt sexuality in dress had become quite blurred.[10] Women were depicted in a variety of roles, from the object of desire used to advertise popular brands of cigarettes, to the virtuous wife and devoted mother who appeared in the New Year prints.

Two stereotypes are evident: one the "new" or "modern" worldly woman, and the other the conventional "family woman", who stayed at home to care for her children and husband. Despite moves towards emancipation, both stereotypes were, in their own ways, sexually subordinate to their male counterparts.[11] But all classes of women wore the cheung sam, the differences being distinguished by fabric, style, shape, and detail and the use of accessories. Essentially the cheung sam had helped to effect a "feminized" image which paralleled the similar development of female fashion in western countries.

The modernized form of the cheung sam was no longer an item of egalitarian dress, as it had been early in the century. In fact it was considered a symbol of decadence after the Communist Revolution of 1949, and gradually outlawed. As attitudes to dress, like attitudes to life in general, became more serious, the cheung sam was worn less and less in the mainland during the 1950s and 1960s. During the Cultural Revolution (1966–76) it was banned altogether, but by then its popularity had spread from the fashion center of Shanghai, not only north to Beijing, but south to Guangzhou, and also to Hong Kong.

Hong Kong

The cheung sam gained popularity in Hong Kong in the 1950s because of the similarity of the shape to western fashion which, in turn, influenced the cheung sam. Photographs of wearers provide useful documentation illustrating that it was the everyday dress for most Hong Kong women, and was worn very close to the figure with high heeled shoes to add to the fashionable illusion of slimness and height (fig. 109).

The garments were not bought ready to wear, but were tailor made, which ensured a good fit. Many were produced by hand by Shanghai tailors who were renowned for their high levels of workmanship, and had migrated to Hong Kong because of the political turmoil in China in the 1940s and 1950s. By using their fine skills they were able to manipulate fabric into increasingly figure-

109 Short-sleeved, red silk brocade cheung sam with black piping, worn in the 1950s in Hong Kong by its owner. Courtesy of the Asian Design Collection, School of Design, The Hong Kong Polytechnic University, Hong Kong.

hugging garments. Ironing was used to stretch and mold the cloth to create three-dimensional effects, and darts were applied to the bust, waist, and sleeves to make the very fitted garments, with thigh-length slits especially favored by beauty queens and nightclub hostesses. In the late 1950s the traditional silks and satins were still being used for special garments, and cotton for everyday wear in summer, but in that same period western-style patterned materials from England, France, Italy, and Switzerland were being used increasingly in Hong Kong.[12]

In the 1950s and 1960s the cheung sam was consciously promoted at local beauty pageants as a form of "national dress" and a signifier of Hong Kong's cultural identity. This began in 1946 when the first modern beauty pageant was held in the Ritz Garden nightclub. All contestants wore cheung sam in the "casual wear" section, and some also wore it in the evening wear division of the contest. By the early 1950s the cheung sam was the established "casual wear" for beauty contestants.

The cheung sam was further promoted as a fashion belonging particularly to Hong Kong when the local television station, TVB, started hosting the annual Miss Hong Kong pageants in 1973. Local winners would represent the colony in international competitions such as Miss Universe and, in doing so, would draw wider attention to the garment and reinforce its associations with Hong Kong. The Miss Asia contest organized by TVB Asia also required cheung sam to be worn as part of the contest as did the Miss Chinatown contest, introduced by TVB in 1988.[13]

Films had a similar effect. Perhaps the best known is *The World of Suzie Wong,* made in 1960, where Hong Kong actress Nancy Kwan appeared in cheung sam in her role as the Wanchai prostitute Suzie. The very fitted, usually full length, cheung sam with high side-slits worn in the film, is the style that has become associated with Hong Kong. It began to be worn by European women who moved in fashionable avant-garde circles, as seen in the 1960s, for example, in Alain Renais's film *Last Year at Marienbad.* One tailor noted how a French actress came to Hong Kong in the 1960s to order cheung sam.[14] The popularity of the cheung sam outside of Hong Kong was influenced by its shape and fit being appropriate to the long slim line then current in European fashion, as epitomized, for example, by actress Audrey Hepburn.[15]

But by the end of the 1960s the cheung sam was becoming more of a luxury dress as women in Hong Kong turned increasingly to wearing western-style dresses, blouses, and skirts, or ready-made suits.[16] There were a number of factors which contributed to the change. One was the sheer economic reality that a handmade cheung sam was expensive, especially when compared with the mass-produced western-style garments that were becoming available locally. Another was the fact that the change in western dress toward more casual, youthful styles, such as the trouser suit and later the mini skirt, made the cheung sam appear outmoded. As a result, the business of cheung sam tailoring

dropped by over a third during the mid- to late 1960s. Some tailors turned to making western-style clothes, but many simply were forced to close down their premises.

So changing lifestyles affected the popularity of the cheung sam. Differences began to be felt between the generations, as propriety no longer demanded that young women should dress like their mothers. As one local newspaper reported, "On the whole, it seems the older woman is sticking staunchly to the national dress. But the younger woman, raised and educated to a more Western outlook than her ancestors, is turning more and more towards the fashionable styles of the West."[17]

It is an interesting cultural paradox that as the cheung sam had "freed" Chinese women from their trousers and restricting dress at the beginning of the century, the western trend for wearing trousers should contribute to this "liberation" of Hong Kong women from their cheung sam. One of the reasons was essentially practical: the cheung sam was not as comfortable as modern fashions and many wearers have commented on how its high collar could be irritating. Also the body-hugging form it took in the fifties and sixties made women very self-conscious about wearing it if their shape or weight changed. Its length and cut made it a relatively formal style, and therefore increasingly out of tune with the looser and more relaxed contemporary fashion directions. The arrival of the mini skirt in Hong Kong in the early 1970s confirmed the fashion demise of the cheung sam. Although some women wore mini cheung sam, the shorter versions were unable to affect its characteristic "elegance" and "femininity."

Politically, the beginning of the decline was marked by the Hong Kong riots of the late 1960s.[18] The unsettled situation had an adverse affect on the economy. Handmade garments were considered an extravagance and could not compete with the cheaper mass-produced, ready-to-wear fashions that were becoming available from local factories. Foreign goods and culture were desirable as they connoted social progress, informed taste, and elite style. The cheung sam, by contrast, appeared old fashioned and too obviously "Chinese," especially for the younger generation who wished to be seen as "modern." Those women who continued to wear cheung sam had their garments tailor made and favored the fitted version, which became popular in the 1950s and has become emblematic of the garment.

The Contemporary Situation

The slim-line fitted cheung sam, with a high collar, right side fastening, and slits at the hem has become the characteristic form of the garment. This is the style that has been adopted as the uniform of women in different aspects of the service industry, in Hong Kong, in overseas Chinese communities, and

gradually in mainland China. For waitresses, hotel receptionists, shop assistants, and nightclub hostesses, the tourist industry has adopted the cheung sam as an internationally recognized signifier of "Chineseness."

Nowadays, outside of its role as a "uniform," the cheung sam is worn regularly in Hong Kong but only by a small minority of women. This is confirmed by the decline in numbers of the cheung sam tailors from around a thousand in the late 1950s to fewer than two hundred and fifty in the early 1990s. Today wearers are generally motivated either by contemporary fashion trends or by issues of identity. This is evident from conversations with wearers, who tend to fall into two groups; one comprising more mature women, particularly those in the public eye, who wear it as a symbol of their cultural identity, and the other younger women who have adopted it as a fashion item.

When interviewed, Legislator Elizabeth Wong stated that the cheung sam made her feel distinctive and like a representative of Hong Kong when she was on visits overseas. For her, the cheung sam transcended fashion and had stood the test of time. She had, for example, worn one cheung sam in 1983 at a Chanel function and then eight years later for a charity ball.[19]

A university professor who wears cheung sam every day brought to mind its original scholarly associations when she mentioned how her students considered it a respectable form of dress and a symbol of wisdom and power. She keeps most of her cheung sam, and, in common with other wearers, re-wears them or passes them on, but prefers not to throw them away. For her, they have sentimental value. She recalled how her mother had worn cheung sam and that a visit from the family tailor was often popular with other female relatives whose presence turned it into a social occasion. By contrast, her own daughter who was studying overseas has little cause to wear a cheung sam. Nevertheless she was considering wearing one for her college graduation to denote her Chinese identity.[20]

It is not uncommon for migrant women – those who emigrate from Hong Kong to elsewhere – to possess cheung sam as a form of linkage with Hong Kong and to wear one at an important event such as a graduation or a wedding (fig. 110). One tailor noted how at the beginning of the trend towards emigration older people had a number of cheung sam made before leaving.[21] Others would send to their tailor in Hong Kong for new cheung sam, or would have them made on return visits, as they were unlikely to find skilled tailors in overseas Chinese communities.[22]

But just when the cheung sam had virtually disappeared, other than from the wardrobes of older Chinese women, it began once more to gain popularity. The turning of global fashion attention to Asia in the early 1990s produced reinterpretations of the cheung sam, as well as other traditional-style Chinese garments. Internationally renowned designers and design labels reflected the trend. The use of Chinese cultural references by those such as Hong Kong-born, New York resident designer Vivienne Tam helped to interest younger

110 Wedding banquet, Hong Kong, 1985.
The bride is wearing the traditional red
cheung sam and her mother-in-law, seated
in front, wears a full-length brown cheung
sam bearing a hand-painted floral design.
Courtesy of the Asian Design Collection,
School of Design, The Hong Kong
Polytechnic University.

generation Chinese and western women in the cheung sam. This became
evident in Hong Kong, where some young women took to wearing cheung
sam to create individual fashion statements.

One group of friends bought their cheung sam cheaply off the peg for
around HK$300 (about US$40) at the local China Products department store.
Typically, the style was fitted and in familiar colors such as red, black, blue, or
green, but polyester had been substituted as a cheaper alternative to the
traditional silk brocade. They wore them to nightclubs and often personalized
them with such casual accessories as a backpack, athletic shoes, and opaque
black tights. In doing so they retained the original form of the garment but
accessorized it to make statements reflective of their self identity. This fashion
trend coincided with the period leading up to the reunification of Hong Kong
with China in June 1997. During the politically sensitive period before the
handover, as local people were grappling with issues of identity, commercial
entrepreneurs were addressing its representation. One of the most interesting
and ambitious of these was a contemporary Chinese emporium called Shanghai
Tang.

Founded in 1994, Shanghai Tang is a theme retail environment based on
nostalgic images of 1930s Shanghai. Its representations of "Chineseness" are
especially popular with tourists and expatriates who purchase the store's
clothes, gifts, stationery, books, and home furnishings. Women's apparel

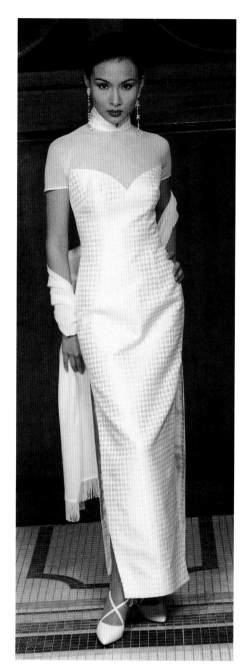

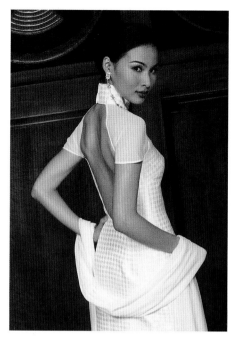

accounts for almost 50 percent of retail sales.[23] This includes casual wear, Chinese jackets and trousers, but, more especially, cheung sam, which can be made to measure by the store's "Imperial Tailors." During the handover period (June to September 1997) the tailoring department sold 40 percent of its output to local expatriates, thirty percent to local Chinese, twenty-five percent to western tourists, and five percent to Japanese tourists (fig. 111).

The opening of the second Shanghai Tang store in one of New York's prime up-market fashion shopping areas on Madison Avenue in November 1997 brought "their distinctive style of interweaving traditional Chinese culture with the modernity and dynamism of the 20th Century to the high-end American consumer."[24] Consequently, the cheung sam would no doubt be seen more regularly at social events in New York worn by non-Chinese as well as Chinese women. And at the same time as the cheung sam was becoming more universalized as a fashion statement, it was also being reclaimed as a signifier of cultural identity in mainland China.

It was notable that when President Bill Clinton arrived in Xi'an, on 26 June 1998, on the first stop of his historic visit to China, the only Chinese woman evident in the welcoming party was wearing a full length, semi-fitted, green cheung sam.[25] No longer was the garment outlawed; rather it had been reinstated as a symbol of national pride, reminiscent of the early days of the century when it was worn by Song Qingling, the wife of Sun Yat-sen, the founder of the Republic.

To celebrate the first anniversary of the reunification of Hong Kong with China, Barbie Collectibles issued a second Barbie doll to follow the "Chinese Empress Barbie Hong Kong Commemorative Edition" launched in 1997 to celebrate the handover. The 1998 version was the "Golden Qi-Pao Barbie"; dressed in a gold cheung sam, she came with a commemorative gold coin, a certificate of authenticity and "The Qi-Pao Story Booklet" (fig. 112). The cheung sam had been appropriated in this edition of 8,888 dolls, promoted to collectors worldwide, as a fitting signifier of Hong Kong's new status as a Special Administrative Region of China.

★　★　★

111a and b Full-length white cheung sam in silk jacquard, from Shanghai Tang, Imperial Tailors department, 1998. Courtesy of Tang's Department Stores Limited, Hong Kong.

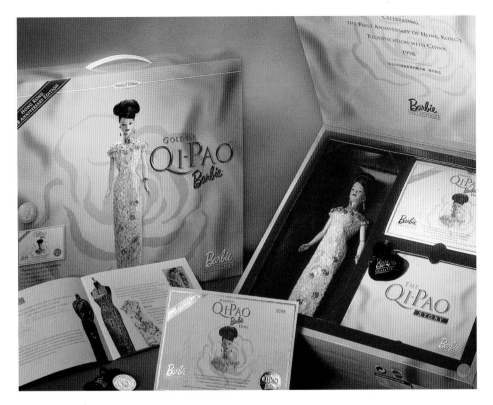

112 Golden Qi-Pao Barbie, 1998.
Courtesy of Mattel East Asia Ltd.

Conclusion

For Hong Kong Chinese people the cheung sam remains a special garment. Although not, strictly speaking, a national dress, it is an object of belonging with particular cultural resonance. This association has been especially important in the post–Revolutionary period when Hong Kong preserved and valued the cheung sam as part of its Chinese cultural heritage, which was all but erased in the mainland as a result of the Cultural Revolution. So the paradox of the origins of the cheung sam in China remains. A century after the fall of the Manchu Qing dynasty, the cheung sam has begun to be worn again in the mainland, thanks to having been preserved both as a fashion object and as a sign of cultural identity in Hong Kong.

Chapter 10

Dress and the Cultural Revolution

VERITY WILSON

Setting the Scene

IN 1949 MAO ZEDONG (1893–1976) and the Communist Party took control of China after several decades of foreign aggression and civil war. Mao presided in person over the ceremony in Tiananmen Square that proclaimed the founding of the People's Republic of China; standing above the gabled gate of the former Imperial Palace in Beijing, he began his long term of office wearing what later became known in the West as a "Mao suit." He subsequently deviated from this style only to don army uniform. During Mao's rule, frequent social upheavals, seen as necessary to maintain the revolutionary spirit, culminated in the ferment of the Great Proletarian Cultural Revolution, the dates of which are now officially given out as 1966–76. During these ten years, in the received account, an attempt was made by the Communist Party to politicize every facet of life, and cliques formed and re-formed to criticize mercilessly those who had supposedly become ideologically entrenched. Mao's is seen as the hand that guided the young and urged them to test the limits of revolution (fig. 113). The profound dislocation to people's physical and mental existence is now remembered and acknowledged as immense, and the suffering as immeasurable. Terrible humiliation, violence, and loss of life became the order of the day for many Chinese, particularly during the cataclysmic late 1960s. Against this harrowing background, a study of dress might seem to be a frivolous affair. However, because everybody wears clothes, the subject touches everybody's lives, literally as well as figuratively, and in a totalitarian milieu such as that pertaining in China during the Cultural Revolution dress can help us understand issues that might otherwise remain obscure. This is also to address the challenge posed by recent scholarship on the problematics of the Cultural Revolution, with its unwillingness to accept "the almost total intellectual block" that affects most writing on the subject in Chinese and in western languages, the consensus among Chinese official, Chinese unofficial and liberal foreign positions that it represents some irruption of the irrational, a poisonous "combination of a personality cult with the imperial tradition."[1] Instead of telling the same stories again and again the time is perhaps right to ask some questions.

How well did people cope with day-to-day dressing? How did they come to terms with subordinating their individual identity to that of the state? In

Facing page Detail of fig. 121.

113 Chairman Mao in a "Mao suit." Poster entitled *Chairman Mao Together with the People of Jinggangshan*, by Zou Liangcai. From *Nianhua xuanji 1975* (Selected New Year Pictures, 1975) (Beijing: Renmin meishu chubanshe, 1975).

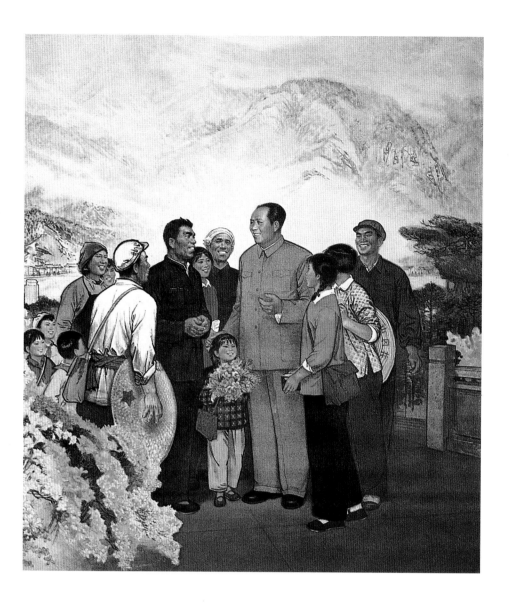

what ways did the state control dress? Did people find strategies for self-fashioning? Asking these and similar questions, as scholars have begun to do in other dress arenas, opens up a whole range of concerns. The answers may be unpredictable and partial, but in seeking them we have to go beyond a description of what people actually wore to the dilemmas surrounding their choices.[2]

An Anecdote about Dressing-Up

In 1977, a year after the Cultural Revolution had officially ended and Mao Zedong had been laid to rest in a crystal coffin, a group of Chinese students studying in London were invited to Sunday lunch with their English teacher.

At the time relations with the People's Republic of China were more open than they had been for some years, but conversation at gatherings such as this still tended toward the general and uncontroversial. These government-sponsored students, picked for their willingness to toe the government line, dissolved into embarrassed giggles when faced with some of the souvenirs their teacher had brought back to Britain when she herself had been an exchange student in China between 1973 and 1975. Significantly for our subject, the two items that caused the most consternation were a pair of long silk gowns from the 1930s or 1940s. Asymmetrically fastened, with a small Art Deco pattern repeated across the silk's surface, these elegant men's clothes, presumably abandoned by their former Chinese owner as dangerously elitist and old, were purchased in a secondhand store by a foreigner motivated by nostalgia for a lost past. The gowns, perhaps originally worn with a fedora hat and two-toned leather shoes, mean different things to different people. That their meaning is not fixed for all time was given confirmation by the students at the lunch party who put yet another spin on the story of these clothes. As they cautiously tried on the long gowns – most of them had never seen such an item of clothing at close hand – they gave an alternative reading of their significance. The image of the dapper Chinese man-about-town was replaced by that of their lost leader, Chairman Mao. For these "children of Mao," born and raised under his all-pervading presence, their English teacher's long gowns reminded them, first and foremost, of Mao's savior-like portrayal in the painting *Chairman Mao goes to Anyuan* of 1967. This much-reproduced oil painting, designed collectively by a group of Beijing students and executed by Liu Chunhua (b. 1943), depicts a young Mao in a long, side-fastening gown, striding forward to lend his support to the first Communist-organized strike by coal miners in 1921.[3] Although he might well have worn such a garment in the 1920s, the students' instant recognition comes from this later rendering. Small wonder, then, that they were nervous about dressing up in London. For them, it was not just a case of putting on unfamiliar clothes from a bygone era. The extraordinary power of that particular image of Mao meant that by dressing in a similar way they felt they were taking on his identity and masquerading as China's recently deceased leader.

The anecdote captures the complicated nature of the dress problem in China for the period 1960–80. It elucidates and enlarges upon the questions posed earlier. The unanimous and instant association of the long gown with Mao by the Chinese students was greeted with total incomprehension by the British people present who remembered Mao only in his eponymous suit or army fatigues. Doubtless everyone at the lunch would have been reminded of Mao in a long gown had they all been subjected to the same propaganda pictures. Eventually, 900 million copies of *Chairman Mao goes to Anyuan* were in circulation, most of them within the People's Republic (fig. 114). In actuality, very few people indeed would have seen the real Mao in a gown. The students'

114 *Chairman Mao goes to Anyuan*. Poster from an original oil painting by Liu Chunhua, 1967. Private collection. Photograph by the Victoria and Albert Museum Photography Studio.

apprehension at changing identity by donning long gowns, even after Mao's death and a long way from home, reminds us how hard it was to negotiate a sartorially acceptable path in a society that was hemmed in by ideology.

"The Four Olds": Dress and Transgressors

When the Cultural Revolution was first unleashed, the student agitators known as Red Guards were instructed to attack elements of the old China. These were named as old customs, old habits, old culture, and old thinking, but were left undefined. Clothes were a highly visible and tangible target in all four categories and Red Guards, euphoric with power, would attack people in the street and use scissors to cut away what they perceived to be offending garments. These "offending garments" were not, in fact, outdated styles – rather the reverse – and the victims are remembered as being women. Clothes are often recalled as the items that were handed over or seized during brutal Red Guard raids.[4] In December 1966 Beijing's Exhibition Center exhibited the Capital City Red Guard Rebels' Victory Exhibition. Supposedly, two million (the numbers may be exaggerated) "outlandish outfits," the results of zealous ransacking, were on display, a cautionary tale made manifest.[5] By confiscating two-piece "'western" suits and qipao the Red Guards were symbolically divesting people of their outmoded attitudes. "A Marxism–Leninism for remolding the souls of the people" was what Mao had created according to a 1966 speech by Lin Biao (1908–71), then minister of defense and compiler of the *Quotations of Chairman Mao*. Clothes would become the outward sign of that inner remolding (fig. 115).

Dress was subsumed into the Maoist doctrine of "planned behavior." Mao himself said nothing in public concerning dress after he came to office in 1949, and by that time the Chinese Communist Party had already had twenty years to perfect a system of ideological control over the cultural life of its people. Relating the individual, physical body to the body politic was not something new for them. The tone was set for a collective identity, the boundaries of which remained fluid enough to shift with changing conditions but which were constantly and vigilantly policed by unsparing street committees on the domestic front and cadres in the workplace.

Setting the Limits: Frugality as Fashion

In China, during the period under discussion, men and women wore jackets and trousers of cotton or a cotton/synthetic mix. Clothes were often, but not exclusively, blue, and were cut full, concealing the contours of the figure. Underneath the jackets, which were padded for winter wear, were home-

115 Posing with the "Little Red Book,"
*c.*1966. Photograph from Kurt Mendelssohn,
In China Now (London, 1969), Plate 61.

knitted jumpers and white shirts and tops which, as the decade wore on, gave way to quiet plaids and patterns for women, especially the young. Blue or khaki flat caps, plastic sandals, cloth slip-ons, canvas laced shoes and nylon socks were other familiar items of dress.

The eminent journalist and writer Dai Qing (b. 1941), a subsequent supporter of China's democracy movement, recalls her enthusiasm for this frugal style of dress: "We lived simply and modestly, wore patched clothing, cut our hair short and combed it smooth. We believed our intellectual life was rich and pure. Luxury and pleasure were things we despised. After all, we were revolutionaries and how else could you imagine a revolutionary?"[6]

The Chinese word that conveys this sense of simplicity is *pusu*, and its constant repetition in different forms of state propaganda was understood to apply to all forms of consumption including dress, although this might not be mentioned by name. Such phrases, embedded in directives and slogans, the formulations of which were carefully controlled and manipulated, were homogenizing tools of the totalitarian state.[7] As such, they put limits, never otherwise practically spelled out, on what was acceptable clotheswise. It is pertinent to our subject that a contemporary dictionary definition of *pusu* gives "simply dressed" as the first example of the use of the phrase.[8]

In the unambiguous world of the party-state, just as sleek-fitting dresses signaled sexual laxity, so simple clothes manifested an inner spirit of *pusu*. "A Bundle of Clothes," a short homily published in 1969, tells how a graduating student from Hangzhou University challenged the dress norms of the period by throwing away her student clothes. As luck would have it, the inquisitorial

gaze of the Mao Zedong Thought Propaganda Team fell on the discarded threads and, on being questioned about her actions, she replied that now she had graduated she no longer needed them. Casting them aside was seen by both sides as a symbolic act. She, on the one hand, was shedding the skin of her student days, looking forward to a change in status. Her accusers, on the other, equated her prospective change of clothes with a desire to move away from the "revolutionary masses." She had thrown away "the qualities of the laboring people." Veteran workers salvaged the student's plain clothes, washed and dried them, folded them neatly and returned them to their contrite owner. On top of the pile was a piece of red paper bearing Mao's latest instructions about integrating with the workers, peasants, and soldiers. "I'll put on these precious clothes again which you have retrieved for me and gladly accept re-education," says the student at the end of the tale.[9] Clothes, although such very personal artifacts, can, nonetheless, be used to emphasize ideological agendas. By the time this story came out in 1969, the Red Guards had been disbanded and the Campaign to Purify Class Ranks was at the top of the Party's list. The tenor of the parable sits well with the aims of the campaign, which were to re-establish control over higher education and simultaneously to clamp down on ultra-Left excesses as well as any remnants of bourgeois thinking. A university education should not alienate you from your working-class roots, and the clothes you wear are a daily reminder of those roots.

The discursive power attached to the concept of *pusu* is powerfully shown through the contested figure of Premier Zhou Enlai (1899–1976), political target of the ultra-Left faction, whose death in January 1976 – just a few months before that of Mao Zedong – provoked a spontaneous outpouring of grief by the Chinese people. In their eyes, his life was seen as a symbol of moderation in tumultuous times. However, there is a dichotomy between Zhou's moral rectitude and the way he looked. His well-fitting suits in good-quality cloth did not accord with the ideals of *pusu*, but there is more to the problem than that (fig. 116). Even in his Yan'an days, when the Communists were still renegades in the remote countryside, Zhou, despite shabby clothes, retained a distinctly debonair presence that never escaped him whatever he wore. As Mao consolidated his control over China, the chairman's tailor went to considerable lengths to show the leader off to best advantage. Zhou Enlai's generally acknowledged inherent good looks made it necessary to manipulate his image, after his death, to emphasize his allegiance to the spirit of *pusu* so that it could stand in opposition to that of the perpetrators of what is seen as ten years of excess.

Deng Xiaoping (1904–97), who, after several falls from grace during his long career, would eventually rise to become China's pre-eminent leader after Mao's death was, at the time of Zhou Enlai's demise, the vice-premier, and it fell to him to give the eulogy at Zhou's state funeral. That it was Deng and not Mao who read the address raised questions about the possible opposing parts

played by Mao and Zhou during the Cultural Revolution. The excuse for Mao's absence from the funeral was illness, but the words of the oration, read by millions in the Chinese press that had little else but that to report, struck a chord with a people who would be increasingly encouraged to see Zhou as a counter to the Revolution's intemperance: "We should learn from his fine style – being modest and prudent, unassuming and approachable, setting an example by his conduct, and living in a plain and hard-working way. We should follow his example of adhering to the proletarian style and opposing the bourgeois style of life."[10] Echoing these sentiments, *China Pictorial*, a magazine propounding the merits of the socialist state and published in several different languages, produced a commemorative issue for Zhou Enlai in what would have been his eightieth year: "All his life, Premier Zhou Enlai as a proletarian revolutionary maintained a style of thrift and industry and arduous struggle."[11]

It is significant for our theme that the pictures alongside this text articulate Zhou's virtues in clothing terms. One photograph shows a pair of cloth shoes specially made for the premier's swollen feet during his last illness. He apparently wore them when he insisted on struggling from his sickbed to greet Kim Il Sung (1912–94), North Korea's autocratic communist ruler. The other photograph is of Zhou's twenty-year-old leather shoes, still serviceable, his patched shirts, and his darned socks, along with the darning block used by the premier himself. These items of Zhou Enlai's wardrobe were reverently put on display in an exhibition about his life staged at the Museum of Chinese History. The fact that they are preserved at all is a telling tribute to the power of clothes. The choice of these articles for posterity sets out to legitimize Zhou as heir to the ascetic, industrious, and committed aspects of revolution, a compelling negation of the indiscipline of the 1960s and 1970s as exemplified by the notorious Gang of Four.

These radical leaders of the Cultural Revolution were arrested in the same year that Zhou Enlai died, following Mao's own death. Amongst a plethora of accusations brought against Jiang Qing (1913–91), one of the quartet and Mao's widow, was the fact that she had paid too much attention to her own appearance. It was rumored that she had permed her hair, worn luxurious silks, and ostentatiously appeared in public at Mao's funeral with a veil over her head. Her extravagances, real or fabricated, were set against Zhou's frugality. Wearing a red sweater beneath a Mao jacket, as Jiang Qing was reported to have done at Zhou Enlai's memorial service, may go unremarked by those not conversant with the significance of the color to Chinese people who were scandalized by such a show of joy. Red is a happy occasion color in China, inappropriate for such solemnity and doubly so as it became generally known that a rift had developed between her and Zhou. She rejoiced at his passing.[12] Clothing affairs, often no more than vignettes within broader concerns can, nonetheless, give us the flavor of the times. By understanding that Madame Mao had transgressed the limits of what was thought reasonable, a transgression

In Deep Memory of Esteemed and Beloved Premier Chou En-lai

CHINA 1977 1

116 Premier Zhou Enlai from a commemorative issue of *China Pictorial*, January 1977.

which from other cultural standpoints may not seem extreme, we learn what was expected of China's population in matters of dress.

Uniforms versus Uniformity

In the western imagination, the Chinese Communist Party transformed the people of China into an army of blue-uniformed revolutionaries. In reality, the Chinese civilian population did not wear a uniform even during the Cultural Revolution. No dress regulations were promulgated. It would not have suited the Chinese leadership to have everyone dressed alike, for clothes were a key factor in class distinction. Right from the beginning of the People's Republic, a system of classifying people was in operation, and it was to be refined and redefined time and time again. It reached new heights in parts of China during the Cultural Revolution years.[13] The communist elite's obsession with pigeonholing the population tells us just as much about them and their anxieties over maintaining order as it does about those who were labeled.

Trying to be anonymous, pretending to be someone you were not, falling in with the crowd or, like the student in the story, forgetting your class origins – all these could be achieved by how you looked and were the exigencies that contributed to a commonality of dress. The trick was to match your appearance to the label assigned to you and to be alive to the nuances of changed directives from above. For most people this meant a sartorial sobriety that verged on the boundaries of a uniform, although everyday Chinese garb of this period lacked the uniform's clarity and precision. Like the uniform, however, it went some way toward suppressing individuality.[14]

To temper the received view of these years, however, there is evidence to suggest that many of "those who were labeled" retained a lively interest in clothes despite the privations. The restraints meant that people did not have very many clothes, so when they did buy something new it was imperative to choose with care. Material would be sized up in the store, its weight, color, and feel vetted and fretted over. Advice from those who were merely window shopping was quickly forthcoming. It was one of the ways people were able to engage in banter in a state system where gossip could be synonymous with informing. Dress concerns, of this sort at least, were seen as a relatively safe arena for exercising judgment, skill, and choice. The placement of pockets, the stitching of a seam, the depth of a collar and the suitability of the buttons were all details to engage the discerning dresser. A personal touch could be instilled by striped gloves knitted from leftover pieces of wool, and hand-knitted jumpers themselves could be uniquely fashioned. One Chinese girl wore a beautiful white sweater made by a relative who unraveled five pairs of cotton work gloves. Even Mao badges, those most ideologically correct accessories, could be collected, swapped, pinned at various angles and in varying formations

(fig. 117). That their sartorial antennae had not been dulled by an overreaching state is clear from the homage people still paid to the metropolis of Shanghai as the cutting edge leader of everything that was stylish. Jacket pockets had special stitching one year in Shanghai and the trend reached Beijing two years later.[15] Foreign visitors recall how, during the second half of the Cultural Revolution decade, some of their Chinese hosts, the young especially, scoffed at what the foreigners regarded as much-prized handwoven fabric from rural China. Conversely, long queues would form whenever any new textiles appeared in the shops.

The interrelatedness of uniforms and non-uniforms at this chaotic time in China, notwithstanding the small touches, demonstrates how far the state viewed clothes as the visible expression of a moral system as well as a means of control. While civilian clothes were limited in their diversity and became more "uniform" – one common style of jacket was even called a *zhifu* (uniform clothing) – the organization of the army ostensibly came to reflect civilian life by becoming more egalitarian. In 1965 ranks and insignia were abolished in the People's Liberation Army, concealing the officer class, but the gesture did not prevent the military from exerting a high degree of control over the population. An army uniform, in whatever way it was configured, was still emblematic of power, and by dressing the urban youth in near-facsimiles of PLA uniform at the beginning of the Cultural Revolution, Chairman Mao was empowering them and legitimating their actions.

Their younger sisters and brothers, meanwhile, were taking up the red scarf of the Young Pioneers. The square of red cotton, not an entire uniform but an abbreviation of one, is remembered by some who later became Red Guard activists as being the very embodiment of revolutionary ideals. It was imbued with so much glory and myth that children felt compelled to keep it clean, wear it correctly, and never lose it. Enrollment in the organization was restricted, and those who remained without a scarf were marked out as rejects. Both the scarf and the PLA uniform, at certain times during the Cultural Revolution decade, came to signify something other than that originally intended.

The scarf provided older children with a focus for rebellion. It was something they could physically manipulate and boys, especially, left off wearing it, let it get dirty and crumpled it up. The scarf's "symbolic shorthand" could cut both ways.[16] As the Cultural Revolution years unfolded, the army uniform too took on a new shade of meaning for an elite few. Children whose parents were high up in the military felt themselves to be superior and to have an inborn right to a position of power when they in turn grew up. For some of these children, wearing their fathers' old army clothes became a status symbol, imbuing them with enviable heroic qualities and giving them the privilege of looking different from their peers. Their monopoly did not last long, and the "military look" was taken up generally as a clothing trend.[17] In the late 1960s

117 A selection of Mao badges from the collection of the Victoria and Albert Museum. Ian Thomas, photographer. Courtesy of the Trustees of the Victoria and Albert Museum.

large numbers of China's youth traveled around the country spreading the message of the Cultural Revolution. Many were arrogant and hot-headed adolescents, and one of them, Ma Bo, gives us an alternative, perhaps more honest, view of the time than the predictable memoirs formatted for a non-Chinese audience. He admitted to enjoying the violent atmosphere and the freedom it gave him to be a tough guy. He sported chains around his wrist and a knife stuck in his belt. His leather trousers were grimy, torn, and patched. His "uniform" had been broken down to its guerilla basics.[18]

The link between external looks and inner conviction was fundamental to the narrative of the state. How you looked created an observable relationship with the ideology of the time. Politico-economic factors determined a desirable uniformity of appearance rather than a uniformed one. The visual culture of communism depended on conformity, with the concomitant loss of individuality. This is exemplified by outdoor parades and indoor Party functions. Photographs of the successive National Congresses of the Communist Party of China held in the Great Hall of the People give an idea of the magnitude that swallowed people's separate identity (fig. 118).[19] The vast spaces of this austere public building, flanking the west side of Tiananmen Square in Beijing, swamp the individual. Row upon row of anonymous delegates are framed by the iconic architecture of the hall. Inappropriate clothes, hairstyles or accessories would have stood out immediately in such an awesome gathering. These things were sacrificed as part of the whole. Wearing the same as your neighbor and matching your bodily decorum to theirs signaled your engagement with the state.

There was no place for corporeal chaos. Clothes and bodies awry defied the visual expectation of the state. This is taken to its limits when people are choreographed in such a way as to form giant pictures.[20] These truly breathtaking tableaux, enacted in sports stadiums in authoritarian states the world over, are the acme of uniformity in dress and body language. Creating a giant image of Chairman Mao with thousands of human brushstrokes can be seen as a paradigm for the way the state controlled people's lives. Susan Brownell has commented how mass calisthenics at sporting events in China are a supreme example of the synchronization of the rhythms of the social body.[21] One person out of line disrupts the whole. The picture fragments into anarchic abstraction.

118 The Twelfth National Congress of the Communist Party of China in the Great Hall of the People, Beijing, September, 1982. Photograph from *Renmin da Huitang (1959–1989)* (The Great Hall of the People, 1959–1989). (Xianggang/Hong Kong, 1989), Plate 43.

Setting the Limits: The Material Restraints on Dress

The state's disapproval of any preoccupation with individuality was reinforced by the scarcity of consumer goods. China's limited economic base narrowed down options for dressmaking, and, although on occasion there was a range of different textiles on offer in large urban stores, choice was restricted by low

income and rationing. The stated aim of the cotton industry was to provide enough material to clothe China's millions adequately, but cotton exports also earned valuable foreign currency. To reconcile domestic and export demands, rationing was introduced in 1954, and quotas were set annually and announced in the local newspapers. By 1969 the average amount of cotton per household was fixed at six meters; we should bear in mind that inventive dressing was also curtailed by the selective rationing of other items besides cotton. For example, from 1961 coupons were needed in Beijing for cotton thread, yarn, synthetic fiber, wool, silks, shirts, underwear, shoes, and stockings.[22] Shortages of cotton and its rationing to ensure an egalitarian distribution encouraged the buying of material and clothes only when a garment was beyond repair. New clothes were for replacement purposes; shopping was not meant to satisfy an appetite for change.

Role Models minus the Looks

During the Mao era, clothing as a topic of interest in its own right came to public attention only briefly in the mid-1950s, when a state-orchestrated women's dress reform movement was allowed to surface.[23] In the widely disseminated magazines *Zhongguo funü* (Women of China) and *Zhongguo Qingnian* (China Youth), discussion of dress design temporarily replaced stories in which flashy clothing is treated as both the cause and the symptom of immoral behavior.[24] This more moralistic line was quick to return during Mao's ill-starred and famine-inducing Great Leap Forward (1958–61).[25] Echoes of this campaign's insistence upon mass mobilization for higher production levels reverberated through the Cultural Revolution period. The importance of bulk production of cloth, eliding any expression of ways it might be used effectively for dressmaking, was emphasized in the media by stories of model workers who produced particularly high yields from their fields or broke the speed limits of their spinning or weaving machines. Human tools radiantly playing a role in the economic life of the country was the scenario put forward by the communist propaganda machine. What these model workers did was far more important than what they looked like, and although billboard posters, a ubiquitous feature of Chinese street life, depicted good communist types in some detail, newspapers and periodicals distributed within China were poorly illustrated, ensuring that the named workers in these inspirational stories were remembered for their actions not their clothes. *Zhongguo funü*, the national magazine that had carried dress patterns, ceased publication during the Cultural Revolution.

Rising reverence for the virtues of self-sacrifice and self-reliance in the Cultural Revolution and the years leading up to it were seen as incompatible with concerns about appearance. These prudent qualities were propounded in

the *Quotations of Chairman Mao*, first brought together in 1963 and issued to the army, but soon made available to everyone in the form of a small, red plastic-covered book. As one woman remembers, the book became "an essential part of every Chinese, as important as his shirt or trousers and just as necessary for protection."[26] The posthumous *Diary of Lei Feng*, the story of a young soldier's fervent devotion to the revolution, published in the same year as the *Quotations*, was designed to dispel ambiguities about how to respond to a remodeled society where Chairman Mao was a god on earth and his thoughts the "supreme instructions." Clothing's propensity to dissemble did not sit squarely with the stories of heroes like Lei Feng, who played out their lives with such unwavering certainty.

Hero emulation was one of the mainstays whereby the Party attempted to mold people's characters. Nationwide campaigns circulated tales of these selfless individuals who carried out simple good deeds and often died attempting to save others. Because heroism is synonymous with individual honor, Chinese communist heroes were caught in a dilemma. Personal glory was not comparable with Maoism.[27] The fact that dress is never an issue in these stories has a lot to do with the way readers were supposed to view the idealistic men and women portrayed in them. Paying or drawing attention to a hero's clothes emphasizes the hero rather than the deeds. Ignoring dress, conversely, is a device for establishing modesty and anonymity.

Dress, Visual Imagery, and the State

There is very little evidence of what motivated people's choices in dress at this period. However, there is an enormous amount of evidence about how they were represented to themselves by the propaganda organization of the party state. Early on, in the first years of the new nation, photographic portraits of a single person shot from a close range were a familiar visual format. They took their cue from Soviet precursors showing muscular state heroes and radiant heroines. A photograph album published in 1952 and containing images that would have been widely disseminated includes, for instance, a photograph of a young farm girl taken from a low viewpoint to make her appear monumental. She is smiling broadly. Most of her clothes are hidden by the ripened sheaf of corn she carries in her arms and which almost swamps her with its largesse. The caption, making no reference to the model at all, is "The whole country again enjoyed a bumper harvest of wheat in 1952, the total output being about 15 percent above that of 1950."[28] Not very much later, the single subject framed against a plain background has been replaced by quite a different setting. The redistribution of land into people's communes from 1955 signaled the changeover. Now, people became part of a landscape. The girls standing amid the sesame flowers blend with the tall plants (fig. 119). They are subsumed by

119 Pruning sesame in Hubei Province. Photograph from *People's Communes* (Ministry of Agriculture, People's Republic of China; Beijing: Foreign Languages Press, 1960).

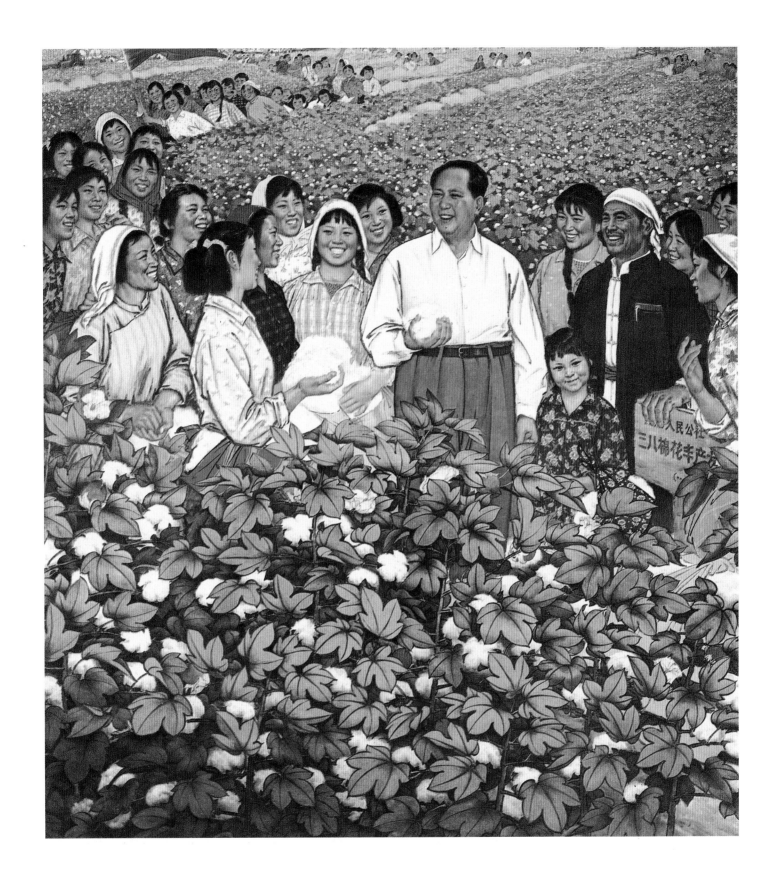

the growing stalks for as far as the eye can see. People were visually indoctrinated into seeing themselves as part of a whole.

Staged propaganda photographs and performances, however much they are airbrushed and orchestrated, still, arguably, do not give the same control as graphic representations. That is why the balance of photographs to posters tipped in favor of the latter as the politics of the 1960s tightened its freezing grip on society. By comparing a photograph from the second half of the 1950s with a poster from the 1970s we can see how painted images can more easily be manipulated (figs. 120 and 121). The subject matter in both is much the same. Chairman Mao, triumphant, processes through the rural acres overflowing with bounteousness. The people rejoice much more fervently among the cotton bolls because the medium allows their smiles to be wider, their dress to be more colorful and varied, their cheeks to be rosier. One artist, Li Huasheng (b. 1944), who, during the Cultural Revolution, kept his hand in at painting by producing the prescribed images, thought he could save paint for his clandestine work by putting thin layers on his Mao pictures. However, the result was too much of a departure from the standards. He recalls "The principal standards for painting Mao were *hong, guang, liang* – red, bright, and shining. For the red flag, and for the star on Mao's cap, only the purest red pigment could be used. And one couldn't use any gray for shading."[29]

The dressed bodies of these idealized peasants in an edenic setting are what confronted the real people of China everywhere they turned (fig. 122). These hyperrealistic scenes, towering over people's lives in the form of huge billboards and on sale in smaller format very cheaply indeed, had no rivals in a China very largely closed-off to outside influences of any sort until the visit of President Richard Nixon to the People's Republic in February 1972. Indeed, momentous as such states visits were politically, ordinary American visitors in the era of "ping-pong diplomacy" also served to give Chinese people a glimpse of how others presented themselves.

That photography was a mendacious medium in the wrong hands was forcefully expressed in attacks by the Chinese authorities on the documentary film *China*, made by Michelangelo Antonioni, the Italian film director, in the People's Republic in the early 1970s. They derided his use of dim colors, accused him of taking sneak shots, and exposed him for pasting together a medley of scenes: "Did he not work hard in cities and countryside to describe people as 'poorly dressed' in order to spread the false impression that one could meet 'poor people' everywhere in China?" Antonioni's critics were very much alive to dress as the most noticeable of signifiers: "On another occasion he got people to change clothes to suit his purpose, otherwise he would not take any pictures."[30]

By contrast, national exhibitions of Chinese photographers' work from the 1960s and 1970s, both amateur and professional, depict scenes that are predictable. Clearly, the unalloyed joy radiating from these photographs of

120 (*page 180*) Chairman Mao inspecting a sorghum crop in Henan Province. Photograph from *People's Communes* (Ministry of Agriculture, People's Republic of China; Beijing: Foreign Languages Press, 1960).

121 (*previous page*) *Chairman Mao inspects the Cotton Harvest*. Poster from *Nianhua xuanji, 1975* (Selected New Year Pictures, 1975) (Beijing: Renmin meishu chubanshe, 1975).

people felling timber in snowy forests or going to an evening class does not reflect reality.[31] This was not the point of photography in China. Susan Sontag, in her analysis of the ways photography influences our perceptions of the world, sees photographs in China displaying what has already been described. What we call clichés, the Chinese call "correct" views.[32]

It is somewhat surprising, therefore, to find photography playing a part in matters of Chinese self-fashioning. It unspectacularly transcended the divide between personal and national interests and was careful not to disturb the regnant ideologies. For those living in a regime of panoptic socialist surveillance there was a paradoxical freedom in displaying the self to a singular vision. Urban Chinese were able to afford and own their own cameras by the 1960s. Courting couples especially, but increasingly also family groups and workers' organizations on outings to beauty spots and historic sites, took photographs of each other. At the Chinese New Year Festival in the early 1970s, Tiananmen Square in Beijing was crowded with people trying out their new cameras. People who did not have cameras formed long queues behind government photographers whose tripods dotted the square. The sitters

122 *Setting Out on Campaign*, poster by Wang Shun. From *Nianhua xuanji 1975* (Selected New Year Pictures, 1975) (Beijing: Renmin meishu chubanshe, 1975).

smoothed their hair and adjusted their clothing. They carefully took up a position. A cherished watch was revealed by folding back a cuff before the shutter clicked. A "good" profile was turned towards the lens. There were choices to be made. Marc Riboud (b. 1923), the renowned Magnum photographer and an inveterate recorder of the Chinese scene over a period of some forty years, never posed his subjects although he clearly enjoyed the stasis of a posed photograph and recognized the genre as almost cathartic for people whose lives were mainly controlled by external forces. Several of his works show Chinese photographers and their formally positioned subjects.[33] The girl in Shanghai (fig. 123) is being photographed by her fiancé who in turn is being captured on film by a European photographer. Riboud, ever sympathetic to China, took this picture in the first half of the 1960s just before the Cultural Revolution. When he published it in 1966 he gave a political spin to the caption:

> New Elegance in Shanghai. This glamor-girl has even put on lipstick to be photographed by her fiancé. She is posing in front of a building in a public park which was formerly the property of an extremely wealthy Shanghai businessman. The authorities are proud that feminine stylishness bears witness to an improvement in living standards, but at the same time are concerned lest it be a sign of growing revisionist mentality.[34]

The "growing revisionist tendency" was what the Cultural Revolution set out to dispel, yet private photography was not banned at this time. People's sense of their corporeal selves was, of course, circumscribed by the orthodox and limited vision of the times, as when women on a trip to the Great Wall of China were seen taking up the stance of revolutionary operatic heroines for a friend's camera.[35] However, although all of these people were posing, none of them was posing for the state.

Cameras were tolerated up to a point, but those other self-reflecting devices, mirrors, were deeply distrusted. While billboard posters might serve as mirrors in one sense, they gave back a reflection of what the Party machine wished its subjects to look like, not one that evoked notions of introspection. Real mirrors, associated with vanity and self-contemplation, ceased to exist in public places, except those used by foreigners, in the China of the Cultural Revolution period and beyond. Right up until the late 1980s, it was not always possible to try on garments before buying. There were no changing rooms in the shops, although some large Beijing department stores had a rack of used jackets to be employed just for gauging the size, not for seeing if the style or color suited.

A poem, written by an anonymous malcontent towards the end of this troubled decade, vented anger indirectly at Mao's dictatorship by criticizing his wife Jiang Qing. She was not named in the poem, although from the title it was clear that the piece referred to her. Called "To A Certain Woman," it begins like this:

123 Photograph of a young girl in Shanghai, mid-1960s, by the French photographer, Marc Riboud. Courtesy of Magnum Photos.

You must be mad
To want to be an empress!
Here's a mirror to look at yourself
And see what you really are.
You've got together a little gang
To stir up trouble all the time,
Hoodwinking the people, capering about.[36]

This dissenting voice, by offering a mirror, invites an unwelcome kind of self-appraisal, different from the pressurized, constant self-evaluation demanded by a totalitarian governance. As societal control gradually loosened in the period after the death of Chairman Mao in 1976, the narrative of the clothed figure changed and diversified. China's cities gave promise of a new kind of life where *pusu* was no longer a desirable attribute. When the late Zhou Enlai's sanctified clothing was put on display in Beijing in 1978, a color poster was issued that served to reinforce the virtue of *pusu*, an attribute he was supposed to have wholeheartedly embraced. Entitled *Premier Zhou shares our Happiness and Hardship*, it has self-sufficiency as its theme. It depicts the deceased premier himself, Gandhi-like, at a spinning wheel with a peasant and some Eighth Route Army soldiers. The wheel is inscribed with the message "Exert oneself to provide ample food and clothing."[37] There is an irony here in that, during the years shortly after Premier Zhou's death, city shops provided China's newly fashion-conscious youth with tailored blue denim jeans. These ubiquitous trousers are associated in the West, from where they originated and, despite designer labels, with romanticized ideas of equality, the common man, unpretentiousness, and simplicity.[38] This list of attributes could be defined in Chinese by one phrase, *pusu*.

The students tentatively trying on the long robes and gazing at themselves in the mirror of a foreign friend in London in 1977 stood on the cusp of a new era of selfhood in a rapidly commercialized China. In the 1980s and 1990s, as the state withdrew from attempts to control quotidian personal behavior, the equally demanding dictates of fashion and cultures of consumption were to provide new mirrors in which the Chinese could see themselves (fig. 124).

124 Photograph from a professional photographer's studio window, Wuhan, 1981. Photograph by John S. Major.

Notes

Introduction

1 Dr. A. F. Legendre, *La Civilisation chinoise moderne* (Paris: Payot, 1926), p. 86.

2 John E. Vollmer, *Decoding Dragons: Status Garments in Ch'ing Dynasty China* (Eugene: University of Oregon Museum of Art, 1983).

Chapter 1

1 Watt and Wardwell, *When Silk Was Gold*, p. 116.

2 Ssu-ma Ch'ien, *Shi Chi*, 8, trans. Burton Watson, *Records of the Grand Historian*, rev. ed., 2 vols. (New York: Columbia University Press, 1993), vol. 1, p. 51 .

3 *Huainanzi*, chap. 5, the "Treatise on the Seasonal Rules," trans. by John S. Major, in *Heaven and Earth in Early Han Thought: Chapters Three, Four and Five of the Huainanzi* (Albany: SUNY Press, 1993), pp. 238–9. This treatise is one of several surviving versions of an early text called the Yue ling or "Seasonal Ordinances," which prescribes the ritual behavior of the emperor and his court throughout the year.

4 *Analects* XIV.18.2

5 Rawski, *The Last Emperors*, p. 40.

6 Mencius IV.II.XXIX.6–7

7 Prof. Eric Henry, University of North Carolina; private communication.

8 *The Book of Guanzi* 1, 4, tr. in W. Allyn Rickett, *Guanzi: Political, Economic, and Philosophical Essays from Early China*, vol. 1 (Princeton: Princeton University Press, 1985), pp. 108–9, translation slightly modified by JSM.

9 *Yan tie lun*, quoted in Martin J. Powers, *Art and Political Expression in Early China* (New Haven and London: Yale University Press, 1991), citing the translation of Essen M. Gale, *Discourses on Salt and Iron* (Leiden: E. J. Brill, 1953).

10 Chen Yao quoted in Brook, *The Confusions of Pleasure*, p. 220.

11 Sima Qian, *Shiji*, chap. 112, trans. Burton Watson, *Records of the Grand Historian of China*, rev. ed., 2 vols. (New York: Columbia University Press, 1993), vol. II, pp. 189–90.

12 Barber, *The Mummies of Ürümchi*, pp. 75–6, 141–3.

13 This division of labor was widespread in the ancient world, of course; compare the English catch-phrase "Adam delved and Eve span."

14 See Bray, "Textile Production and Gender Roles in China." See also her recent book, *Technology and Gender*. But in early modern times (the Ming and Qing periods) just as in early modern England, the industrialization of textile production led to an increase in the number of male weavers working for wages or on a piecework basis.

15 Zhang Hou quoted in Brook, *The Confusions of Pleasure*, p. 221.

16 See Angela Sheng, "The Disappearance of Silk Weaves with Weft Effects in Early China," *Chinese Science* 12 (1995).

17 Garrett, *Chinese Clothing*, p. xiii.

18 See the chart of rank badges in Garrett, *Chinese Clothing*, p. 15.

19 Mrs. Archibald Little, *Intimate China* (London, 1901), p. 124, quoted in Wilson, *Chinese Dress*, p. 52.

20 In the famous formulation of Joseph Levenson, the transition from the imperial to the modern era required the Chinese to accept a complex and difficult shift in world-view: from "all under heaven" (*tianxia*) as the proper realm of the emperor of China, to one "nation-state" (*guojia*) among many. See Levenson, *Confucian China and its Modern Fate* (Berkeley: University of California Press, 1958, 1965), pp. 132–9.

Chapter 2

1 Ko, *Teachers of the Inner Chambers*, p. 148.

2 Ko, "The Body as Attire", p. 15.

3 Ebrey, *The Inner Quarters*, pp. 38–9.

4 Feng Jicai, *The Three-Inch Golden Lotus*, p. 236.

5 Cited in Ebrey, *The Inner Quarters*, p. 40.

6 Ebrey, *The Inner Quarters*, pp. 42–3.

7 Ko, *Teachers of the Inner Chambers*, p. 149.

8 Ibid., p. 263.

9 Ibid., p. 150.

10 Ibid., p. 171.

11 Isabella Bird, *The Golden Chersonese and the Way Thither* (first published London, 1883; reprinted, Singapore: Oxford University Press, 1990), p. 66.

12 Ko, "The Body as Attire," pp. 17–19.

13 Finnane, "What Should Chinese Women Wear?" pp. 107–108.

14 Ibid., p. 106.

15 Ibid., pp. 111–112.

16 Ibid., p. 111.

Chapter 3

1 The Chinese term, more precisely, is *Zhongshan zhuang*, or "Zhongshan suit," after Sun Yat-sen's *nom de guerre*, Sun Zhongshan (Central Mountain Sun).

2 Scott, *Chinese Costume in Transition*, p. 65–6.

3 Ibid., p. 99.

4 Ibid., p. 100.

5 Nien Cheng, *Life and Death in Shanghai* (London: Grafton, 1987), p. 85.

6 Kei-king Lam, personal account to the authors.

7 See for example Ch'en Jo-hsi's chilling story "Residency Check" in *The Execution of Mayor Yin and Other Stories from the Great Proletarian Cultural Revolution*, trans. by Nancy Ing and Howard Goldblatt (Bloomington: Indiana University Press, 1978), describing how a Shanghai woman living in Nanking in the 1960s is subjected to vicious attacks and accusations of immorality because she persists in wearing attractive and fashionable clothing (clothing that is actually quite modest, but

anathema to the fanatical standards of the Cultural Revolution).

8 Harold C. Hinton, ed., *The People's Republic of China 1949–1979: A Documentary Survey, vol. 3: 1965–1967, The Cultural Revolution, part I* (Wilmington, Delaware: Scholarly Resources, 1980), p. 1700.

9 We were given an account of this episode in the history of Chinese fashion by Miss Chen, our guide on a 1979 trip to China, and her mother. The account seems credible, but we have not been able to find documentary evidence of Jiang Qing's efforts as a fashion designer.

10 The draconian "one-child-per-family" population control program that attracted such condemnation in the West for its excesses of zeal was a phenomenon of the post-Mao era, inaugurated in 1978.

11 Steele, "Fashion in China," p.10.

12 Ibid., pp. 10–11.

13 Christopher S. Wren, "Peking's Fashion Code Leans Toward the Don'ts," *The New York Times* (October 18, 1983), p. A2.

14 Steele, "Fashion in China," p. 15.

15 *Chinese Clothing* (Beijing: *China Reconstructs*, 1985), p. 11.

16 Linda Jakobson, *A Million Truths: A Decade in China* (New York: M. Evans and Co., 1998), p. 159.

Chapter 4

1 Quoted in Legrand-Rossi, *Touches d'exotism*, p. 199.

2 Chu, "Artificial Flavour," pp. 10–11.

3 *Beijing Scene* (June 1–14, 1995), p. 3, quoted in Antonia Finnane, "What Should Chinese Women Wear?" pp. 125–6.

4 Chu, "Artificial Flavour," p. 12.

5 Legrand-Rossi, *Touches d'exotism*, p. 187.

6 Ibid., pp. 189–93.

7 Honour, *Chinoiserie*, p. 31.

8 Robert Fortune, *Wanderings in China* (1847), quoted in Honour, *Chinoiserie*, p. 199.

9 Florence Winterburn, *Principles of Correct Dress*, quoted in Barbara Burman Baines, *Fashion Revivals from the Elizabethan Age to the Present Day* (London: B.T. Batsford Ltd., 1981), p. 171.

10 "Dora Wong Translates the East for the West," *Dallas Times Herald* (December 8, 1965), p. D6.

11 "The Chinese Look: Mao à la Mode," *Time* (July 21, 1975), p. 52.

12 Valerie Steele, "Orientalism: Asian Themes in Western Fashion," paper given at the annual meeting of the Costume Society of America, Seattle, June 1993.

13 *Women's Wear Daily*, various issues, 1997.

14 "Paris Couture: Splendor, seduction . . . the pleasure principle," *Vogue* (October, 1977), pp. 260–65.

15 Charlotte Du Cann, *Vogue Modern Style* (London: Century, 1988), p. 58.

16 Thierry Mugler, "Mode Aventure: Bleu Sans Frontiers," *Vogue Hommes* (March 1985), p. 144.

17 The Helmut Newton photograph was on the cover of *Photo* (May 1993).

18 Du Cann, *Vogue Modern Style*, p. 56.

19 *Intimate Architecture: Contemporary Clothing Design*. Catalogue for an exhibition held at the Hayden Gallery, Massachusetts Institute of Technology, May 15–June 27, 1982 (Cambridge, Mass.: Committee on the Visual Arts, 1982), n.p.

20 Personal communication from Yeohlee, 1998.

21 Julia Szabo, "The China Syndrome," *Newsday* (March 26, 1998), p. B35.

22 Kin Yeung, introduction to the 1998 Blanc de Chine catalogue.

Chapter 5

1 Ouyang Xiu et al., *Xin Tang shu* [The new book of Tang], [1081 C.E.] (Beijing: Zonghua shuju, 1975), p. 879.

2 *Quan Tang shi* [Complete Tang poetry anthology] (Beijing: Zhongguo shuju, 1979), p. 4396. This poem is cited in Li Xiaobing, *Zhongguo xiyou minzu fushi yanjiu*, p. 128.

3 Ouyang Xiu et al., *Xin Tang shu*, p. 531.

4 *Quan Tang shi*, p. 4636.

5 Ibid., pp. 4616–17. This poem is cited in Schafer, *The Golden Peaches of Samarkand*, p. 28, where the poem is given a slightly different translation.

6 *Quan Tang shi*, p. 4705.

7 Ouyang Xiu et al., *Xin Tang shu*, p. 879. This passage is cited in Xiang Da, *Tangdai Chang'an yu xiyou wenming*, p. 47.

8 *Quan Tang shi*, p. 9050.

9 Ouyang Xiu et al., *Xin Tang shu*, p. 531.

10 John S. Major, personal communication.

Chapter 6

1 Yu Qing, "Hong zhuang su guo" ["Red" clothing, white gaiters], in *Lao zhaopian* [Old photos] (Jining: Shandong huabao chubanshe, 1996), pp. 90–92.

2 Stuart R. Schram, ed., *Mao's Road to Power: Revolutionary Writings 1912–1949: Volume 1: The Pre-Marxist Period, 1912–1920* (Armonk, N.Y.: M. E. Sharpe, 1992), p. 353.

3 Wang Ermin, "Duanfa, yifu, gaiyuan: bianfa lunzhi xiangwei zhiqu" [Cutting hair, changing dress, altering the calendar: symbolic intentions of reform], in *Zhongguo jindaide weixin yundong – bianfa yu lixian taojihui* [Research Conference on the modern Chinese reform movement – reform and the establishment of the constitution] (Taipei: Institute of Modern History, Academia Sinica, 1981), p. 61.

4 Wang Ermin, "Duanfa, yifu, gaiyuan," p. 62.

5 Ralph Powell, *The Rise of Chinese Military Power, 1895–1912* (Princeton, N.J.: Princeton University Press, 1955), p. 246.

6 William Ayers, *Chang Chih-tung and Educational Reform in China* (Cambridge, Mass.: Harvard University Press, 1971), pp. 205–9.

7 See Susan Brownell, *Training the Body for China: Sports in the Moral Order of the People's Republic* (Chicago: University of Chicago Press, 1995), p. 38.

8 See, e.g., the advertisement in *Shishi huabao* [Current events pictorial (Guangzhou)] 4 (March 1906): 2a.

9 See class photos of the foreign language school in Beijing in 1904, in Wang Wenyuan, ed., *Yuan Shikai yu beiyang junfa* [Yuan Shikai and the Northern Army regime] (Hong Kong: Commercial Press, 1994), pp. 29–31.

10 Powell, *Rise of Chinese Military Power*, p. 192.

11 Sally Borthwick, *Education and Social Change in China: The Beginnings of the Modern Era* (Stanford: Calif.: Hoover Institution Press, 1983), p. 82.

12 *The Times*, Saturday, October 21, 1911, p. 6. See also Donald Sutton, *Provincial Militarism and the Chinese Republic: The Yunnan Army, 1905–1925* (Ann Arbor: University of Michigan Press, 1980), pp. 14–20.

13 Tong Te-kong and Li Tsung-jen, *The Memoirs of Li Tsung-ren* (Boulder, Colo.: Westview Press, 1979), p. 21.

14 Sun Fuyuan "Xinhai geming shidai de qingnian fushi" [Young people's dress in the period of the 1911 revolution] in *Sun Fuyuan sanwen xuanji* [Selections from the Collected essays of Sun Fuyuan], (Tianjin:

Baihua wenyi chubanshe, 1991), pp. 184–5.

15 Godley, "The End of the Queue," 65–6.

16 Sheng Cheng, *A Son of China*, trans. Marvin McCord Lowes (London: George Allen and Unwin, 1930), p. 206.

17 Aiguo ziyouzhe Jin Yi [Jin Tianhe], *Nüjie zhong* [Warning bell for women], (Shanghai: 1903), p. 15.

18 Chang, "Chinese Life and Fashions,": 66–73.

19 See Tanya McIntyre, "Picturing Women in Chinese New Year Prints."

20 Cited in Tao Ye, "Minqu funü de xinzhuang," [New fashions among women in the early Republic], in *Lao zhaopian*, p. 105.

21 Sheng Cheng, *A Son of China*, p. 198.

22 See Finnane, "What Should Chinese Women Wear?: 115–23.

Chapter 7

The author wishes to acknowledge the invaluable advice of Prof. Ng Chun Bong, of Chinese Baptist University, Hong Kong.

1 Lu Xun, "Anxious Thoughts on 'Natural Breasts'" (1927), in *Selected Works*, II, p. 353.

2 Ibid.

3 Georg Simmel, "Fashion," *International Quarterly* 10 (October 1904), quoted in Valerie Steele, *Women of Fashion* (New York: Rizzoli International Publications 1991, p. 40.

4 See Ng Chun Bong et. al, *Chinese Woman and Modernity*, for a helpful overview of the calendar posters and their historical context.

5 Chen Duxiu, "Xin Qingnian xuanchuan" (New Youth Manifesto), *New Youth* 7.1 (15 November 1919).

6 Lu Xun, "Anxious Thoughts on 'Natural Breasts.'"

7 Hu Shi, T*he Greatest Event in Life*, trans. Edward Gunn. In Edward Gunn, ed., *Twentieth Century Chinese Drama* (Bloomington: Indiana University Press, 1983), pp. 1–9.

8 Bing Xin, "Going Abroad" [*Quguo*] in *Bing Xin Xiaoshuo Quanji* (Complete Fictional Works of Bing Xin) (Beijing: Zhongguo wenlian chuban gonsi, 1995), p. 34.

9 Ba Jin [Pa Chin], *Family*, trans. Sidney Shapiro. (New York: Doubleday, 1972), p. 48.

10 Lu Xun, "Regret for the Past," in *Selected Works*, I, p. 249.

11 Ba Jin, *Family*, p. 65.

12 Bing Xin, "Two Families" (*Liangge jia ting*), *Complete Fictional Works*, pp. 1–10.

13 Lu Xun, "What Happens after Nora Leaves Home?" in *Selected Works*, II, p. 87.

14 Hu Huaishen, "Nüzi dang feichu zhuangshi."

15 Deng Chunjin, "The Present Condition of Xining Women's School and How it Should be Improved." *The Spring Morning Society Quarterly* (*Chunchao Xuehui Jikan*), 1.1, (December 1919): 47–48 (photocopy of handwritten manuscript).

16 Ibid.

17 Xu Dishan, "Women's dress" (*Nüzi di yifu*).

18 Ibid.

19 Ibid.

20 Ibid.

21 Ono Kazuko, *Chinese Women in a Century of Revolution, 1850–1950* (Stanford, Stanford University Press, 1989) p. 60.

22 Ibid.

23 See Zhou Huilin, "Nü yuanyan, xieshi zhuyi, 'Xin Nüxing' lunshu – wanqing dao wusi shiqi Zhongguo xiandai juchangzhong de xinbie biaoyan" (On actresses, realism and the New Woman-gender performance on the modern Chinese stage from late Qing to May Fourth), *Jindai Zhongguo funü shi yanjiu* 4 (August 1996): 87–133, for a comprehensive analysis of gender and performance on the early Republican stage.

24 See Ng Chun Bong et. al, *Chinese Woman and Modernity*.

25 Chang, "Chinese Life and Fashion," p. 71.

26 Bing Xin, "Wo de tongxue" (My Schoolmates), in *Bing Xin Sanwen*, I, p. 235.

Chapter 8

1 Literature scholar Lydia Liu has used the notion of "translated modernity" to describe the process of legitimization of the Chinese modern in a colonial world; pp.183–5. I agree with her insistence on Chinese "agency" and her weariness of the determinism embedded in such terms as "belated modernity." My use of "mimetic modernity" is not meant to be deterministic, nor do I imply a lack of agency or creativity on the parts of the Chinese. Instead, I wish to call attention to the visual and formal resemblance between the goals of the Chinese modern project and those of the "advanced" industrial nations.

2 In the novel, the scholar is cold and also in need of disguise. Rejected by the Buddhist monks with whom he is boarding, he borrows the attire from an enlightened missionary who speaks Chinese. Li Boyuan, *Wenming xiaoshi*, pp. 65–7.

3 Zhou Xibao, *Zhongguo gudai fushi shi*, p.561.

4 Lung-kee Sun ("The Politics of Hair and the Issue of the Bob in Modern China," *Fashion Theory* 1.4 (1997): 353–65) has studied how the bob was sexualized in the writings of Lu Xun and his brothers Zhou Zuoren and Zhou Jianren. He places these May Fourth giants not in a discourse of enlightenment, but in a discourse of *fin-de-siècle* decadence.

5 Yao Lingxi, *Caifeilu xubian* (A sequel to Picking Radishes; Tianjin: Shidai gongsi, 1936), pp. 261–3.

6 See one such pair in the collection of Beverley Jackson, illustrated in her book *Splendid Slippers*, p.47. It is made of pigskin and measures 3¾ inches long. Jackson dates it to the 1920s. Zhang Yanfeng has suggested that western-styled small shoes were first made in the late Qing-early Republican period for wealthy ladies (see his *Lao yuefenpai guanggaohua*, I, p. 80).

7 The term *shizhuang* (current attire) is a homonym of *shizhuang* (current adorn-ment) which appeared in the lyrics of famous Tang poet Bo Juyi. In Bo's hands, *shizhuang* or *shishizhuang* (current-world adornment) refers to the Persian-influenced make-up style of fashionable Tang women. See Suzanne Cahill's translation of one of Bo's poems on this theme in chapter 5 above. *Shishizhuang* is a native Chinese term for fashion-as-attire.

8 Calendar girls promoting a brand or a commodity comprised a distinct genre born of the commercial culture of Shanghai. These calendars were distributed to Chinese customers as far away as North America and South East Asia. The W. D. & H. O. Wills Tobacco Company established its own institute in Shanghai in 1915 to train artists, photographers, and printers for its advertising campaigns, heralding the popularity of such calendars. Ding Song (who also used the name Muqin) was one of the Chinese artists employed by the advertisement department of the company. Zhang Yanfeng, *Lao yuefenpai*, I, p. 67.

9 Other leisure activities include swimming, reading, tending to a birdcage, painting, and napping. Equally striking are drawings depicting women working in and out of the household, nursing babies, teaching on a podium, mailing a letter, and so on. See *Shanghai shizhuang tuyong, passim*. The contrast between leisure and work is yet another indication of the conflicting demands placed on the modern Chinese woman. These contradictions contributed to a multiplicity and a certain indeterminacy of her visual images.

10 Shu-mei Shih, "Gender, Race, and Semicolonialism: Liu Na'ou's Urban Shanghai Landscape," *The Journal of Asian Studies* 55.4 (1996): 934–56, p. 935 n. 2. Shih sees this bifurcation as particular to China's semicolonial context. By semi-colonialism she means "a discursive context [that] designates both the multiple intellectual positions available due to both a fragmented colonial structure and the urgency of the appointed task of anti-traditional cultural criticism via pro-westernism, in tension with the material existence of multilayered colonial domination." (p. 939).

11 Shih, "Gender, Race and Semi-colonialism," pp. 948–52. Shih added that this kind of semicolonial cultural resistance ended with the onslaught of the Sino-Japanese War in 1937.

12 Zhang, *Lao yuefenpai*, 1, p. 80.

13 The qipao made its first appearance in the early 1920s and became popular during the second half of the decade among urban middle-class women. Antonia Finnane has written that: "They were the female face of a progressive China and what they wore assumed a transcendental importance, signifying the hegemony of the modern." Finnane, "What Should Chinese Women Wear?" pp. 109–111.

14 Li Yishu, "Cong jinlian shuodao gaogenxie," pp. 30–31.

15 Yao Lingxi, *Caifeilu chubian* (Picking Radishes; Tianjin: Shidai gongsi, 1934), p.183. Yao lived in the northern treaty port of Tianjin but a vague caveat at the end suggests that these observations could have been made by a friend from Shanghai.

16 Yao, *Caifeilu chubian*, pp. 213–15.

Chapter 9

1 *Cheung sam*, sometimes spelled *cheongsam*, and pronounced "chang shan" in Mandarin, is the Cantonese term which literally means "long shirt." The more common Mandarin Chinese term for the same garment is *qipao*, which is translated as "banner gown."

2 *Chinese Costume in Transition*, p. 83.

3 Clark and Wong, "Who Still Wears the Cheung Sam?" pp. 68–70.

4 Eileen Chang gives 1921 as the date of the earliest reference to its being worn; see Eileen Chang, "Chinese Life and Fashions," p. 72.

5 Lee, "A Study of Calendar Poster Painting," p. 93.

6 Ibid., p. 102.

7 Ibid., p. 93.

8 Thanks to my colleague William Cheung for this information.

9 Quoted in Scott, *Chinese Costume in Transition*, p. 81.

10 Finnane, "What Should Chinese Women Wear?" p. 118.

11 Shi Shumei, "Yijiusanjiu nian de Shanghai nüxing," p. 148.

12 Scott, *Chinese Costume in Transition*, p. 86.

13 Hazel Clark and Agnes Wong, *The Cheung Sam in Hong Kong: From Functional Garment to Cultural Symbol*. (Hong Kong: Regional Council, unpublished research report, 1996), p. 6.

14 Interview with two members of the Hong Kong Wearing Apparel Industry Employees General Union, January 12, 1996.

15 Clark and Wong, "Who Still Wears the Cheung Sam?" p. 72.

16 *The South China Morning Post*, December 9, 1968.

17 Pauline Aylward, "Men Despair – Our Girls Are Tired of Their Cheong-Sams". *The Standard*, Hong Kong, January 13, 1964.

18 The riots of 1967, which occurred at the height of the Cultural Revolution in the mainland, were inspired by the Red Guards. They were soon brought under control, but not before they had had an effect on the economy and on property prices.

19 Clark and Wong, "Who Still Wears the Cheung Sam?" p. 73.

20 Ibid., pp. 70–72.

21 According to tailor Gwai this tendency began in the early 1980s. Tailor Gwai interview, Hong Kong, March 3, 1997.

22 This point was made by older generation Chinese women who had migrated from Hong Kong and China to Sydney, Australia. Interviews, Sydney, June 1998.

23 Based on April 1996 to March 1997 sales figures.

24 "Shanghai Tang – First Flagship Store in the United States", Shanghai Tang press release, Hong Kong April 18, 1997.

25 *South China Morning Post*, Hong Kong, June 26, 1998.

Chapter 10

1 Alessandro Russo, "The Probable Defeat: Preliminary Notes on the Chinese Cultural Revolution," *positions*, Spring 1998: 179–202, p. 181.

2 Laura Fair, "Dressing Up: Clothing, Class and Gender in Post-Abolition Zanzibar," *Journal of African History* 1:1 (1998): 63–94; Irene V. Guenther, "Nazi 'Chic'? German Politics and Women's Fashions, 1915–1945," *Fashion Theory* 1 (1997): 29–58; Emma Tarlo, *Clothing Matters: Dress and Identity in India* (London: Hurst, 1996).

3 Julia F. Andrews, *Painters and Politics in the People's Republic of China, 1949–1979* (Berkeley: University of California Press, 1994), pp. 338–42.

4 Nien Cheng, *Life and Death in Shanghai* (London: Harper Collins, 1993), pp. 82, 102; Wen Chihua, *The Red Mirror: Children of China's Cultural Revolution* (Boulder, Colo.: Westview Press, 1995), p. 8; Zhang Xiaofei, "The Painter: Zhang Xiaofei," in *China For Women: Travel and Culture* (New York: The Feminist Press, 1995), pp. 210–11.

5 Sang Ye, "From Rags to Revolution: Behind the Seams of Social Change," in Roberts, *Evolution and Revolution*, 40–51, p. 43.

6 Dai Qing, "How I Experienced The Cultural Revolution," in *China for Women: Travel and Culture*, p. 79.

7 Michael Schoenhals, "The Proscription and Prescription of Political Terminology by the Central Authorities, 1949–1989," in Chun-chieh Huang and Eric Zürcher, eds., *Norms and the State in China* (Leiden: E. J. Brill, 1993), 337–58.

8 Beijing Foreign Languages Institute, English Department. *Chinese/English Dictionary* (Beijing: Commercial Press, 1980).

9 *China Pictorial* 1969.2: 40–41.

10 Quoted in Jonathan D. Spence, *The Search For Modern China* (New York: W. W. Norton, 1990), p. 646.

11 *China Pictorial* 1978.5: 12–15.

12 Jan Wong, *Red China Blues: My Long March from Mao to Now* (London: Bantam, 1997), pp. 166–7.

13 Lynn T. White, *Policies of Chaos: The Organizational Causes of Violence in China's Cultural Revolution* (Princeton: Princeton University Press, 1989), pp. 10–15.

14 Nathan Joseph, *Uniforms and Nonuniforms: Communication Through Clothing* (New York: Greenwood Press, 1986), pp. 2, 68, 115.

15 Lois Fisher, *Go Gently Through Peking: A Westerner's Life in China* (London: Souvenir Press, 1979), pp. 87, 136, 162.

16 Anita Chan, *Children of Mao: Personality Development and Political Activism in the Red Guard Generation* (London: Macmillan, 1985), pp. 15, 28–9, 49; Joseph, *Uniforms and Nonuniforms*, pp. 105, 118–19.

17 Chan, *Children of Mao*, p. 118; Nien, *Life and Death in Shanghai*, p. 319.

18 Ma Bo, *Blood Red Sunset: A Memoir of the Chinese Cultural Revolution*. First published in China in 1988 (London: Penguin, 1995), pp. 1, 289.

19 Renmin da huitang guanliji/Zhongguo zhaopian dang'anguan (The Administrative Bureau of the Great Hall of the People/Chinese Photo Archives), *Renmin da Huitang (1959–1989)* (The Great Hall of the People: 1959–1989), Xianggang: Zhongguo guanggao youxiangongsi, 1989 (Hong Kong: Chinese Resources Advertising Co., Ltd., 1989), pp. 44–5, 60, 84–5.

20 *China Pictorial* 1975.8: 10–11; *China Pictorial* 1975.12: 20–21.

21 Susan Brownell, *Training the Body for China: Sports in the Moral Order of the People's Republic* (Chicago: University of Chicago Press, 1995), p. 146.

22 Chao Kang, *The Development of Cotton Textile Production in China* (Cambridge: Harvard University Press, 1977), pp. 289–91; Sang Ye, "From Rags to Revolution," p. 43.

23 Yu Feng, "Jintian de funü fuzhuang wenti" ("The Question of Women's Dress Today") in *Zhongguofunü* ("Women of China") (March 1955): 31–2.

24 Harriet Evans, *Women and Sexuality in China: Dominant Discourses of Female Sexuality and Gender since 1949* (Cambridge: Polity Press, 1997), pp. 135–6.

25 Delia Davin, *"Woman-Work": Women and the Party in Revolutionary China* (Oxford: Clarendon Press, 1976), pp. 109–10, 152–3, 169–72.

26 Nien, *Life and Death in Shanghai*, p. 265.

27 Mary Sheridan, "The Emulation of Heroes," *China Quarterly* 33 (January–March, 1968): 47–72.

28 *New China*, 1952 (Peking: Foreign Languages Press), n.p.

29 Jerome Silbergeld, with Gong Jisui, *Contradictions: Artistic Life, the Socialist State, and the Painter Li Huasheng* (Seattle: University of Washington Press, 1993), p. 43.

30 Anonymous, *A Vicious Motive, Despicable Tricks – A Criticism of M. Antonioni's Anti-China Film "China"* (Peking: Foreign Languages Press, 1974), pp. 4–14.

31 *Selected Photographs of China* (Peking: Foreign Languages Press, 1977).

32 Susan Sontag, *On Photography* (London: Penguin, 1979), p. 173.

33 Marc Riboud, *Marc Riboud in China: Forty Years of Photography* (London: Thames & Hudson, 1997).

34 Marc Riboud, *The Three Banners of China* (London: Macmillan, 1966), p. 169.

35 Fisher, *Go Gently Through Peking*, p. 43.

36 Quoted in David S. G. Goodman, *Beijing Street Voices: The Poetry and Politics of China's Democracy Movement* (London: Marion Boyars, 1981), p. 32.

37 Chinese Visual Arts Project, University of Westminster, London, "Poster Reference Guide," N27.

38 Fred Davis, *Fashion, Culture, and Identity* (Chicago: University of Chicago Press, 1992), pp. 70–71.

Selected Bibliography

Barber, Elizabeth Wayland. *The Mummies of Ürümchi*. New York: W. W. Norton & Co., 1999

Berliner, Nancy Zeng. *Chinese Folk Art*. Boston: Little, Brown & Co., 1986

Bing Xin. *Bing Xin sanwen* [Essays of Bing Xin]. Beijing: Zhongguo guangbo dianshi chubanshe, 1997

Bray, Francesca. "Textile Production and Gender Roles in China, 1000–1700." *Chinese Science* 12 (1995): pp. 113–35

Bray, Francesca. *Technology and Gender: Fabrics of Power in Late Imperial China*. Berkeley: University of California Press, 1997

Brook, Timothy. *The Confusions of Pleasure: Commerce and Culture in Ming China*. Berkeley: University of California Press, 1998

Cahill, Suzanne. *Transcendence & Divine Passion: The Queen Mother of the West in Medieval China*. Stanford: Stanford University Press, 1993

Cammann, Schuyler v. R. "The Development of the Mandarin Square." *Harvard Journal of Asiatic Studies* 8 (1944): 71–130

Cammann, Schuyler v. R. *China's Dragon Robes*. New York: Ronald Press Company, 1952

Chang, Eileen [Zhang Ailing]. "Chinese Life and Fashions." *Lianhe wenxue* (*Unitas*) 29 (1987): 66–73. Originally published in *The XXth Century* (Shanghai), IV.1 (January 1943)

Chinese Clothing. What's New in China (10). Beijing: China Reconstructs, 1985

Chu, Ingrid. "Artificial Flavour: Asian Identity & the Cult of Fashion." *Plus Zero*, no. 2 (Toronto: PlusZero Press, 1998)

Clark, Hazel, and Agnes Wong. *The Cheung Sam in Hong Kong: From Functional Garment to Cultural Symbol*. Hong Kong: Regional Council (unpublished research report, 1996)

Clark, Hazel, and Agnes Wong. "Who Still Wears the Cheung Sam?" in Claire Roberts, ed., *Evolution and Revolution: Chinese Dress 1700s–1990s*. Sydney: Powerhouse Publishing, 1997, pp. 65–73

Davin, Delia. *"Woman-Work": Women and the Party in Revolutionary China*. Oxford: Clarendon Press, 1976

Dickinson, Gary, and Linda Wrigglesworth. *Imperial Wardrobe*. Hong Kong: Oxford University Press, 1990

Ebrey, Patricia Buckley. *The Inner Quarters: Marriage and the Lives of Chinese Women in the Sung Period*. Berkeley: University of California Press, 1993

Evans, Harriet. *Women and Sexuality in China: Dominant Discourses of Female Sexuality and Gender Since 1949*. Cambridge: Polity Press, 1997

Fairservis, Walter A. Jr. *Costumes of the East*. New York: American Museum of Natural History, 1971

Feng Jicai. *The Three-Inch Golden Lotus*. trans. David Wakefield. Honolulu: University of Hawaii Press, 1994

Finnane, Antonia. "What Should Chinese Women Wear? A National Problem." *Modern China* 22.2 (1996): 99–131

Finnane, Antonia, and Anne McLaren, eds. *Dress, Sex and Text in Chinese Culture.* Melbourne: Monash Asia Institute, 1998

Garrett, Valery M. *Chinese Clothing: An Illustrated Guide.* Hong Kong: Oxford University Press, 1994

Garrett, Valery M. "The Cheung Sam – Its Rise and Fall." *Costume: The Journal of The Costume Society* 29 (1995): 88–94

Godley, Michael. "The End of the Queue: Hair as Symbol in Chinese History." *East Asian History* 8 (December 1994): pp. 53–72

Harada, Yoshito. *Kan Rokuchō no fukushoku* [added title in English: *Chinese Dress and Personal Ornaments in the Han and Six Dynasties*]. *Toyo Bunko Ronso*, series A, vol. 23. Tokyo: Tōyō Bunko, 1937

He Jianguo, Zhang Yanying, and Guo Youming. *Hair Fashions of Tang-Dynasty Women.* Hong Kong: Hair and Beauty Co., 1987

Honour, Hugh. *Chinoiserie: The Vision of Cathay.* New York: Harper & Row, 1961

Hu Huaishen. "Nüzi dang feichu zhuangxi" [Women must give up adornment]. *Funü zazhi* 6.4 (5 April 1920)

Hua Mei. *Zhongguo fuzhuang shi* [A history of Chinese dress]. Tianjin: Renmin meishu chubanshe, 1989

Huang Neng and Chen Juanjuan. *Zhonghua fushi yishu yuanliu* [Origin and development of the Chinese art of dress]. Beijing: Higher Education Press, 1994

Huang Neng and Chen Juanjuan. *Zhongguo fuzhuang shi* [A history of Chinese dress]. Beijing: Zhongguo luyou chubanshe, 1995

Jackson, Beverley. *Splendid Slippers.* Berkeley: Ten Speed Press, 1997

Jacobson, Dawn. *Chinoiserie.* London: Phaidon Press, 1993

Ko, Dorothy. *Teachers of the Inner Chambers: Women and Culture in Seventeenth-Century China.* Stanford: Stanford University Press, 1994

Ko, Dorothy. "The Body as Attire: The Shifting Meanings of Footbinding in Seventeenth Century China." *Journal of Women's History* 8.4 (1997): 8–27

Ko, Dorothy. "Bondage in Time: Footbinding and Fashion Theory." *Fashion Theory* 1.1 (1997): 3–27

Laumann, Maryta M. *The Secret of Excellence in Ancient Chinese Silks.* Taipei: Southern Materials Center, Inc., 1984

Lee, Jack S. C. "A Study of Calendar Poster Painting in Early 20th Century Canton and Hong Kong." *Besides: A Journal of Art History and Criticism* (1997): 91–110. Hong Kong: The Workshop, Hong Kong Art History Research Society

Legrand-Rossi, Sylvie, et al. *Touches d'exotisme, XIVᵉ–XXᵉ siècles.* Paris: Union centrale des arts décoratifs, Musée de la mode et du textile, 1998

Levy, Howard. *Chinese Footbinding: The History of a Curious Erotic Custom.* New York: Bell, 1967

Li Boyan. *Wenming xiaoshi* [A short history of civilization], in *Wan-Qing xiaoshuo daxi* [Collectanea of late Qing fiction]. Taipei: Guangya chuban youxian gongsi, 1984

Li Xiaobing. *Zhongguo xiyou minzu fushi yanjiu* [Studies of clothing and adornment among the peoples of China's western regions]. Urumqi: Xinjiang renmen chuban she, 1995

Li Yishu. "Cong jinlian shuodao gaogenxie" [From the golden lotus to high heels]. *Funü zazhi* 17.5 (1931): 15–31

Liu, Lydia H. *Translingual Practice: Literature, National Culture, and Translated Modernity – China, 1900–1937*. Stanford: Stanford University Press, 1995

Lu Xun. *Selected Works of Lu Xun*, trans. Yang Xianyi and Gladys Yang. 2 vols. Beijing: Foreign Languages Press, 1980

McIntyre, Tanya. "Picturing Women in Chinese New Year Prints," in Antonia Finnane and Anne McLaren, eds., *Dress, Sex and Text in Chinese Culture*, Melbourne: Monash Asia Institute, 1998

Martin, Richard, and Harold Koda. *Orientalism: Visions of the East in Western Dress*. New York: Metropolitan Museum of Art, 1994

Ng Chun Bong, et al., eds. *Chinese Woman and Modernity: Calendar Posters of the 1910s –1930s*. Hong Kong: Commercial Press, 1995

Ng Chun Bong, et al., eds. *Hong Kong Fashion History*. Hong Kong: Committee on the Exhibition of Hong Kong Fashion History, 1992

Ono Kazuko. *Chinese Women in a Century of Revolution, 1850–1950*. Stanford: Stanford University Press, 1989

Rawski, Evelyn S. *The Last Emperors: A Social History of Qing Imperial Institutions*. Berkeley: University of California Press, 1998

Roberts, Claire, ed. *Evolution and Revolution: Chinese Dress, 1700s–1990s*. Sydney: The Powerhouse Museum, 1997

Roberts, Glenn, and Valerie Steele. "The Three-Inch Golden Lotus." *Arts of Asia* 27.2 (1997): 69–85

Schafer, Edward H. *The Golden Peaches of Samarkand: A Study of T'ang Exotics*. Berkeley: University of California Press, 1963

Scott, A. C. *Chinese Costume in Transition*. Singapore: Donald Moore, 1958

Shanghai shizhuang tuyong [Drawings with colophons of Shanghai fashion]. Taipei: Guangwen shuju, 1968

Shanghai Theatrical College Editorial Committee. *Ethnic Costumes and Clothing Decorations from China*. Hong Kong: Hai Feng Publishing Co., 1986

Shen Congwen. *Zhongguo gudai fushi yanjiu* (Researches on ancient Chinese costume). Hong Kong: Commercial Press, 1981; reprinted, Shanghai, 1997

Shi Shumei. "Yijiusanjiu nian de Shanghai nüxing: cong hou zhimin lunshu de juedu kan Zhonggou xiandai nüxing zhi 'xiandai xing.'" [Shanghai women in 1939: the 'modernity' of modern Chinese women from a post-colonial perspective]. *Lianhe wenxue (Unitas)*, 115 (1994): 139–48

Shi Shumei. [Shih, Shu-mei]. "Gender, Race, and Semicolonialism: Liu Na'ou's Urban Shanghai Landscape." *The Journal of Asian Studies* 55.4 (1996): 934–56

Steele, Valerie. "Fashion in China." *Dress* 9 (1983): 8–15

Sun, Lung-kee. "The Politics of Hair and the Issue of the Bob in Modern China." *Fashion Theory* 1.4 (1997): 353–65

Szeto, Naomi Yin-yin. *Dress in Hong Kong: A Century of Change and Customs*. Hong Kong: Museum of History, 1992

Vollmer, John E. *In the Presence of the Dragon Throne: Ch'ing Dynasty Costume (1644–1911) in the Royal Ontario Museum*. Toronto: Royal Ontario Museum, 1977

Vollmer, John E. *Decoding Dragons: Status Garments in Ch'ing Dynasty China*. Eugene: University of Oregon Museum of Art, 1983

Watt, James C. Y., and Anne E. Wardwell. *When Silk Was Gold: Central Asian and Chinese Textiles*. New York: Metropolitan Museum of Art, 1998

Williams, C. A. S. *Outlines of Chinese Symbolism and Art Motives*. Peking: Customs College

Press, 1921

Wilson, Verity. *Chinese Dress*. London: Bamboo Publishing in association with the Victoria and Albert Museum, 1986

Wrigglesworth, Linda. *"The Badge of Rank": China*. London: Linda Wrigglesworth, 1990

Xiang Da. *Tangdai Chang'an yu xiyou wenming* [Tang dynasty Chang'an and the culture of the western regions]. Beijing: Xinhua shudian, 1957

Xu Dishan. "Funü di fushi" [Women's dress] in Fan Qiao and Ouyang Jing, eds., *Xu Dishan sanwen* [Essays of Xu Dishan], Beijing: Zhongguo guangbo dianshi chubanshe, 1996, pp. 239–43. First published in *Xin shehui* [New society], 11 January 1920

Ye Wa. "Tangdai funü di gongfu he changfu" [Public and private clothing of Tang dynasty women]. *Kaogu yu wenwu* [Archaeology and cultural artifacts] 1983.3: 236–46

Yu Feng. "Jintian di funü fuzhuang wenti" [The question of women's dress today]. *Zhongguo funü* [Women of China], March, 1955: 31–32

Zhang Yanfeng. *Lao yuefenpai guanggaohua* [Poster girls on old calendars [from Shanghai, 1908–1939]]. 2 vols. *Hansheng zazhi* 61–2. Taipei: Hansheng zazhishe, 1994

Zhou Xibao. *Zhongguo gudai fushi shi* [A history of dress in ancient China]. Taipei: Nantian tushu youxian gongsi, 1992

Zhou Xun and Gao Chunming. *5000 Years of Chinese Costumes*. San Francisco: China Books & Periodicals, 1987

Index